COLOR
FOR THE
WATERCOLOR
PAINTER

COLOR
FOR THE WATERCOLOR PAINTER

BY TOM HILL
A.N.A., A.W.S.

WATSON-GUPTILL PUBLICATIONS/NEW YORK

PITMAN PUBLISHING/LONDON

First published 1975 in the United States and Canada by Watson-Guptill Publications,
a division of Billboard Publications, Inc.,
One Astor Plaza, New York, N.Y. 10036

Library of Congress Cataloging in Publication Data
Hill, Tom, 1922–
 Color for the watercolor painter.
 1. Water-color painting—Technique. I. Color in
art. 3. Artist's materials. I. Title.
ND2420.H54 751.4′22 74-30127
ISBN 0-8230-0733-2

Published in Great Britain 1975 by Sir Isaac Pitman & Sons Ltd.,
39 Parker Street, Kingsway, London WC2B 5PB
ISBN 0-273-00905-2

Manufactured in U.S.A.

First Printing, 1975

To watercolorists everywhere

CONTENTS

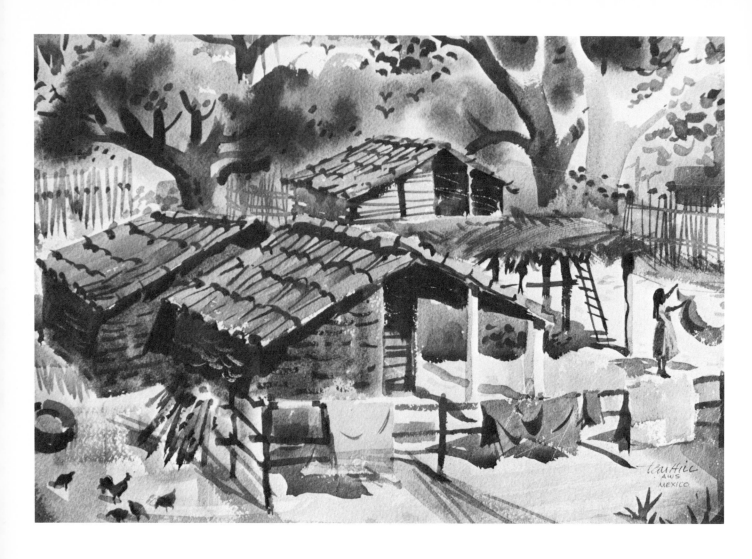

Rural Farm, Mexico *(14" × 22"). Collection Mr. and Mrs. H. Kroehl. Where this little scene exists, there are no problems with cold weather, and the house is always wide-open to the breezes. Handmade roof tiles divert the downpour during the rainy season, keeping the inside of the house dry. Life is perfect here — except for the bugs! I liked the patterns and textures that I saw in this scene as I drove by, and tried to convey them in my painting with a series of soft and hard edges, plain and complicated textures, and large and small shapes. I started with wet-in-wet, doing most of the underpainting of the trees in the background, and floating light-value underpainting colors in the foreground. The painting progressed mostly from light to dark, with the calligraphy and details left until last.*

INTRODUCTION

Transparent watercolor! Ah, that elusive, swirling, magic mistress-of-a-medium! Just when you think you've won her, you find that she's still capricious and she's slipped from your grasp! Then, when you're least expecting it, she rewards your attention and efforts with success!

Many declare her to be the most difficult of the major art media to master and control. Comparing watercolor with her more matter-of-fact sisters — oil, tempera, and pastel — I'm inclined to agree.

So — why watercolor? Transparent watercolor is (or can be) a free-wheeling, *happy* medium. A battle and peace treaty in every painting session. Tension and relief combined. Always a new discovery or two ahead for the practicing watercolorist!

With little chance to correct, change, or work over paintings done in transparent watercolor, the artist's feelings, skills, and approach are laid bare to the viewer's eye. Nothing is hidden or adjusted; everything is straightforward and honest. What a challenge!

This book is about transparent watercolor — and especially about the second half of the word watercolor: *color.*

We'll warm up with a review of what watercolor is, some basic techniques for getting watercolor to *behave*, and a discussion about painting materials and gear. Then we'll get further into exploring the business of color — what it is and what we can do with it in our painting.

I first became interested in watercolor painting while I was still in my teens. In those days, I didn't know a warm blue from a cool one or a staining pigment from one which stayed on the surface. I just blundered along, making mistake after mistake. But, all the same, I was intrigued. Every so often, the dawn would come to me, and I'd realize some new-to-me truth that should have been apparent all along. And so I'd progress a bit. Today, it's still a process of learning — and I hope it's always going to be this way.

Maybe this book will enable you to leapfrog over some of the blunders that I've made in learning about painting, and help put you farther down the road toward the goals of mastery, knowledge, and excellence in your work.

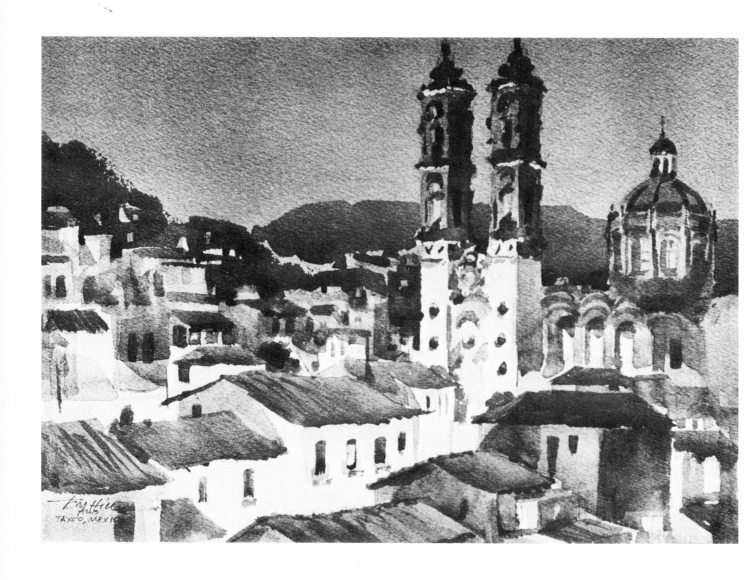

Evening in Taxco *(14″ × 22″). Collection Dr. and Mrs. D. Holden. Twilight is a magic time in Taxco, Mexico, when the already unreal, storybook town turns even more unreal! The evening sky to the east is a grayed violet, the hills are almost black-green, and the tile-topped roofs are a warm, grayed burnt sienna. The yellow and orange from the streets and shops shine upward, casting reverse lighting and shadows on the buildings. Striving to capture this magic hour, I greatly simplified the architecture and let the light run in paths to show where the streets are, below, out of view. This painting was definitely a cool violet, warm yellow color combination, with the violets grayed and predominating, and the yellows (and the white paper) fairly intense though receding. I painted the sky a flat wash, which actually grades to a little lighter at the bottom, and runs clear on down behind where the mountains will be. After the sky was dry, the roof top patterns were established and the mountains painted in. All that was left to do were the church towers and snappy little details in the buildings.*

I
LET'S START WITH THE RIGHT TOOLS

Since this book is about *color* in watercolor, you're probably wondering what I'm doing starting off talking about *tools*. I know many of you have already painted in watercolor and so know quite a bit about such things as paint, paper, technique, etc. But I think that a little review won't hurt, will refresh our memories, and at the very least we'll all be talking about the same thing, in the same terms! Of course, the first step should be to define what watercolor *is* and *isn't*.

Setting the Record Straight

Let's begin by examining some of the notions that people seem to have about our favorite medium.

Some mothers of young children think: "Watercolor is the paint that I buy in those little metal trays at the dime store, and the nice thing about it is that the kids can mess around with it and can't really hurt themselves — or the house, either!"

Other people think (if they think about it at all): "Oh yeah — watercolor is what my great-aunt used to paint all those anemic paintings of flowers that were up in the attic when we were kids. I wonder what ever happened to them? Gee, they were pale, insipid things!"

Another opinion: "Watercolors are nice — it's a shame that they aren't permanent. I'd be willing to buy one if watercolor paintings were permanent like oils!"

Still another opinion: "Watercolor? That's the stuff the old masters used to make their preliminary sketches and studies before they did their paintings."

A final one: "Watercolor painting is for beginners, before they tackle the more difficult mediums."

Let's start now to change all these opinions into something closer to the truth.

True, there are watercolor sets for little children, and they're fine for what they are, but they've little relationship to what we're talking about. Watercolors are a popular medium for the early school years—they're relatively inexpensive and they can be easily cleaned off the kids' clothes and the classroom floor. Maybe this is why so many people associate watercolor painting with simple basic learning and think it's for beginners.

Sure, watercolor has been used by nearly everyone's ancestral aunt to paint thin, delicate, "ladylike" paintings, but that's by no means all the medium is capable of!

Today, the colors in quality watercolors are as permanent as the colors in any other medium. The pigments used are identical to the pigments used in oil, pastel, etc., and with their simple formulation (water, gum arabic, glycerin), there's not much that can spoil, craze, crack, or fall off a watercolor done on good 100% rag paper!

True, the old masters often used watercolor to make their studies and sketches preparatory to painting their larger works. Modern masters do too, and in more and more instances, go on

to do the final larger painting in transparent watercolor!

And, though watercolor is used in the beginning school years, it happens to be one of the more difficult mediums to master — one that is really best understood after the artist has painted opaquely, and has developed a good grasp of value and color relationships, composition, and so forth.

So — let's put mature watercolor painting where it belongs: right at the top of the pile, equal to any and all!

What Watercolor Is

The dictionary describes "transparent" as "having the property of transmitting light through its substance so that bodies situated beyond or behind can be distinctly seen." It's this transparent quality of the watercolor pigment — allowing light to travel through it, hit the white paper underneath, and bounce back up again through the color — that accounts for a lot of watercolor's esthetic qualities, such as its vitality and brilliance. I'm sure that you've seen watercolors that actually seem to glow from within.

The transparency of the medium also influences the manner in which the artist paints. In transparent painting, no opaque paint is used, and because he will not be able to add his whites or light values later in the painting process, the artist must always think ahead to how he'll use and save the white paper which is his "color" white. In opaque painting, the whites or lighter values can always be added later, and even over darker values already applied. In a sense, the thinking involved in transparent painting and the thinking involved in opaque painting are really opposite.

So — our definition of this medium could be: watercolor is a transparent aqueous pigment through which light passes and reflects off the white ground, and for which the whites, or near whites, are simply the paper itself.

Brushes

Art supply stores and catalogs offer a bewildering array of brushes in all sizes, materials, and prices. It can be confusing, but don't let it be, for you'll only need a few brushes. I usually use only three or four, and often fewer, to complete my paintings. See Figure 1 for the parts of a brush.

Although brushes are made of such diverse materials as goat, squirrel, badger, and skunk hair (not, however, camel's hair), let's confine ourselves to only *three* brush materials, sable, oxhair, and bristle, and *two* brush styles, round and flat. Figure 2 shows some of my favorites that I use all the time in watercolor painting.

Sable. No question about it — the finest watercolor brushes are made from sable hair, which is actually the tail hair of the red tartar martin, or Kolinski, as it's called in Siberia, where it lives. This hair is sometimes hard to obtain and is expensive. By the time the hair is imported, selected, cleaned, sized, and baked (!), hand-cupped so that each hair's natural bend is accommodated to the brush's final shape, then hand-fitted into rust-proof, seamless metal ferrules and balanced handles are added, well — you've got an expensive item. I hasten to add, however, that if you have a good sable and take proper care of it, it can be a pure joy to use.

Sables come in rounds and flats. I'd suggest that you have at least one good quality round red sable. The rounds range in size from No. 00 (smallest) up to Nos. 12 and 14. Get yourself a No. 8, and if your pocketbook is fat, maybe a No. 12 — hope for a No. 10 or No. 12 for next Christmas! The largest flat sable that I've ever seen in the stores is 1" (2.5 cm); these, too, are expensive, but not quite as much as the rounds. Flat sables are made in sizes from ⅛" (3.1 mm) up to the 1". You could invest in a 1" flat, or you could use a substitute for the sable, namely, oxhair.

Oxhair. This makes an excellent substitute for red sable — particularly in the flat brushes. It is made in rounds, too, and I suspect that this is what the manufacturers call "imitation sable." I prefer, however, to stick to the flats in oxhair, and to the larger brushes at that. Good oxhair has many of the qualities of good red sable at about one-fourth the price! Oxhair flats come in sizes from ⅛" up to 1½" (3.8 cm), and are available even in a 2" (5.1 cm) size. Get yourself a 1" and even a 1½" if you want, and you'll find you can do *most* of your painting with this large a brush. I'm convinced that working with the larger-sized brushes forces you to do more direct painting with big, simple shapes, with less

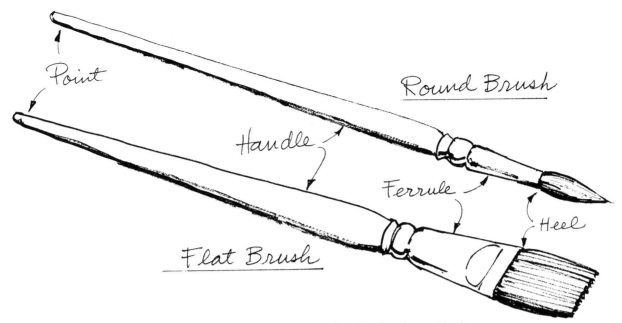

Figure 1. Shown here are the major parts of a brush: point, handle, ferrule, and heel. I've placed a flat brush next to a round one so that you can compare the parts on each.

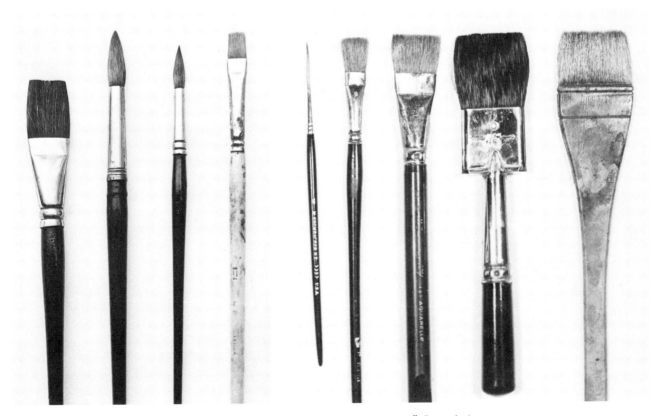

Figure 2. Some of my favorite watercolor brushes are (from left to right): 1" flat oxhair or sable, No. 12 round red sable, No. 8 round red sable, and No. 6 flat bristle. To supplement these basic brushes, I also use: a No. 4 Rigger, ½" flat oxhair or sable, California brush, muslin brush, and the Japanese brush.

fiddling around, filling in, and getting bogged down with detail. (One interesting note is that the finest oxhair, which is a golden color, comes from the ears of oxen that live in mountainous regions, such as the Alps.)

Bristle. Although bristle brushes are thought of as being for oil or opaque painting, they can also be useful to the watercolorist in some ways. There are both natural bristles and synthetic bristles. The best natural bristles are made from the center back hair of hogs, and the older animals have the strongest and best bristle. Synthetic bristles are usually nylon and have been developed especially for painting in acrylic paints.

I use a bristle (and either the natural or synthetic will do) as a "sometimes" tool for scrubbing out an area or for softening a hard edge a bit. It's not a brush I use often, but it's one that's good to have around when you need it. I suggest a No. 4 or No. 6 bristle.

Other Brushes. Your basic brush selection will then include a No. 8 quality round red sable, a 1″ quality flat oxhair, and a natural or synthetic flat bristle, say a No. 4. You could add to these basics a larger round red sable, like a No. 10 or No. 12, and a 1½″ oxhair flat. What other brushes will you need? Not any, really, but let's mention a few "extras" that you might want to try sometime, or maybe have around for special effects — who knows, you may find them better suited to your needs than my selection.

There's a flat watercolor brush, made in both sable and in oxhair, that's referred to as a "California" brush or by the trade name Aquarelle. It's 1″ wide, but has shorter hairs than the other 1″ brushes we've been talking about, and the back end of the handle is cut diagonally, so you can use it as a scraping tool. This is a good brush, and could be used in place of your regular 1″ brush if you liked the feel of the shorter and slightly "snappier" hair action.

You might also want to investigate the possibility of a smaller round brush as a supplement to your No. 8. Try a No. 5 or No. 6 for that occasional little last-minute touch — or for signing your name! However, I still think the smaller brushes are best left in the drawer when it comes to transparent watercolor painting.

Also shown with the California brush in Figure 2 are four other brushes, all of which I find useful as supplements to the basic brushes described earlier: The ½″ (12.7 mm) flat works well as a replacement for your 1″ flat, especially for small areas or on small paintings. The large Japanese brush is probably made of squirrel hair and is useful for big, simple washes. The little Rigger, a No. 4 sable, is good for skinny lines and accents. The most useful of all, to me, is the muslin brush, shown here in a 1½″ size. I use it in place of the 1½″ flat oxhair mentioned earlier, because it's thicker and holds a lot of pigment and water. Mine was purchased in a store that sells supplies to sign painters and house painters, and was actually designed for large poster lettering.

There are others that you may find by yourself. Again, it's a matter of trying them out and if they really do the job better for you, adopting them for your painting requirements.

Proper Care of Your Brushes

Once you've acquired the right brushes and you're painting with them, then the next logical thing to review is how to maintain them in a "nearest to new" condition, so that you can enjoy them as long as possible. To keep them in good condition, do the following: Always, and I mean *always*, lay your brush flat when not actually holding it in your hand. *Never* rest it hair down in the water jar — not even for a minute! Instead, lay it across the mouth of the water jar, or flat on your palette or table. After you're through painting for the day, always wash all your dirty brushes out in water. Pour a little liquid detergent into the palm of your hand and rub the bristles or hair back and forth in it, working the lather up into the "heel" of the brush. Mild hand soap will do if you've no detergent. Rinse the brush well, and form the hairs back into their original shape. Stand the brush on its heel, brush end up, in a coffee can or mason jar, etc., ready for you the next painting session.

If you won't be painting for quite some time, follow all the above as far as cleaning, but store the brushes flat in a box or drawer where the moths can't get at them. (Moths *love* sable and oxhair!) A couple of moth crystals in with the brushes is always a good idea.

There's another hazard to your brush's longevity. When you pack your kit and travel

off to paint on the spot, your brushes might arrive on the scene with their poor hairs all askew—some even bent back and actually broken! This is especially true if they've been allowed to "seek their level" amidst all that junk I'm sure you have in your paintbox! There are several ways that this can be avoided. One way is to wrap the brushes, either individually or as a group, with a fairly heavy paper, several times around, securing this with a strong rubber band at the thickest part of the brushes' handles. If the paper extends out beyond the brushes' ends, and the paper is wound enough times around to be somewhat rigid, then your brushes are safe. See Figure 3.

Another way to protect brushes is to sew or interweave ordinary elastic to one side of a split bamboo or "match-stick" table placemat. Then you can insert your brushes under the elastic, roll the whole thing up and tie it with a shoestring or rubber band. See Figure 4.

Paper

Next on our list of absolute essentials is paper, which is a critical part of good watercolor painting. The paper must not only have a surface and texture that accepts watercolor but it must be permanent in terms of its whiteness and its resistance to the ravages of time. (Some papers, containing wood pulp, turn yellow and even crumble in a relatively short while.)

The best papers for watercolor paintings are 100% rag content, acid-free, and contain no bleaches. The less expensive papers made for watercolor are usually machine-made and have a rather uninspiring, repetitive texture. These are called "student" grade, and you'll find that although they may be good for practicing brushstrokes or testing colors on, they simply won't give you the results that you can hope for on good handmade paper. So, I prefer and use the best handmade papers I can get, even though they cost more—seems we can't get too far away from that old idea that "you gets what you pays fer"! Narrowing the field down to the good quality handmade papers, we find that they're nearly all imports. There are a fair number, though you won't find them *all* at any one art store, and may even have to order them from your art-supply dealer. There are probably some that I've never heard of, but here

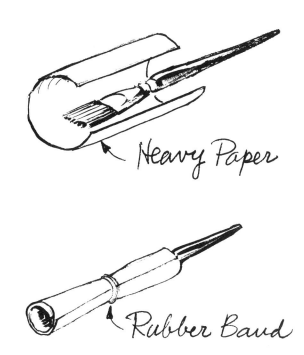

Heavy Paper

Rubber Band

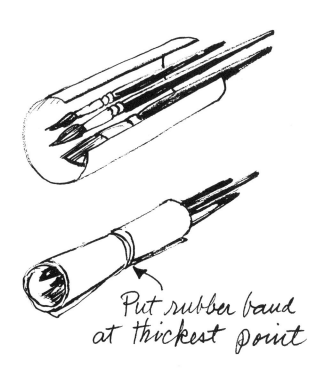

Put rubber band at thickest point

Figure 3. Here's an easy way to protect your brushes while you're traveling or when simply storing them in your paintbox.

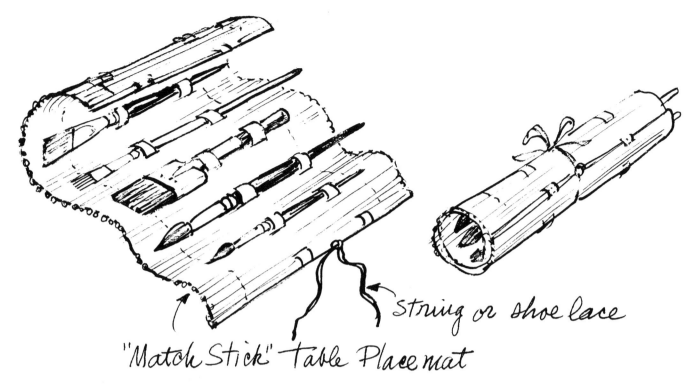

"Match Stick" Table Place mat

string or shoe lace

Figure 4. *This is an alternate method for protecting brushes. Weave a piece of ordinary elastic through a bamboo placemat to create "holders" for brushes. Then simply roll up the mat and — presto — you've got a protective carrier for your brushes.*

are some that I know about and have used: Crisbrook, J. Green, and Royal Watercolour Society papers, all from England. France supplies the famous d'Arches, while Italy makes Fabriano and Capri.

Textures

Watercolor papers come in different textures: *rough, cold-pressed* (semi-rough), and *hot-pressed* (smooth). This last is probably the least popular among watercolorists, since transparent watercolor tends to roll right over the smooth surface, depositing pigment in little hard edges. (Smooth paper is fine, however, for working in tempera watercolors, which are thicker and opaque, and so don't run like transparent.) Cold-pressed paper allows you to slide your washes on rapidly, yet still provides enough tooth (texture) to make control fairly easy. Rough is probably the surface most watercolorists prefer; the paint is somewhat easier to control, since all the little "hills and valleys" act as a sort of brake for your wet, running washes.

Another advantage of the rough paper is that when a brush is passed lightly or rapidly over the rough surface, it may touch only the hills with color, leaving the little white valleys grinning up at you and giving that special sparkle. (Some people say that colors aren't quite as brilliant on rough paper as on cold-pressed and hot-pressed surfaces, because the little hills actually cast tiny shadows in the valleys. This results in the viewer looking at a slightly less well-lit, or "grayer," painting.)

While we're still talking about paper surfaces, I should mention that they vary from brand to brand. Cold-pressed in brand A might more nearly resemble rough in brand B.

Sizing

Different surfaces and different brands will also vary as to their *sizing.* Sizing, a material (usually a gelatin or animal-hide glue preparation) that is applied to the paper during its manufacture, controls how absorbent the paper is. For example, a paper that has *no* sizing would be a blotter. A highly sized paper, such as some printing papers, wouldn't accept the watercolor

at all; it would just stand on the surface. So the sizing in watercolor paper is quite important and has to be "just right." Often there's a little more sizing than the artist wants on a new sheet of paper, and a little sponging-off with water will make the paper accept paint more readily.

One last thing about surfaces: some papers can take more manipulation — and more corrections — than others. The only way to find out all these things and decide what's best for you is to buy different sheets and try them!

Weight

As a watercolorist, you've no doubt come across the terms "140 lb." or "70 lb." paper. If you're like me, you've wondered what all that stood for. I finally found out, after a bit of asking! If a ream of paper (usually 500 sheets) weighs 140 pounds, then that's "140 lb. paper" — similarly, a ream of 300 lb. paper weighs 300 pounds, and so on. Naturally a sheet of, say, 300 lb. paper is going to be considerably heavier than one of 140 lb.; it will be just about twice as heavy, and about twice as thick. The average selection in watercolor papers is 72 lb., 90 lb., 140 lb., 200 lb., 300 lb., and once in a while, 400 lb. The lighter weights, up through 140 lb., really have to be "stretched" in order to paint on them comfortably, otherwise they wrinkle and buckle when wet.

When I was in art school, I couldn't afford to buy the heavier weight watercolor paper and had to settle for 72 lb. Though the *quality* of this paper can be every bit as good as the heavier paper, it simply won't hold the same amount of water that the heavier and thicker papers will, its thinness won't allow you to make as many "scrub-outs" or corrections as the heavier paper, and it has to be stretched before you can really paint on it.

Stretching Watercolor Paper

As I said, I think all paper up to and including 140 lb. should be stretched — and I even like to stretch 300 lb. paper, if I've the time! It's not difficult to do, and you can just about as easily do two or three sheets (or more) in the same time as one. Besides, you can get two sheets of 140 lb. paper, which needs to be stretched, for the price of 1 sheet of 300 lb., which doesn't.

There are some old-fashioned ways to stretch paper, such as gluing the edges of wet paper to a frame or board and allowing it to dry. I'm certainly not recommending this technique, though, since it's much simpler to do with gummed tape or staples.

Most of you probably already have your own method of stretching your paper, but allow me to go over some of the ways I find satisfactory, and also why I feel stretching is important. The basic idea is to let the paper expand in size by soaking it in water, and then to fasten it down so securely that upon drying, the paper can't shrink. It remains "stretched" — as tight as, and just like, a drum! Naturally, this is a great surface to paint on, because the paper would have to become almost as wet during the painting process as it was when soaked, in order for it to wrinkle at all. Even if you manage to get a little hump or two, these dry out perfectly flat. An added advantage is that a bit of the sizing is washed off when soaking, so your paper will be more receptive to the paint.

Some artists paint on even 140 lb. paper without stretching it; they just use paper clamps around the edges (of course, the board underneath must then be about the same size as the sheet of paper). As their paper swells and buckles with the painting process, they simply release the clamps, carefully flatten out the paper, reclamp, and continue to paint. I've done this, but find it's just one more thing to remember while painting in a medium that is already demanding my full attention just to keep up with it. I prefer stretching!

Here are two easy ways to stretch paper:

Canvas Stretchers. This way is handy and lightweight. Soak your paper five to ten minutes in the sink or bathtub. The length of time depends on the weight of the paper, and this means you'll just have to test out different papers for yourself. Lay the soaked paper carefully on top of regular canvas stretchers. Carefully fold the paper down over the stretcher strips and staple (or thumbtack) it all around, at about every two-and-a-half to three inches. I use a Swingline No. 101 staple gun that takes clips of ¼" staples. You just put the nose of the gun down where you want the staple to go, and squeeze the handle! Let the whole stretch dry in a horizontal position. If you plan to use this

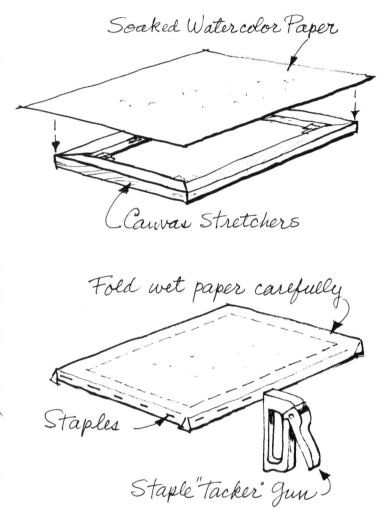

Soaked Watercolor Paper

Canvas Stretchers

Fold wet paper carefully

Staples

Staple "Tacker" Gun

Figure 5. Pictured here is my first method for stretching watercolor paper: place soaked watercolor paper on a wooden canvas-stretcher and then staple the paper to the stretcher.

stretcher at home or in your studio, you might want to glue and nail its corner joints so it will be a little more rigid. However, if you're planning to condense things for a trip, and space is critical, you can leave the canvas stretcher unassembled until you are ready to make your stretch. See Figure 5.

Plywood Board. Another way to stretch paper is to fasten the soaked paper to a sheet of plywood (preferably waterproof or "exterior" plywood) with ordinary 2″ kraft or "butcher" tape — the kind you have to moisten. Don't use masking or Scotch tapes because they really won't adhere to a damp or wet surface. It's best to blot up most of the water from the paper with a clean towel, so the tape won't be flooded and its glue so diluted that it comes loose. The board in this case should be big enough to extend beyond your paper's edges by at least an inch, and should be heavy enough to remain flat as the drying paper shrinks. Try a piece of ½″ × ¾″ plywood. Make sure the whole thing dries in a horizontal position and that you've really rubbed the tape down well so it won't let go as the drying proceeds. See Figure 6.

Instead of using tape, you could use staples: they are easier to handle, I think, and less messy. As before, staple the paper at two-and-a-half-inch to three-inch intervals and let the whole thing dry flat. This is my favorite method of stretching paper, especially when working in my studio. See Figure 7.

Paper Sizes

There are a number of sizes that watercolor paper is made in, though you'll find that many of them are not available in the usual art-supply store in the States. They range all the way from a sheet called Royal, 19″ × 24″ (48.2 cm × 60.9 cm), through Double Elephant, about 27″ × 40″, (68.5 cm × 101.6 cm), up to a sheet called Antiquarian at 31″ × 53″ (78.7 cm × 134.6 cm)! The size that is most likely to be found is a sheet called Imperial, which is 22″ × 30″ (55.8 cm × 76.2 cm), give or take a fraction, and is referred to as a "full sheet."

It is a good all-around sheet, because it has pleasant proportions that divide well into a "half sheet" at 15″ × 22″ (38.1 cm × 55.8 cm), and a "quarter sheet" at 11″ × 15″ (27.9 cm × 38.1 cm). These divisions work well for

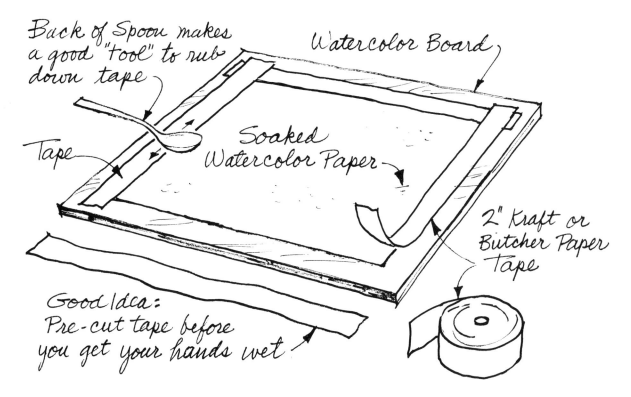

Back of Spoon makes a good "tool" to rub down tape

Watercolor Board

Tape

Soaked Watercolor Paper

2" Kraft or Butcher Paper Tape

Good Idea: Pre-cut tape before you get your hands wet

Figure 6. *A second method for stretching watercolor paper consists of fastening soaked paper to a sheet of plywood with ordinary kraft paper tape.*

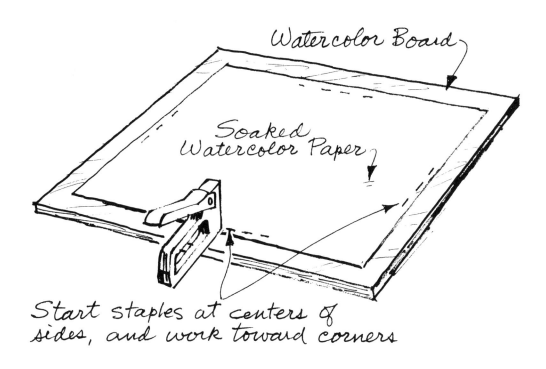

Watercolor Board

Soaked Watercolor Paper

Start staples at centers of sides, and work toward corners

Figure 7. *A variation of the method seen in Figure 6 is to fasten the paper to the plywood with staples rather than with tape.*

either horizontal or vertical compositions.

Also on the market are watercolor-paper blocks and spiral-bound pads. I don't use these too much, for the reason I've mentioned before —I just don't need the extra battle with buckling and wrinkling paper while I'm painting. I do sometimes use the pads for little color studies, but usually these are so small that the paper doesn't get wet enough to buckle.

Paint

Let's review the types of paint available in watercolor. I mentioned earlier the watercolor sets for children, which come with the paint in little pans. Well, professional-quality watercolor paint has always been available that way, too. However, its formulation is somewhat dryer than that of tube colors. Consequently, you'll find yourself slowed down, rubbing and scrubbing with your brush to get enough pigment into the wash you're preparing and need *right now!* The resistance of the pan-paint to softening up in sufficient quantities in a hurry can be very frustrating. Another consideration is the wear and tear on your brushes. Remember how much trouble it was, and how much it cost to get those brushes? Why wear them out using them as little mops and scrubbers to lift that pigment out? Instead, I recommend that you use tube colors — especially for anything larger than a quarter sheet. Tube colors are moister than pan colors, and their consistency is easier to work with. The little pans are okay when you're making very small color sketches and notes and

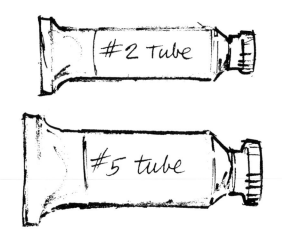

Figure 8. *Buying the larger-size tubes of paint can save you money.*

don't want to carry much painting gear with you.

There are three things to keep in mind when you're shopping for tube colors: *quality, size of tube,* and *color selection.* Most manufacturers make several lines, or grades, of watercolor — and the second or "student" grade can be tempting, with its lower prices for what appears to be about the same thing. Here, as in the case of brushes and paper, you're going to get what you pay for, even in these days of higher and higher prices. The amount of pigment in the cheaper colors is simply less than in the higher grade and — it stands to reason — the amount of filler is more. You just won't get the same results using the student colors that you can expect from the first-quality line. I'll discuss color selection at greater length in Chapter 5, but, briefly — there are over 80 colors available and you're probably not going to need one-third that number.

The size of the tube can also make a difference in your selection; if you buy the No. 5 size tube instead of the No. 2 (Figure 8), you'll wind up with nearly three times the amount of paint for about twice the money. Buying the larger-size tube is very sensible, especially if you plan to paint enough in the next year or so to use it up. Good paint, kept with the tops tightly screwed on the tubes, will last at least that long!

Palettes

Everyone agrees you need a palette when you paint, but they disagree on what *sort* of palette is best. The simplest palette possible is one you *could* make yourself from a piece of glass, with the underside painted white. I've seen some artists do this. The trouble is that it's difficult to keep any big, wet wash from running off the sides, as well as into the gobs of pigment you've squeezed around the edge! For several years I used a white porcelain-enameled 12″ × 16″ "butcher's tray." Although the washes couldn't run off the edges because it had a low lip all around, the wet, large washes *did* tend to run back into the pigments, and at times it was a mess!

I've seen watercolorists use a simple, white, china dinner plate as a palette, and this works pretty well; you can lay out your colors like a color wheel around the rim, and do your mix-

white China Plate

"Eldajon" Palette

"Allman" Palette

"Broadway"
Palette

White Porcelain-Enameled
"Butcher" Tray

John Pike Palette

Figure 9. *There are all types of palettes available for use with watercolors. However, I prefer the rectangular ones pictured in the second column because of their larger, central mixing surfaces.*

ing in the center, which is lower. The mixing area isn't quite big enough for *me*, especially when I'm mixing up a big batch of color.

This same round idea is incorporated in a plastic palette called the Allman palette, which has little ridges, or "dikes," between each color compartment and between the rim and center, so the colors don't run together. Again, for me, the mixing area in the center is a little too small.

There are other palettes of rectangular shape, with "wells" for your paint, and nice, large mixing areas, and I think one of these will do the job better. Look them over (Figure 9) and see which one will be best for you.

Keeping your colors moist is important, not only from the standpoint of economy (too much drying wastes paint), but also you can come back to your painting after a brief absence and pick up where you left off without having to scrape out dried color or moisten it again. One easy way to keep colors moist is to cover the wells with a piece of plastic wrap when you're through painting, making sure that the plastic seals out the air but doesn't sag down into the paint. Then, when you come back to paint, assuming it's the next day or so, you can just peel off the plastic, and there's your paint — soft and moist, ready for you to dip in your brush and have at it!

The ideal palette for me would have easy-to-get-at paint wells that aren't too small, with dividers that keep the colors from intermixing and with large, easy-to-clean mixing areas. It would also have to be easily carried, so I could use it as a "field" palette, to be taken on location. The Pike palette comes close to this ideal. It has a snap-on plastic lid that keeps the colors from drying out — especially if you put a damp rag or cellulose sponge inside before you cover it up — and also serves as an extra-large mixing area. In any case, don't buy one of those little cramped palettes with tiny wells and small areas for mixing. They're inhibiting, and in watercolor that's bad!

Painting Location

Although the basics for watercolor painting are the same whether you're painting indoors or out on location, other factors can make for considerable differences.

When painting in your indoor studio, you can afford the luxuries of controlled lighting, heating, and cooling, with no bugs, glare, wind, or spectators to bother you. Food supplies, water, and the bathroom are close at hand. Out-of-doors your "studio" must of necessity be quite different — usually simpler, lighter-weight, and compact. You're more likely to have the problems of wind and sun, bugs and "bugging" onlookers, but you do have the marvelous advantage of being face-to-face with your "inspiration," rather than trying to work from memories or second-hand reference. Of course, there's the *equally* valid case that can be made for painting back in the studio, where you're better able to organize your masterpiece, free from the confusion and chaos that often overwhelm you on location.

Both ways — indoors and out — have their good and bad points:

Indoors. Your indoor studio can be anything from a little corner in the kitchen or family room, to a "dream" studio, built expressly for you and your particular painting mode, with ample space, storage, a north-light skylight, a large, expensive easel, and so on. Basically, you need a place to put your watercolor paper, stretch-board, palette, brushes, paint, and water, with good lighting — and something to sit on, in case you don't want to stand all the time.

Let's agree right now that aside from being used to support small sketches and little studies, human laps make lousy easels! Okay? The watercolor stretch-board must be *independently* supported, so that you're free to move about, sit or stand, get close to your work or quickly back off for an overall look. Holding paintings in your lap while you're trying to do all this just won't do the job!

If you want to start your studio, and want to stay simple, not taking up much room or spending much money, you could simply use a table that has sufficient room for your watercolor board. Put a block of wood, a 2 × 4 is fine, underneath the top end of your watercolor board to give it a little tilt or slant. Get a stool or simple chair, if you want to sit. For your taboret, a side table which holds your palette, brushes, paints, water, etc., you could even use an old T.V. tray table. With adequate light and maybe an inexpensive plastic drop-cloth to protect the floor, you're ready to go! (Of course,

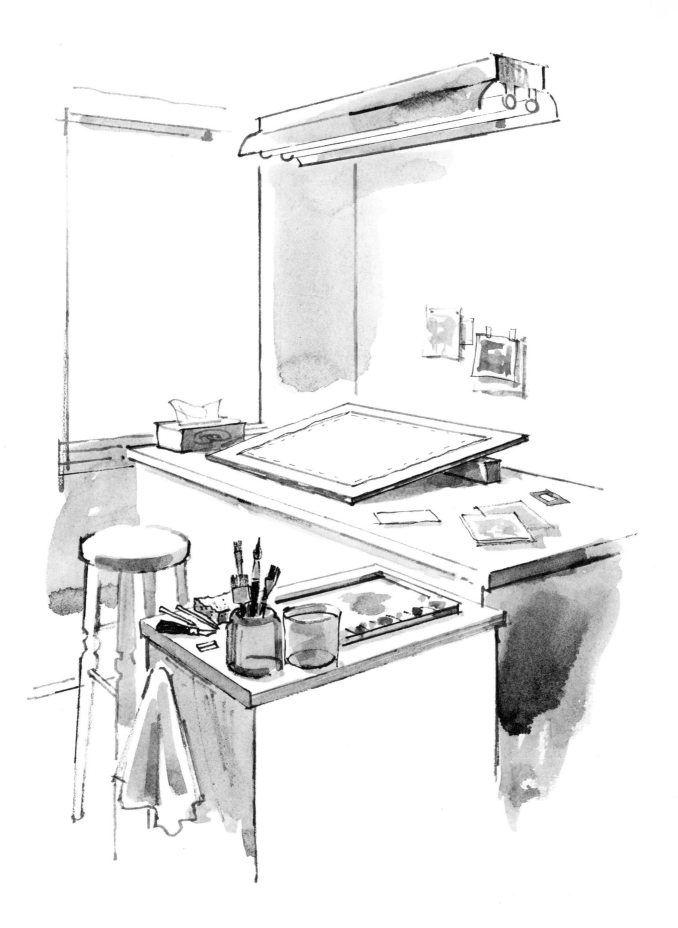

Figure 10. *Here's a simple setup for a studio, yet it contains all the materials and tools you'll need to produce lovely watercolors.*

Table-Top Easel

Tilt-Top Drawing Board

Folding Drawing Board

Figure 11. *Pictured are three different types of indoor easels, or drawing tables, that can provide a nice addition to your studio.*

the love of watercolor painting and a strong desire to master its intricacies, will be a big help!)

Your light source, in any case, is most important, and should be as close to "color correct" as you can make it. A large window facing north, or with no direct sunlight, is ideal. If you need to supplement this with artificial light, *don't* use ordinary incandescent light bulbs; they give off way too much yellow. An inexpensive 2-tube or 4-tube 40-watt 4-foot-long fluorescent light is a good way to solve your artificial-light problem. Be sure, though, that you "balance" the color by having half the tubes in warm white and the other half in cool white. You can also buy a tube made by GE that's supposed to be close to north light, called "deluxe cool white," as opposed to the common "cool white."

Figure 10 shows a sketch of the simple setup I've just described. If you should decide to make your kitchen into an "off-hours" studio, keep in mind that although many kitchens are equipped with fluorescent lighting fixtures, usually the tubes in them are simply "cool white," and you should balance the color as I've described. Also, be sure that the grease particles that unavoidably get into the air in any kitchen have settled — and *not* on your watercolor paper!

If you want to make your studio more elaborate, you could do such things as get a table-top easel (Figure 11). This little gadget will enable you to make more adjustments to your board's slant or pitch than are possible with only the block of wood under one end. Or, you could buy a commercial artist's tilt-top drawing board; they come in a variety of sizes and price ranges. You could put the T.V. tray table back into the closet, and get a really ample taboret, and even put casters on it so it could be moved easily. Same thing goes for the old stool or simple chair; they could be replaced with a swivel chair on casters, so you can easily roll toward or away from your work, or swing sideways to give attention to your palette, etc. In other words, you can start out simply and inexpensively and produce watercolors, or you can go on and on, adding this or that feature for your convenience and comfort and produce watercolors. Either way, the quality of the watercolors will still be up to you!

In my studio (Figure 12) I use a large,

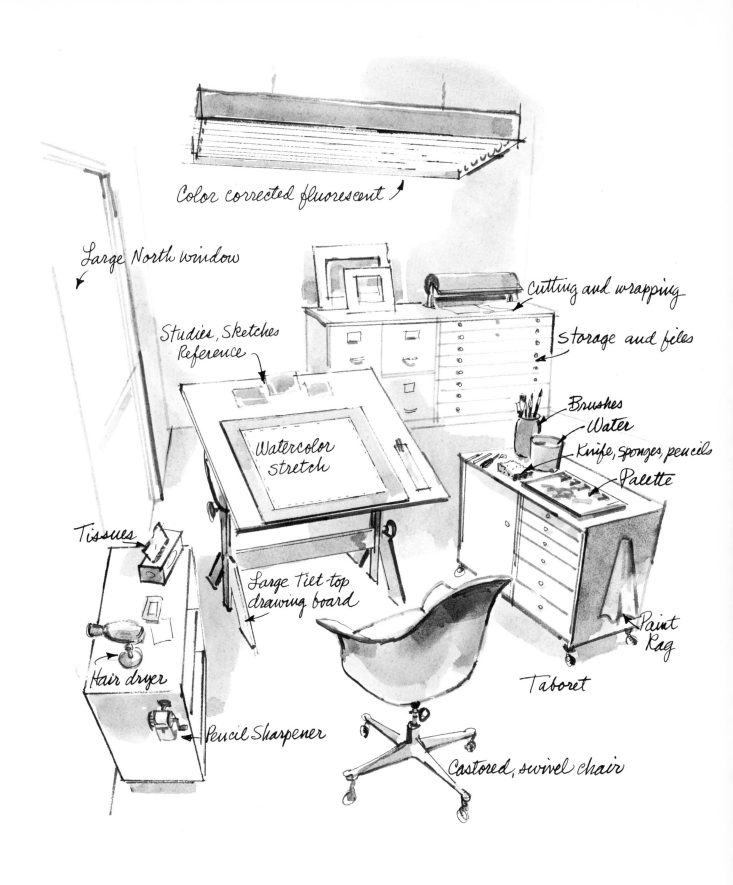

Color corrected fluorescent

Large North window

Studies, Sketches Reference

Cutting and wrapping

storage and files

Brushes
Water
Knife, sponges, pencils
Palette

Watercolor stretch

Tissues

Large Tilt-top drawing board

Hair dryer

Pencil Sharpener

Paint Rag

Taboret

Castored, swivel chair

Figure 12. I've done this tone drawing to give you an idea of how my own studio looks.

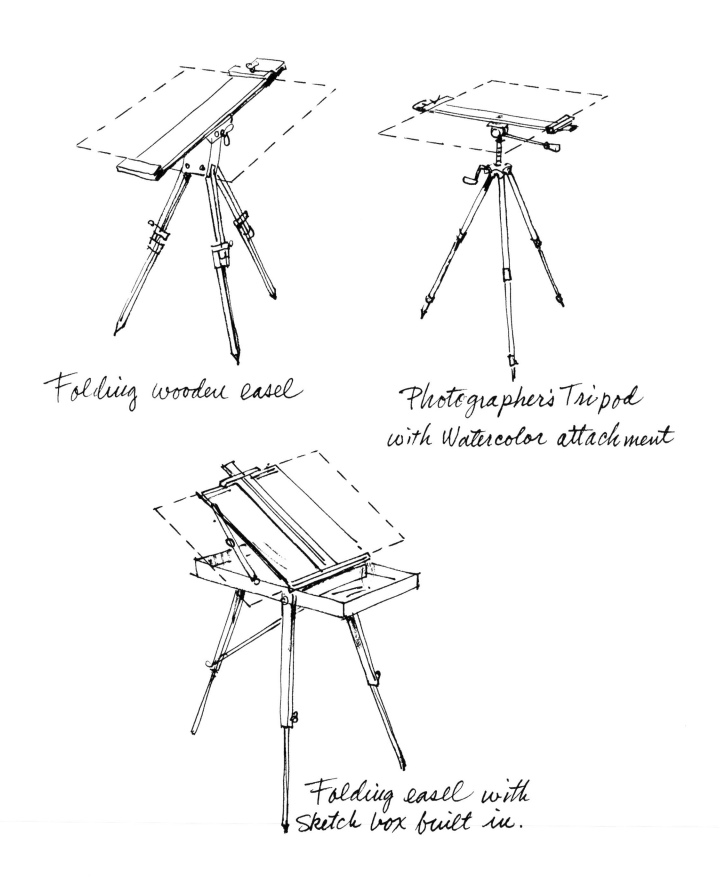

Folding wooden easel

Photographer's Tripod with Watercolor attachment

Folding easel with Sketch box built in.

Figure 13. The easels shown here are particularly useful for work outdoors because they're easy to fold up and carry off to the next landscape.

wooden, tilt-top drawing board which can adjust from horizontal to nearly vertical. It's about 3 feet × 4 feet and is very stable. I have a large, swivel, castered "executive" chair. I designed and built my taboret so I could have enough drawers of the right sizes for my art material needs. Several of the drawers are very shallow, so brushes, pencils, pastels, and tubes of paint, can't pile up and get hidden from view. There's a storage compartment with a door, where larger items can be stored. The whole thing has an opaque white glass top, and is on large, easy-to-roll rubber casters.

My light is from a large window that faces north, so I get a soft-shadowed light all day. I supplement this light with three 4-tube 4-foot-long fluorescent lights which I hang from the ceiling. These are equipped with the GE deluxe cool-white tubes I mentioned and I can leave this light on all day; as daylight fades into twilight I can continue to work with no appreciable difference in light. My taboret and palette are as well-lit as my watercolor paper, although of course no artificial light is as bright as direct outdoors sunlight.

Across the room I have a set of "architect's file drawers," which are shallow and about 28″ × 40″, allowing me to store watercolor paper and other large sheets flat and clean and dry. (If you haven't room for all this in your home, don't forget: watercolor paper, wrapped flat, can be kept under your bed!)

Outdoors. What equipment you use when painting outdoors simply depends on how far you want to carry it. If the scene or subject you're after is right outside your house or you can see what you want from or near your vehicle — then you can of course use more and heavier gear. But even if you never wander far from your house or car, you'll still find that the equipment must be quite different from your indoors setup.

First of all, consider weight. All that carrying can become a problem or a nuisance, even though you're the local weightlifting champ! Second, consider the terrain — the area where you might be painting. It may be rocky or uneven, wet or dusty, and you might have to go quite a way, crossing fences, streams, and goodness knows what else, before you arrive at the spot. So, lightweight, easily adjustable gear

is the answer, and then it's largely a matter of how *you* work, and what *your* preferences are, that will determine what you want to carry. Even then, some experimenting is in order; after some twenty years of this activity, I'm still experimenting, changing, trying new things.

The very *least* that you must have on location is (of course) brushes, paint, and paper, supplemented by a board for your paper, a palette for your paint, a container of water, and something to carry your paint, brushes, and other assorted gear in. Then, in simplest terms, you *could* just sit on the ground, prop your board and paper on a rock or tree trunk, and spread your palette and other gear on the ground beside you. This way, you'd have the very *least* to carry.

Most artists are going to want a little more gear and maybe a bit more comfort, so still keeping in mind the weight and bulk problems, you could add a stool to sit on and something to hold your board while you paint. Some artists use another stool, but I never thought this worked out too well. It places you on the same level as your work and there's no practical way to slant the board and not be in danger of the whole darn business toppling over, ruining your work in the process! So, try a lightweight painting easel. There are many to choose from, from a very simple easel that only holds your board, to complex, expensive ones that hold everything. Be sure that the easel you pick is light, simple to set up, and that it adjusts horizontally as well as to various angles. Figure 13 shows several styles of portable watercolor easels.

I have an old wooden easel that I've used outdoors for years, but lately I have been using a photographer's telescoping tripod with my watercolor board attached to the tripod head. You can buy a watercolor board attachment device that is made for this, or you can bolt the board directly to the tripod head. The nice thing about this solution is that it's easy to adjust the legs to uneven terrain, and I can raise or lower the height of the board in a jiffy simply by cranking it up or down!

I also carry a lightweight folding stool to sit on, and depending on the situation, sometimes take along a second stool to put my palette on.

Different artists have different preferences for the way they carry their gear. Some use a fisherman's tackle box. These boxes are great;

they have trays that are divided and fold back when you lift the lid, making it easy to keep your "junk" in order. Another method is to use a wooden or metal oil painting box. Just put your brushes and paint tubes in the same spaces as the oil painter does, but substitute your watercolor palette for the oil palette.

Water is one of the necessities in watercolor painting, but sometimes it's hard to find it when you need it. I carry a 5-gallon plastic jug of water in my truck, and so have plenty as long as I'm near the truck. If I have to carry the water any distance, that's a different matter, and I become much more careful; water is *heavy!* I've seen a lot of painters use surplus Army canteens to carry their water—these can be carried on your belt, and the cup can serve as the water jar. I think the amount of water that can be carried in this way is minimal, though — just barely enough! Another way, which is a little heavier, but provides more water, is to use one of those gallon plastic jugs, the kind laundry bleach or starch come in, after rinsing it well. Then get a second plastic jug and cut it off about three to four inches from the bottom. This can be carried by jamming the water jug down into the cut-off bottom of the second jug, and presto! There's your water jar riding along with your water jug! In fact, it's good to have *two* of these cut-off jug bottoms, one for clean water and the other for dirty. That way you can really go a long way toward keeping everything clean and your colors clear and bright. Figure 14 shows my outdoors painting setup.

If you possibly can, avoid painting in direct sunlight, because the glare on the white paper and palette makes it almost impossible to judge colors and values. If there simply isn't any shade you can use, and you don't want to create your own with an awning or umbrella (which can really be a hassle, both to put up and take down, especially if a wind comes up!), and you *must* paint in direct sunlight, then you might find that colored glasses will help. Several manufacturers of optical glass make what they call a "neutral gray" that isn't supposed to change colors, only remove the glare. Your optician can give you the details.

Other Painting Supplies

Although brushes are the principal tool used for painting in watercolor, there are a lot of other things that can be employed to get paint on paper, and to modify it once it's there. Here's a list of supplementary items for you to consider, along with my suggestions about what you can do with them. You'll probably discover some things of your own to add to this list!

Sponges. Get a little silk or cosmetic sponge at the drug store or notions counter. These are natural sponges and usually come in little plastic bags for cosmetic use. They're great for wetting an area, whether it's fairly large or very small, and for lightening or wiping out an area that you've made too dark or the wrong color. The synthetic (cellulose) sponge that is so common in the kitchen and bath also makes a very useful tool for us watercolorists. It's perfect for wiping off the sizing from a new sheet of paper, or for wetting down the paper when you're going to stretch it. (Always make sure it's clean before you use it!) I also keep one of these sponges next to my palette and use it to wipe my brush on, especially if I want to take out just a bit of moisture. You can use a paint rag for this, too, but it's a little cruder and usually requires the use of both hands.

Paint Rag. An old standby of most watercolorists, the paint rag is just what it says: a rag (absorbent) for paint (surplus). Old towels and worn-out bed sheets make great watercolor paint rags. You should always have one ready— both for wiping out your brush and for wiping *up* an occasional spill.

Knives. There are many knives to choose from and you may just prefer that pocketknife you've had all along. I use a matknife, which is also referred to as an adjustable stencil knife. The blade can be lengthened or shortened, as you wish, and easily sharpened. A knife is useful for sharpening your pencils, of course, but is also good for scraping or shoving areas out of a wash while it's still wet. When the wash is *very* wet, the pigment will run back in, making a *darker* area. If you wait until the wash is still wet but not runny, then scrape the area with your knife, it will be lighter! After the paint is dry, you can discreetly scratch out a highlight or sparkle here and there with the sharp tip of the knife. Discretion is the key here—a little of this trick goes a long way!

Razor Blades. Naturally, we're talking about the

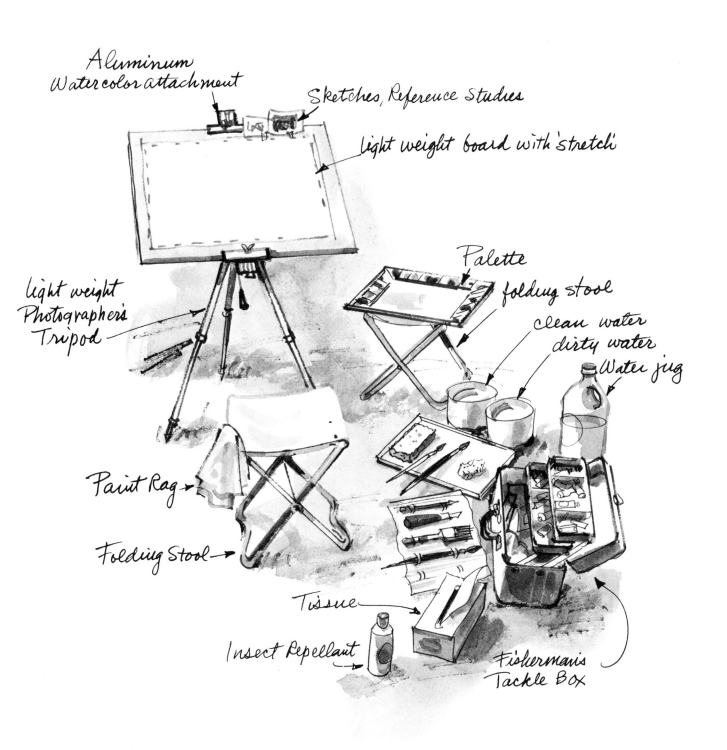

Aluminum
Watercolor attachment

Sketches, Reference Studies

Light weight board with "stretch"

Light weight
Photographer's
Tripod

Palette

folding stool

clean water
dirty water
Water jug

Paint Rag →

Folding Stool →

Tissue

Insect Repellant

Fisherman's
Tackle Box

Figure 14. *Here's all the equipment I'm likely to take with me when I paint outdoors.*

single-edged variety, and it's a good idea to have a few of these in your studio or paint kit. Like knives, they are useful for scraping away a wash, and can also help you in scratching precise, small details or in cutting. There are several holders made just for single-edged blades. You can buy these blades in packages of 100; they're called industrial blades and are made for everything *but* shaving. Your art-supply dealer will often have them in these large packages, and a housepainter's supply store will almost always have them.

Kleenex Tissues. Everyone in the U.S.A. is familiar with these — and their use in watercolor painting is the same as in the kitchen: blotting! Terrific for quickly picking up a spilled "splat" of watercolor or lightening a too-dark wash while it's still wet.

Blotters. These are useful in the same way as tissues, and in other ways as well. For example, you might use a blotter to quickly lighten an area in a wet wash where you want a clean, straight edge, as in next to a wall or line. Or you might use a blotter to produce interesting mottled effects over washes. The longer you wait, the less the blotter will absorb. You can buy blotters in large white sheets from your stationery store, and cut them with scissors to suit your own needs.

Crayons. A white wax crayon, such as kids use in school, will make a "resist" when rubbed on watercolor paper. A white household candle will do the same. When you paint over the rubbed area, the paint is not absorbed, leaving white paper. If you don't want white paper there, be sure to paint it whatever color and value you *do* want, let it dry, apply the crayon, and wash over that. This is a useful "sometime" thing to employ, but don't let it become a crutch for you.

Masking Tape. This is the pressure-sensitive tape that you can stick down as it comes off the roll. (You *don't* wet it.) It is usually light tan in color, and can later be peeled off your painting surface. (Some brands are stickier than others and can remove a bit of the paper surface, if you aren't very careful.) It comes in rolls up to 2″ or 3″ wide, but the ¾″ width will probably be best for you.

You can use this type of tape to "mask out" a specific shape, then paint right up to or over it cleanly and in one big wash. You must apply the tape when your paper is totally dry, and you can carefully cut out shapes from it while it's stuck down on the watercolor paper, using a very sharp razor blade. Work *very* carefully, so as to cut only through the tape and not into the watercolor paper below! Again, this is fine for occasional use, but the hard edges make the results rather mechanical looking. A really skillful watercolorist can paint those shapes with a brush, and get a more casual effect, which I generally like much better.

Masking Fluid. Actually a form of rubber cement that is water-soluble until dry, masking fluid (also known as liquid frisket) can be painted right onto your watercolor paper in fine lines or intricate shapes. Use an old brush and keep washing it out as you use it. If applied properly, masking fluid will resist when you later brush watercolor right across the top of it.

Although when your painting is dry and you peel this liquid-turned-rubber business off, the results won't be quite as mechanical looking as the ones obtained with masking tape, they're still going to have a hard edge. This is something you want to keep in mind. Also, I've come across things I did 10 or 12 years ago using a liquid mask, and I'm sorry to report that there is slight yellowing of the white paper in the areas where it was used. One last point — always test your masking fluid on a scrap of the paper that you plan to use. Some papers are so soft that there's a tendency for the dried film to pull up some of the paper surface with it when removed. This is especially true if there's still a little dampness under the film! Use a rubber cement pick-up to remove the dried film after all the area is really dry; pick-ups are available at any art supply store.

Erasers. My current favorite for cleaning up the smudges and pencil lines from a watercolor after it's done and dry is a Pink Pearl eraser. Of course, there are lots of equally good erasers. Art Gum brand is an old standby that doesn't hurt your paint or paper surface, but be sure to remove the little crumbs it leaves before you apply more paint to the erased areas. Kneaded rubber erasers are also very handy for gently taking out smudges and pencil lines, and they don't leave any crumbs.

Typewriter and ink erasers can be used on a dry passage to lighten or even remove it. They *do* modify the paper surface somewhat, and you'll notice a difference when you repaint an area that has been erased with an abrasive eraser such as this. As with everything else in watercolor: experiment and test it out — then you'll know first-hand from your own experience!

Toothbrush. The toothbrush that you're about to throw away will make a good "sometime" tool that you can use to produce a "spatter" effect. After you've dipped the toothbrush into the color desired, hold it horizontally, pointing away from you toward the area you want to spatter, with the bristles up, and pull a kitchen match (or something similar) toward you over the paint-charged bristles. Another method is to rub the toothbrush bristles across a little piece of window screen held over your painting. Spattering paint onto a dry area produces one effect, while the same paint spattered over a damp area and over a slightly wet area will produce other effects.

Stampings. You can use quite a variety of things to produce "stampings." For example, the cellulose kitchen sponge I mentioned earlier can be painted and used as a "stamp" to produce some very nice textures. The little cosmetic (natural) sponge will do a good job at this, too. Pieces of rough paper can be painted and applied to the painting. Edges of cardboard coated with color can rapidly produce a series of lines, crosshatching, etc. Same old advice as with all these tools — use sparingly, and only *if* these effects are going to help your painting.

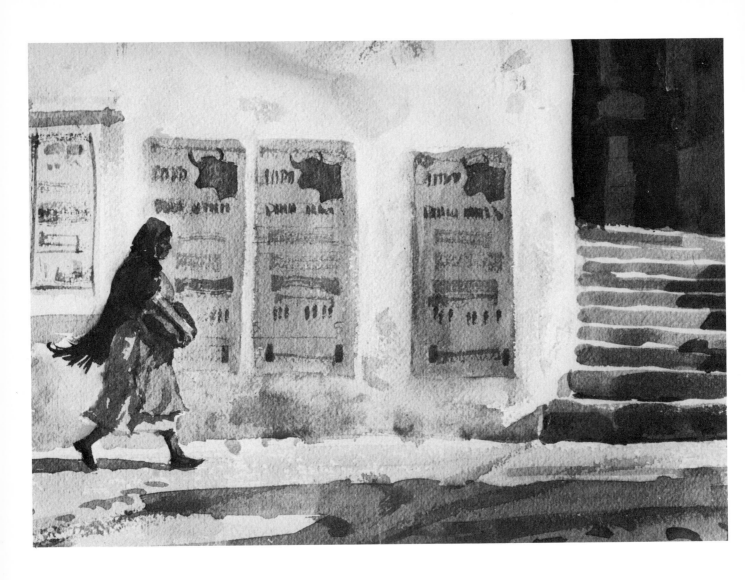

The Steps to Las Monjas (10" × 14"). *Private collection. Mexico is famous for her churches; even the smallest town boasts at least one. San Miguel de Allende has many churches, some of which are very large and impressive. Here the steps lead up into the dark and almost unknown interior — all massive masonry surrounded by a high, white, stuccoed wall. My goal in this painting was to catch the sunny, business-as-usual feeling on the street, as contrasted with the dark, mysterious church at the top of the stairs. I ran the wall up and out of the picture and showed only part of the steps and a glimpse of the dark and somber church interior. This lets the viewer get a feeling of the massiveness of the whole structure and guess at what's inside. Handled largely as flat washes, shape against shape, the feeling of depth in this painting is partly achieved by the cast shadow on the street and on the stairs. These indicate to the viewer that there's lots more structure around that can't be seen in this picture — but which he "feels" is there. The ever-present bullfight posters add color and design to the plain white wall, and with the woman's costume, help say "Mexico."*

2 PUTTING PAINT ON PAPER

If you're going to paint in watercolor — really paint just the way you want and say in that painting the things you feel — then you've got to be in control of the medium. (Of course, watercolor is so elusive that there's always *some* "happening.") Control means that you have a good understanding of transparent watercolor's physical nature and at least a fair mastery of the techniques necessary to make the darn stuff behave! If you feel you're not quite skilled enough in the techniques covered in this chapter, practice until you are. The exercises suggested in each of the wash techniques below should help.

Wash Techniques

Somehow, between your idea for a painting and the finished painting, watercolor *paint* must meet watercolor *paper* and the two combine successfully. *How* to get that paint on the paper has frustrated many an artist and would-be watercolorist! There are lots of ways, of course that paint can be put on paper. The most common one is to apply paint with a brush. Other ways, such as sponges, stampings, spatter, etc., were mentioned and partly discussed in Chapter 1, and we'll talk more about them.

Paint can be stroked onto paper with brushes (as in oil painting) or, in a way almost exclusive to watercolor, applied as a flowing, liquid-color passage, aptly called a *wash*. There are several variations of washes. You should be able to do all of them easily and well.

Flat Wash. The application of liquid color to dry paper in such a way that the result is of the same value overall, and the wash covers a given area evenly and with definite edges, is called a *flat wash*.

☐ To practice this wash, tilt the top of the board up 10 or 15 degrees. Determine the area you want to cover with the flat wash, say 5″ × 8″ or 6″ × 9″. Start at the top of this area with your brush "loaded," that is, full of a well-mixed paint solution, but not so full it will drip. Remember, a 1″ flat brush will probably do this better and more rapidly than a smaller brush. Also, be sure to mix a sufficient batch of paint on your palette so you won't run out of it midway through the exercise.

With your loaded brush, make a horizontal stroke across the top of the area, coming quickly back with a second brushload, making a second pass below the first and slightly overlapping it. You will notice a little puddle or bead of paint-water forming along the bottom of each stroke, and then running down and re-forming at the bottom of the next stroke. The whole trick is to keep the amount of paint about the same but not let that bead of extra paint get out of control and run down the sheet. When you've reached the bottom of the planned area, wipe out your brush on your paint rag or damp cellulose sponge, and quickly take up the bead with it. You see, the brush can take *up* as well as put *down* paint! (Figure 15.)

Of course, not all flat washes are going to be

neat, simple squares or rectangles; indeed, most will be more complicated in shape and have to fit around some intricate patterns. But we'll start with the simple and work up to the complicated!

Graded Wash. Usually applied to dry paper — though there may be occasions where you might use damp paper — a graded wash is one that proceeds from light-to-dark or dark-to-light. You simply use proportionally more and more, or less and less pigment-to-water with each successive stroke to create the desired gradation.

☐ Let's practice a graded wash (Figure 16) that goes from the darkest value at the top to lightest value at the bottom, using, again, an area 6″ × 8″. You can use any color pigment in a graded wash, but for this exercise, let's use one that will produce dark values, say French ultramarine blue or burnt sienna. After you've

mixed the darkest value you can, load your brush and make a pass across the top of your painting area, exactly as you did when you started the flat wash. However, on your second stroke, add a little water to the paintload in the brush, thereby lightening the value. On the third stroke, add still more water to the pigment-to-water ratio, the amount depending on how rapidly you want the gradation in value to occur. And so it goes, until you reach the bottom, where you should end up with clean water and no pigment, and a perfect gradation of value from top to bottom! Don't forget to pick up that bead or puddle right away, even though it's only clean water.

Try reversing the graded wash by starting your first pass across the top with clean water, and then gradually adding more and more pigment with each successive pass until at the bottom you've achieved maximum dark value. Side-to-side gradations are a little different be-

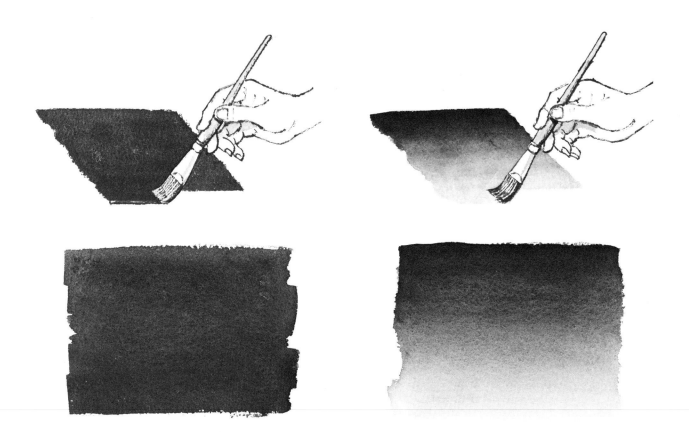

Figure 15. *Here's a flat wash — it can be any color or value, but should be about the same all over. The brush keeps the color moving downward on the page, overlapping each successive stroke and mopping up the puddle or bead of paint-water that forms at the bottom when the wash is complete.*

Figure 16. *The graded wash, sometimes called graduated, changes value from one end to the other. In this case, the brush carried less paint and more water with each successive stroke.*

cause of the slant of your board, but the movement of pigment can be guided by your brush; eventually, with practice, you should be able to make gradations in any direction with ease! Sometimes, with an especially complicated pattern to paint around, it helps to turn the board a bit, even upside down, to facilitate the application of paint.

Wet-in-Wet Wash. As its name implies, this wash is the application of the liquid color to an already wet surface. There are many variables. The paper surface can be wet with clean water or wet from a previous wash. The amount of moisture on the paper and the proportion of water-to-pigment in your brush, as well as how *loaded* the brush is, are all factors that can make a big difference in the results. The wash can be *very* wet into *very* wet, or *not*-so-wet into *not*-so-wet, or *not*-so-wet into *very* wet, and so forth. Timing, wetness, and brushload are criti-

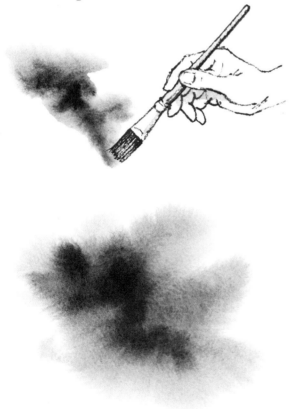

Figure 17. *This is a wet-in-wet wash — also called a floated wash. The paint is charged into an already wet or damp paper; the wetter the paper, the more the paint spreads, or runs.*

cal in this wash—as is the experience of having done lots of practice sheets, so you know what to expect!

Remember my discussion in Chapter 1 about paper surfaces and weights? Well, these two factors can make a difference in your wash, too. The heavy 300 lb. paper, well soaked, is certainly going to remain wet much longer than the lighter-weight papers — or even the same 300 lb. paper that has been only lightly moistened on the surface. The rougher papers are going to slow down the paint, and their little pits or depressions will tend to catch any sedimentary pigment, giving a different look than smooth paper.

☐ Try the following experiment in wet-in-wet: First, get your paint ready on your palette. Then, with your little cosmetic sponge or a clean brush, wet two areas (about the same size as before) side by side on your practice sheet. Make one area so wet it glistens, and the other just very damp. Working quickly, drop some color into your first area. Notice that the color runs almost like it had a mind of its own. If you tilt the board while the surface is this wet, the color will run across the area in streaks. If you tilt the board back, you can stop that streaking and even start it going in the other direction! (Feel a little like a juggler?)

Now, assuming that the second area is still damp (if it isn't, dampen it again), try putting some paint on it. Since the second patch isn't as wet as the first, the color shouldn't run nearly as much, but just form nice, soft-edged shapes that stay pretty much where you put them. Naturally, there are all degrees of this wet-in-wet business. The only way you're going to become master of them all (well, none of us is ever going to become a *complete* master of watercolor, but that's a good *goal!*) is to have done so many practice washes that you really have met and understood all possible conditions.

Right now, while we're talking about wet-in-wet, is a good time to mention the technique of wet blending or "charging" one wet color into another wet color. This could be just an accent or color note that you want to inject into another area and still have soft edges and blending. Or it could be a diffusion effect you need, like a warm reflected light into a cool

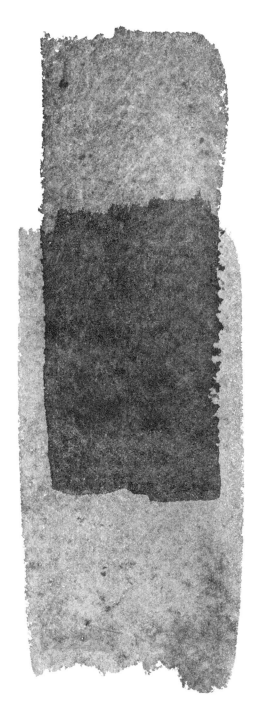

Figure 18. Wash-over-wash, or glazing, is actually two washes, one applied over the top of an already-dry one. The wash on the left is scarlet lake, a staining color, while the wash on the right is burnt umber, a pigmented wash.

shadow. Just keep in mind that charging a color is still wet-in-wet technique. Figure 17 shows a typical wet-in-wet effect.

Glazing. The object of "glazing" — or wash-over-wash — is to achieve dual color and textural effects that are impossible in a single-color wash. You can wash a warm color over a cool, a sedimentary color over a staining one, or apply a wash over several colors, pulling them all together. The method is to paint a first wash, and when it's dry, apply a second wash partially or wholly over the first. This produces a "see-through" effect that's altogether different from the fusion and direct blending of the wet-in-wet technique. Glazing is also sometimes referred to as the "indirect" method because you must wait for each wash to dry before you apply the next. If properly executed, the top wash won't soften or take up the bottom wash; rather, it will veil it and make possible a wide range of useful effects. One fact to keep in mind: this glazing business works best if you paint pigmented colors *over* staining colors. As an example — yellow ochre, a pigmented color, goes beautifully over a staining color like alizarin crimson, imparting a nice little optical "haze," which can be very atmospheric. If you reverse the sequence, though, and paint the staining color on top of the pigmented color, chances are the results will be much muddier, without the "see-through" quality you want in a glaze. Figure 18 shows (in black and white) a staining color glazed by a pigmented color. Later, in Chapter 5, we'll examine the characteristics of individual colors and try to determine which are the best for staining, wash-over-wash, and glazing. In the meantime, you might like to try the yellow ochre and alizarin crimson combination just mentioned; try it each way, letting the first wash dry thoroughly before you attempt to glaze over it.

Brush Techniques

I mentioned earlier that the brush can *stroke* on color as well as be the carrier of paint for the wash. The brush is a most versatile tool — and brushstrokes in watercolor seem endless in their variety. Indeed, brushwork can become a very individual thing and reveal the painter's personality and identify his or her work. To me, brushwork, with the washes just described, con-

stitutes the backbone of watercolor painting, with all the other techniques less important.

Our basic brushes are the round, pointed sable and the 1″ flat oxhair. With these two, we can do almost any brushstroke needed. Experimentation and practice will acquaint you with your brushes' potential.

Rather than waste expensive watercolor paper on these exercises, why don't you use some cheaper paper—even old newspapers will do, and you'll feel free to really let go and swing out. Now try the following brush techniques.

Round Brush. Your round brush is capable of many effects—as you'll see when you do these exercises—limited only by your imagination and practice time.

☐ Using your round red Sable—say a No. 8 or No. 10—try making the finest "hairline" you can, with just the tip hairs touching the surface. Next, press down just a little more and the hairline will be thicker. Apply still more pressure, and the line will widen further. Practice this until you have a feeling for just how much pressure will produce what width line, and also how much paint is necessary in the brush. See Figure 19. Now try making the lines turn, curve, double back. Apply different degrees of pressure to achieve different widths.

☐ Now put the loaded brush flat down on the paper, and then with a little sideways movement, pick the brush up. This should leave a tear-drop or leaf shape. The better the point on your brush, the better the result. Try making these shapes in all directions. Reverse the brush sequence, starting with the tip this time and then laying the brush down to produce the wider part of the stroke. Combinations of this and the previous exercise can produce a variety of brushmarks. See Figure 20.

☐ For this exercise, lay the loaded round brush almost on its side and swish it back and forth, in sweeping motion. The paint will hit the highs of your watercolor paper, but not the lows, and a sparkle or glitter effect can be produced this way (Figure 21).

Flat Brush. Now let's explore a few of the possibilities that go with the 1″ flat brush.

☐ Taking advantage of its nice broad coverage in one stroke, hold the brush, rather fully

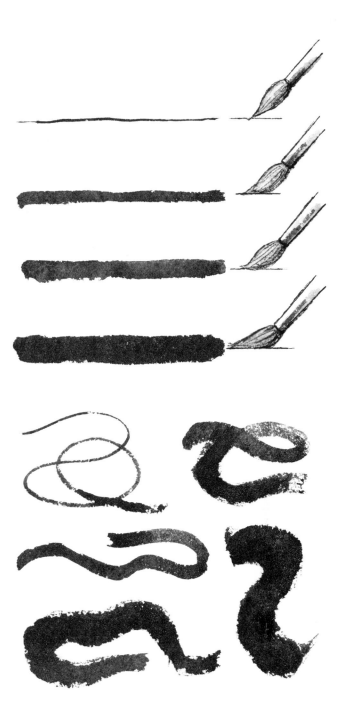

Figure 19. *The round sable brush can produce lines of varying width, straight or curved, depending on how hard you press down as you make the stroke.*

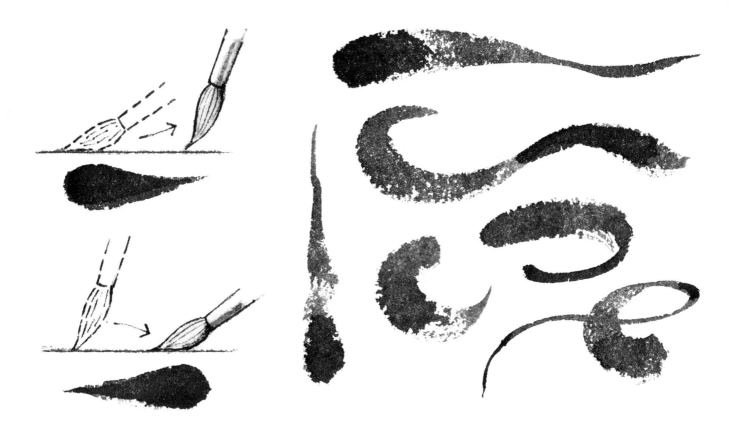

Figure 20. *This exercise shows some of the effects you can get by using the tip and then the heel of the round sable, and varying the pressure as you move the brush.*

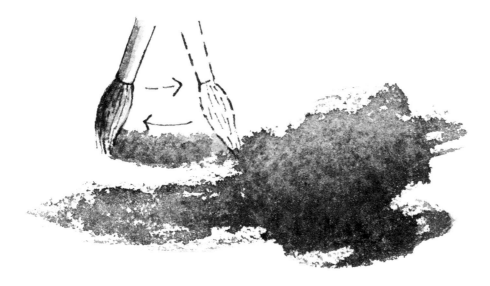

Figure 21. *Holding the round brush at an angle to the watercolor paper and manipulating it almost like a little broom, you can produce some nice sparkly or scraggly effects.*

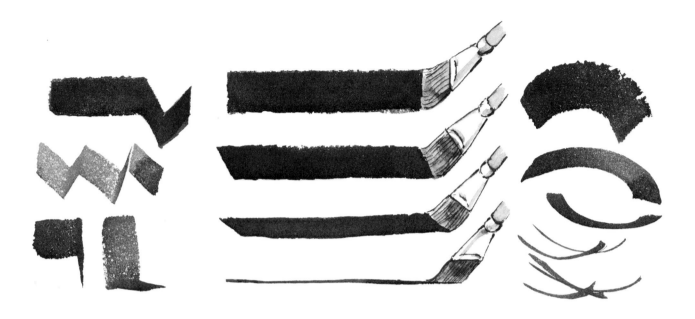

Figure 22. *The 1″ flat brush can easily produce angular effects, but it can also make thick-to-thin strokes, depending upon the angle at which it is held.*

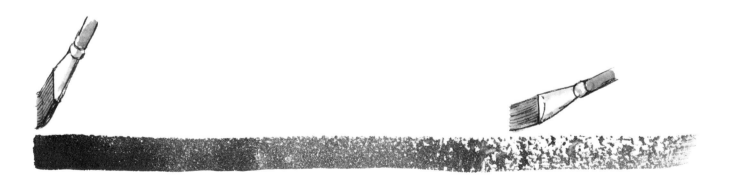

Figure 23. *Held vertically and moved somewhat slowly, the 1″ brush makes a solid stroke. Moved faster and held at an angle closer to the paper, a rough-dragged or "skipped" effect can be obtained.*

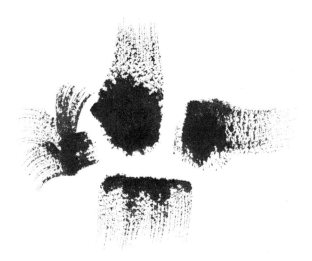

Figure 24. Here you can see the effect achieved by setting the brush down on the paper, then lifting it with a little sweep-and-up motion.

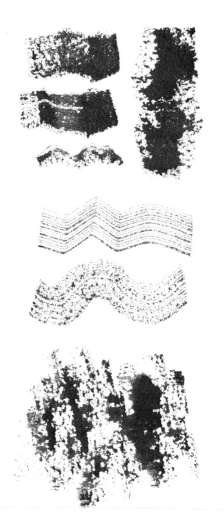

Figure 25. This illustration shows you drybrush effects done with paint that's not too wet: the swatch on the top was done rather forcefully, the next with the brush hairs barely touching the surface of the paper, and for the last, I held the 1″ brush nearly flat on its side, and literally patted the paper.

loaded, in a nearly vertical position and make a series of zigzags, left-to-right, right-to-left, etc. You can see that this brush is very useful for painting angular shapes. But don't stop there — try rotating the brush as you move across the paper to produce a thinner line. The more you turn the brush, the thinner the line will be, until you've turned the brush 90 degrees and are producing very thin lines instead of the 1″ stroke that you started with! By tipping the brush up on its corner, you can even produce hairlines. Figure 22 shows how all this looks. With practice, you can also do all the above lines as curves!

Next, hold the loaded 1″ brush in a nearly vertical position and move it somewhat slowly across the paper. In this position, and at this speed, the paint is going to run into and fill all the little depressions in your watercolor paper, making a solid stroke. However, if you tip the brush on its side a bit, and move it faster, the brush is going to hit only the high points on the paper, leaving the lows to remain as they were, sparkling and smiling at you! This is a most useful brushstroke to master. See Figure 23.

☐ Now charge your 1″ brush full of paint that's not too wet or runny, put the brush straight down on the paper, and then pick it up with a sort of side-sweep. If your paint is the right consistency and you "flirt" the brush up and away just so, you'll have an effect similar to the one in Figure 24. This stroke is most useful in depicting grass, rough-textured edges, and ragged silhouettes.

☐ Try using your brush in the "drybrush" manner; the brush isn't really *dry,* but the paint in it is a lot drier than you'd use in most other watercolor techniques. You can "tickle" the paper surface, drag the brush across it at various angles, etc. Figure 25 shows some drybrush work. Although drybrush is useful in adding textures and a feeling of depth, like everything else, it can be overdone, and you should avoid letting it become a crutch to help you try to save otherwise unsuccessful passages.

When practicing your brushstrokes, always keep in mind the following points:

1. Don't hold your brush down at the ferrule; instead, hold it halfway up the handle — or farther!

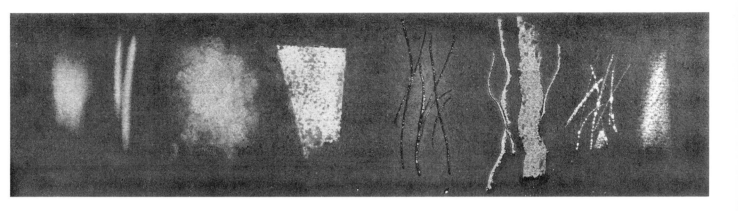

Figure 26. *The top of this illustration shows several methods of taking paint out of an area (from left to right): sponging out a dry wash; scrubbing out a wet wash with a bristle brush; lifting out a wet wash with a tissue; pressing a blotter into a wet wash; scraping a knife in very wet wash (color runs back into scrapes, making dark lines); knifescrapes in a not-so-wet wash (color isn't wet enough to run back very much); razor scratches in a dry wash; ink eraser in a dry wash.*

The middle row shows ways to avoid getting paint in an area (from left to right): paint with brush around shape; paint over masked (taped-out) shape; paint over liquid frisket; paint over white wax crayon.

The bottom row shows a few of the effects and textures possible using tools other than your brush (from left to right): kitchen sponge stamping; cosmetic sponge stamping; painted cardboard edges used as stamp for linear effect; rough paper, painted and laid flat as stamp; toothbrush loaded with paint and spattered into a damp area, then into a dry area; salt sprinkled into a wet wash, then brushed off after dry.

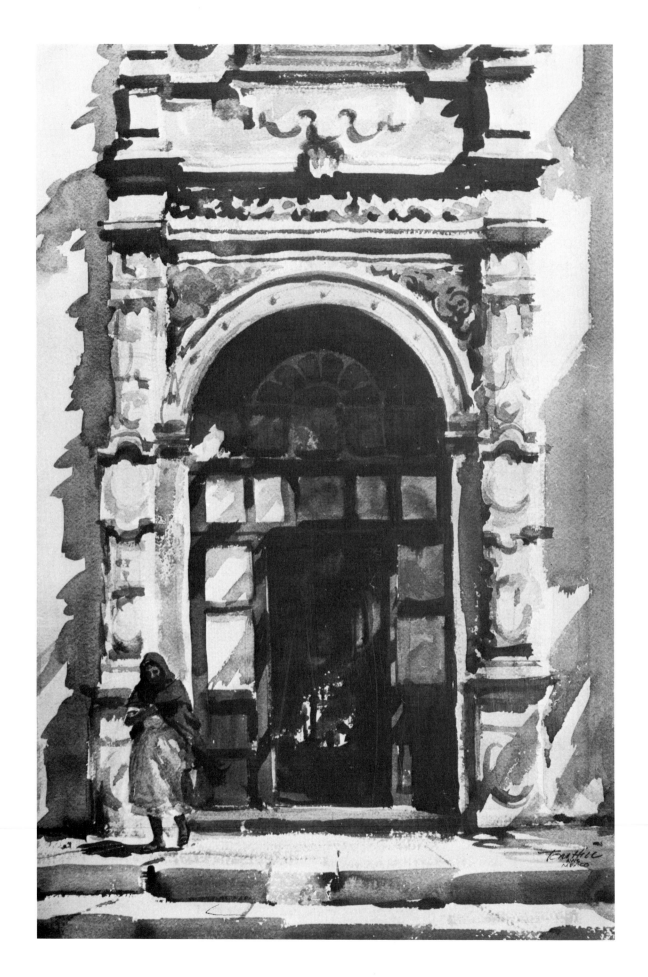

2. In nearly every case, avoid resting your hand on the paper when making brushstrokes. Better to have a little less security and a lot more freedom!

3. Whether you're standing or sitting to paint, try to keep a feeling of freedom in your whole body — so you can easily swing the largest stroke, or delicately apply the littlest dab, and never feel cramped!

Other Ways to Put Paint on Paper

. . . or to take it off! In Chapter 1, I talked about a variety of painting tools other than brushes and suggested some uses for them. Figure 27 illustrates some of these uses.

You can transfer paint from your palette to the paper by stamping with sponges, by applying the painted edge or the flat side of a piece of paper, or by spattering with a loaded toothbrush. Be careful when using a sponge; if you fuss or stamp too much, you could deaden the color or soften the pigment in the wash below and wind up with a muddy, overworked mess.

Blotting areas of a wet wash with tissue or blotter paper is a good way to take *out* paint and give you back light areas, or "reverses." However, if you're trying to get a soft edge and you blot while the wash is quite wet, there's a good chance that the remaining wet wash will still run part-way back into the blotted area. You'll end up with hard, crinkly edges, rather than the hoped-for soft ones! Of course, if you wait *too* long to blot the wash, you probably won't get out as much of the color as you wanted. As always, timing and practice will tell you how and when.

Taking out wet paint with a clean, squeezed-out brush also works well. Or you can soften an already-dry area with clean water and then take out most of the paint. A bristle brush will scrub out even more. An ink eraser will take paint off a dry area. With these last two methods, remember that scrubbing will alter the paper surface, making any new paint you apply later go on differently and darker. Try all these techniques and get them down to where they become easy and natural for you, in effect, second nature!

Iglesia San Antonio, San Miguel (22" × 30"). Collection Dr. and Mrs. Thomas Skinker. Even though this is a poor church, it boasts an elaborate and impressive entry. I wanted to depict the interesting facade without delineating any detail, and to give a hint of the cavernous interior by the simplest means possible. So, I just suggested the carved stone entry with a light and shadow pattern created by the sunlight falling across it, and left the interior a warm dark, relieved only by a bit of light coming from a side window and picking out the suggestion of an altar. The figure of the woman tells a story, or at least gets the viewer guessing: is she coming out from mass, or confession, or what? She also gives the architecture measurable scale. The painting is largely a series of flat, or nearly flat, washes, and generally, I worked the lighter values first and darker values second. Pinks and grayed violets (the actual color of the stone) predominate, and these are complemented by some dark red-oranges in the wood of the door, and a few bright yellows, hinting of gold, in the altar.

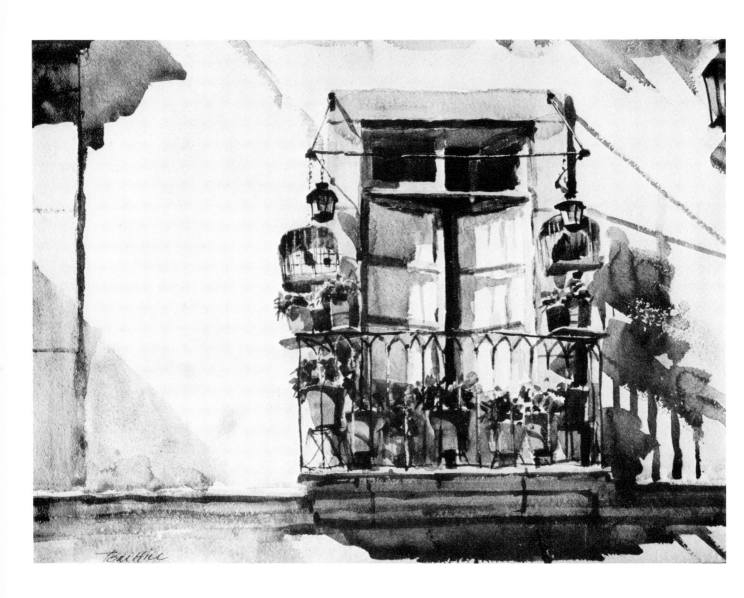

Mexican Balcony *(22" × 30"). Collection Mr. Keith Martin. Although this window on the second floor of a Guanajuato building is very typical of many windows and balconies in that colonial city, it could also easily be in any number of other towns in central Mexico. The people love to have growing things nearby, and crowd their windows with potted plants and flowers of all sorts. Birdcages are common, too. I wanted to show the morning light streaming across the face of the stuccoed wall, and used a little bit of the neighboring architectural detail on the left and a hint of lantern on the right, to add compositional balance to my picture. After carefully studying the window and making several little pencil studies, I decided on this composition. I lightly penciled the elements in place, taking care to get the perspective to show that the view is from below, looking up. Seeing the bottom of the window lintel, balcony, and the birdcages accomplishes this. The large, light-value pink wall was brushed in with a 1-1/2" brush, and when dry, the window, window frame, pots, cages, etc. were painted. Next, the cast shadows — a grayed, darker value of pink — were added, and finally, the wrought-iron railing and small details.*

3
PLANNING
THE PICTURE

Perhaps you've heard people refer to how an artist was "inspired" to paint a certain picture — or how his or her God-given talent plus just the right moment of "mood" combined to produce a masterpiece? Well, maybe that's the way it works for some artists, but I've never observed or heard of this happening to any artist I know, nor has it happened to me. Sure, I'm hit by the desire to paint when subjects and themes move me or grab my imagination, and I envision final paintings in my mind. More than likely the same things happen to you. It's how we proceed from this point to the completion of a successful painting that makes the difference. For me, it doesn't just "happen" — and there's no "instant" art. I think a successful painting involves self-discipline, practice (with many "learning" failures), understanding of and empathy for the subject or theme, and, after quite a bit of work, a success here and there! So whether you are a skilled artist, a rank beginner, or somewhere in between, and whether you paint in watercolor, oil, or acrylic, when you get right down to the wire, certain things have to happen. You have to want to paint a picture, be able to organize and construct that picture, and have a reason to paint — something to say.

True, there are artists today who feel that the picture or work of art doesn't have to say anything — that the viewer brings his own interpretation to it. In other words, the painting is its own reason for being. For myself, I prefer to paint a picture because I've had a feeling or reaction to a subject or theme and want to try to put that feeling down in paint. If the viewer responds to my painting by understanding what I've tried to say (even if only partly), then I'm gratified and feel the painting to be a success. If you agree with me so far, then I think you'll also agree that when you paint because you've something to say or record about a subject or theme, your painting effort stands a better chance to succeed simply because you're personally involved in your subject.

Understanding Your Subject

It has been said: "an artist paints his times." I think it's certainly true that we paint or interpret best those things and experiences we know and have lived. We have a reserve bank of knowledge in our subconscious that we can draw upon at will, without even realizing it. As a crazy example, suppose you sit down to paint a picture of that old barn down the road — the one that's been there ever since you can remember. Suddenly, a little man from another planet sits down beside you to paint that same barn! It's his first time on Earth, and, unlike you, he has never seen a barn, much less touched the old wooden boards, played in the hayloft as a child, or smelled all the barn smells. Naturally, he won't have the feeling for it that you do, nor will he know what you know about its structure, texture, or history. At first he certainly won't interpret "barn" as well as you. However, if he stays around awhile, and gets thoroughly acquainted with the whole barn

scene, as well as the life-in-general of the neighborhood, then he might be able to come up with some pretty good "barn" paintings.

So, if you really don't know your subject, the first order of business in producing that painting is to *get* to know your subject!

Observing and Drawing

Two excellent ways to quickly get to know a subject are observing and drawing it. The observation process certainly includes more than looking at your subject from afar. Walk up to, around, and if possible, through it. Feel and touch, taste and smell it if those senses can be applied. Drawing has always been the key to better understanding for artists. I don't mean snappy pencil techniques — I'm talking about a drawing that is for you alone, for your understanding, and to give you concrete personal references later when you're painting, as well as to reinforce your memory through having to think, study, and analyze in order to draw the subject! At this point, I should mention a couple of tricks that might be useful to you in seeing, simplifying, and composing your subject matter. The first, illustrated in Figure 27, is a little viewer that you can cut out of heavy paper or cardboard. It seems to work better if it's black. The closer you hold it to your eye, the wider the angle you see. The farther away you hold it, the less subject matter is included. Make it pocket-size or even wallet-size. A similar effect can always be accomplished by simply forming your hands and fingers in a rectangle and studying your subject through the opening.

Notes

Written notes help you remember the information you've gathered — not only about the size, shape, texture, value, and color of your subject, but also about the atmosphere, time of day, and the mood of the scene. The notes can be taken right on your drawings, or written down separately; spelled out, or in your own shorthand.

Camera

The camera, and all sorts of photography, have become very big in our present-day culture, and photography itself is an art form of major im-

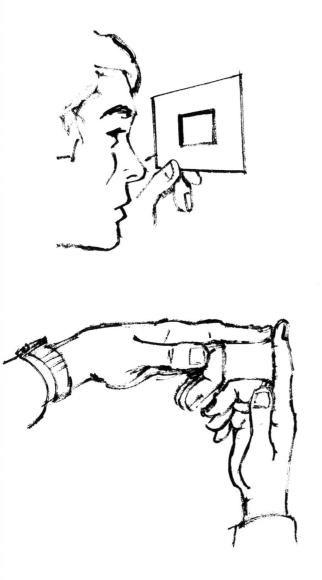

Figure 27. This little cardboard viewer is easy to make and helps you to see, simplify, and compose your picture, while studying the subject. Use your hands as shown if you don't have a viewer.

portance. Artists have utilized photography from as far back as when the first cameras were available. For painters, it's another way to record information — a quick way.

However, popping a quick snapshot or color slide of a subject to later rely on as your sole source of information and understanding simply isn't enough. Observing, drawing, and even "living" the subject are necessary to develop a feeling for it, and then any photos you have can be of supplementary help. Just be sure that you can paint what you want without the camera as a crutch, and keep photography as just another information-recording tool for you.

Thumbnail Studies

The need for thumbnail studies depends, of course, on what you're painting, and looking at a simple still life or a single-figure subject probably doesn't present the bewildering array — even chaos — of material that some landscape subjects offer. Even so, I usually try to make several "thumbnail" or miniature studies of the subject, in addition to the informational drawings described above. Thumbnails aren't detailed or large; in fact, mine are often smaller than postcard size. Their purpose is to record some of the compositional elements that attracted me to the subject in the first place. Also, these small studies, which are easily modified or changed, hopefully solve some of the picture-construction problems that will come up later in the final painting.

Picture Construction: Composition

There's no question that the way you put your picture together — the composition — can make or break the success of the painting. The little thumbnail studies just mentioned are an important step in planning the painting, and could be carried to quite a degree, solving compositional, color, value, and other problems within themselves.

It's difficult to *talk* about composition, which is really a *visual* thing — although there have been many theories, traditions, even hard-and-fast rules about how successful compositions can or should be made. Although a study of these rules (dynamic symmetry is one example) can be helpful, I'm inclined to think that com-

position, like painting itself, is a personal matter, with solutions to problems successfully varying from artist to artist.

When planning a painting, one of the most important things to do is decide what we want the picture to say. Then we have to determine which of the available picture elements should be used to help say it. In contrast to the photographer's situation, where adding or subtracting elements from a picture can be difficult if not impossible, we, as artists, can organize our pictures with ease. Reality can be intensified, changed, simplified, abstracted, or even eliminated, all in pursuit of the goal of producing a statement or conveying a feeling. This is important because when we view a painting (even our own!), certain involuntary things happen to us: we have a reaction to the painting we're looking at, good, bad, or indifferent. Even a totally white sheet of paper can produce an emotional reaction — ask any watercolorist starting a new painting and about to put down that first brushstroke! If nothing else, the viewer might wonder why there isn't an image there, or notice the contrast between the white paper and whatever surrounds it. The addition of only one little mark or shape painted on that white paper can instantly change the viewer's reaction to it. Even without representational content in a painting, it's possible that textures, shapes, lines, values, and colors can be arranged in ways that will evoke such disparate moods or reactions as coolness and warmth, agitation and tranquility.

Another important factor to consider in composing your painting is balance. Apparently the eye involuntarily follows "paths" that the composition seems to dictate, moving about the painting, coming to rest here, passing rather quickly there, delighted in this area, bored in that. It can be irritating to the viewer if his eye seems trapped by elements in the picture, or even forced out of the picture by the arrangement. A picture that somehow seems "unbalanced" can be disturbing, even though the viewer isn't quite sure what it is that's upsetting him!

So, it's really important to "tune up" your sensitivities to compositional relationships, and to try for picture constructions that really work for you! Figure 28 shows a few basic things to consider when planning a composition.

Figure 28. *Using a typical rectangular picture shape, I've introduced some compositional elements. Test your reactions.*

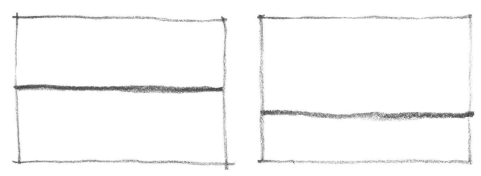

These picture shapes are divided by a single horizontal line, the left side equally divided, the right side unequally. Which is more interesting to you?

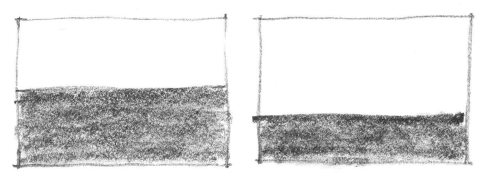

This time I divided the picture shapes with a gray value tone. Any preference?

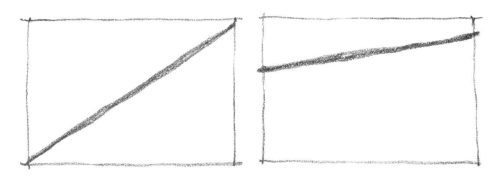

The picture shapes are once again divided, this time diagonally. Left is corner-to-corner, the right side uneven. It's the same line, but the effect is different.

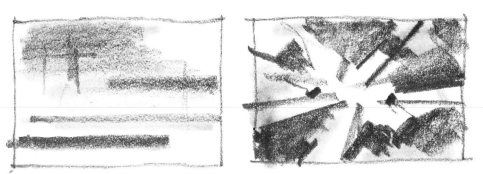

Shapes and lines combine to give a feeling of tranquility on the left, agitation — even explosiveness — on the right.

Just adding a few dark-value shapes to the right-hand picture balances what is unbalanced in the left-hand example.

 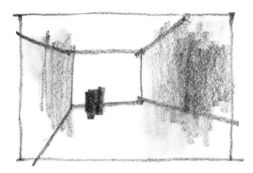

On the left, the strong little dark in the exact center with diagonal lines going out to the corners seems disturbing. These slight changes in the right-hand picture make the picture visually pleasing.

Your eye seems to zip right out of the top corner of the picture on the left, whereas a slight modification in the right-hand picture acts as a barrier to stop your eye, leaving it free to wander more leisurely about the rest of the composition.

Compared to the boring left-hand solution, the right side shows the edge or frame of the picture being used as part of the design. The diagonals of the tree and shadow shapes add some dynamic qualitites.

Development of an Actual Painting

Water has always been a scarce commodity in the Southwest, and in the early years of settlement many windmills dotted the countryside, pumping water into storage ponds for cattle and into elevated water tanks for humans. The solid, bulky shape of these water tanks contrasted with the spidery web of the windmills' vanes, tail, pipes, and tower make interesting shapes and patterns. A few of these oldtimers are still at work pumping water, while others, retired from duty and disconnected from their wells, stand in some remote areas, turning their faces to the wind and squeaking and sighing a story of the not-too-distant past.

Just such a windmill and water tank stand out on the desert not too far from where I live. Together with the neighboring barn, they have been a subject for several of my paintings. No longer in use, they are gradually giving way to the elements. The Palo Verde, Mesquite trees, cactus, and greasewood are beginning to overgrow the scene, surrounding and softening some of the harsher lines.

This is surely wonderful, appealing material for a painting — but a rather chaotic mess! How to organize it? What to use, what to discard, what to modify? It has been my experience that the artist seldom finds a landscape subject that doesn't need some reorganization, and usually a lot! The following demonstration shows you the way I went about making a painting of this scene — gathering information, so I knew my subject well, and planning the composition. Maybe these procedures will be useful to you when you're faced with the problem of turning chaos into order.

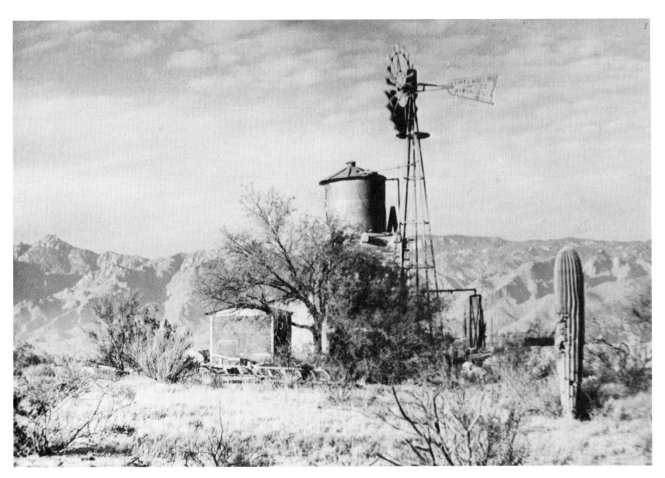

Step 1. *This photo, taken several years ago, was shot from a different angle than that used in the painting. It gives you an idea of the subject and setting.*

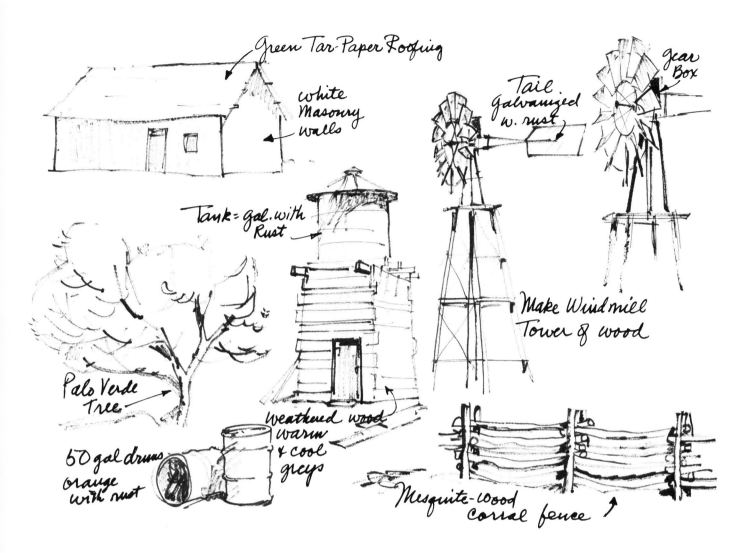

Green Tar-Paper Roofing

White Masonry walls

Tail Galvanized w. rust

Gear Box

Tank = gal. with Rust

Make Windmill Tower of wood

Palo Verde Tree

Weathered wood warm + cool greys

50 gal drums orange with rust

Mesquite-wood corral fence

Step 2. *These drawings were made for my information and understanding of the subject.*

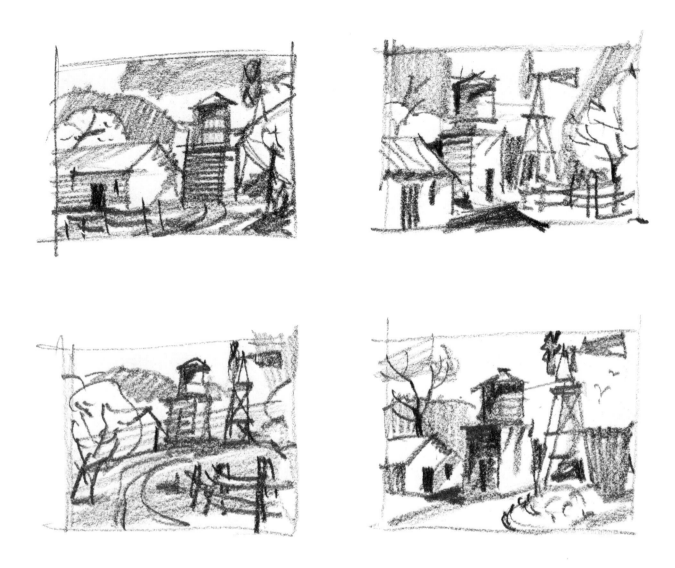

Step 3. *With little compositional studies or thumbnail sketches like these, you can try a number of compositional arrangements and solve many picture design problems, before you actually start to paint.*

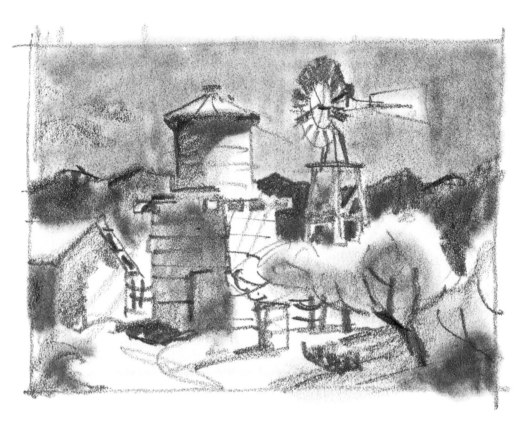

Step 4. *I liked this compositional solution, and decided to use it for the painting. I developed the values (dark to light) in it farther than I did in the other studies.*

Step 5. *To transfer my final thumbnail solution onto my watercolor stretch, I used an old and simple device. With a pencil I made a few vertical and horizontal divisions on the thumbnail study; then I did likewise on my watercolor paper, on a larger scale. I used these lines and divisions as guides in transferring the design of the little thumbnail study, enlarged to painting size, onto the watercolor paper.*

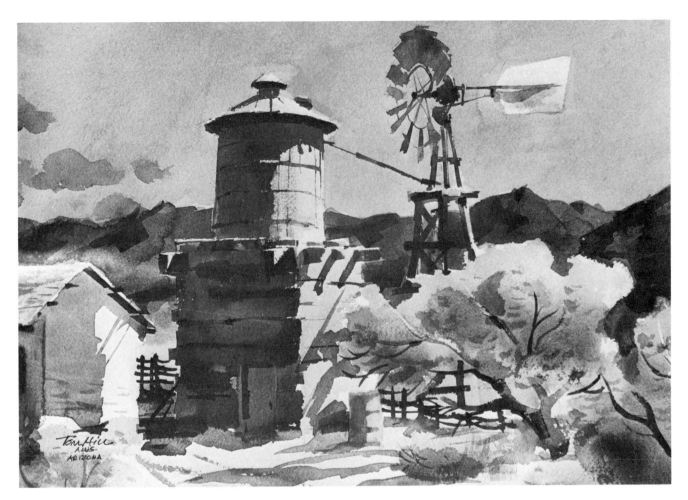

Old Arizona Windmill (15" × 22"). *Private collection. I guess the reasons that I wanted to paint this deserted old windmill and watertank are several — the wonderful patterns and shapes, the subtle colors and textures — but mainly, I painted it because I had the feeling that someone should be there — but wasn't! The brilliant desert sunshine cascaded over everything, speaking of life as sunshine seems to do, and the disconnected windmill creaked and turned to face the changing springtime breeze, adding to the illusion of human occupancy. But no human life was there — only a small lizard carefully eyeing me from atop a flat rock.*

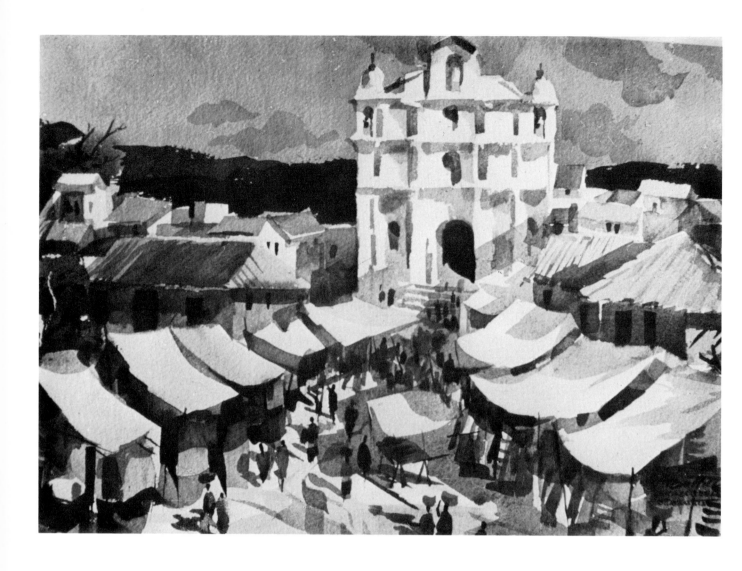

Market Day, Chichicastenango *(14" × 22"). Collection Dr. and Mrs. C. Skinner. Sunday, market day in this little Guatamalan highland town, has to be one of the most colorful affairs anywhere. Indians from surrounding towns arrive, setting up the sunshades, and their wares underneath them, early in the day, then the market goes full-tilt until late afternoon (when I painted this). At this time, the whole business is then dismantled and taken away, so that by evening there's hardly a sign of the bustling market that filled the plaza only a few hours before! I did my painting from a high point facing the famous white church, using it as a center of interest. The sunshade shapes were used as design elements to lead the eye to the church. The shadows and material under the sunshades were painted first, leaving the largely white sunshades as reverse shapes. The cast shadows defined the church with a minimum of detail and no line. The dark mountains were painted, followed by the detail of figures and buildings.*

4
COLOR: WHAT IS IT?

Color, the word and the fact, is so common in our daily lives that many of us don't give it more than a passing thought. Yet every once in a while I hear about some blind person who, never having seen at all, is given vision through modern surgical techniques and suddenly, for the first time in his life, can *see!* His reaction is always one of amazement at the visual world revealed. Usually, he already has a fairly good idea of the shapes and textures of things in his life, but *color* — the beauty and intensity of our colorful world — overwhelms him. In a fresh, new way, he sees what we take for granted.

If we could suddenly see color in a new way, I wonder if we wouldn't want to know more about it, to understand it better? As artists, color is one of our main concerns. I'm often amused when people "oooh and aaah" over some color snapshots, when all around them, all the time, is the real thing — in "living color!"

Once, in art school, we were having a discussion about color and one of the students asked, "If I put a red ball in a totally dark room what color would it be?" Right away someone answered: "Red, of course, it's still red!" He was wrong. In the dark, without light, the ball would have *no color at all!* Then, what *is* color?

Colors of Light

Color, says the dictionary, is "the quality of an object or substance with respect to light reflected by the object." *Reflected* is the word to remember!

Within sunlight — which is white light — are all the colors of the spectrum. You've probably seen how sunlight, shining through a prism or into a rainstorm, is broken up into the colors of the rainbow — red, orange, yellow, green, blue, and violet, each color blending into its neighbor as they meet. See Figure 29.

Now let's consider that red ball again. If we take it out from the dark room and put it in direct sunlight, it will appear red again. Why does it appear *red* when the *white* light of the sun is falling on it? Why not white? The answer is that the ball is reflecting and sending back to our eyes only the *red* rays of the sunlight, while absorbing all the other rays. In the same way, a lemon appears yellow in white light because it's reflecting only the *yellow* rays and absorbing all the others; a blue plate reflects the *blue* rays and absorbs the rest; and so forth.

Then what is black? What is gray? In the sense we're talking about here, black is the *absence* of reflected light, because a black object absorbs *all* white light. Thus, a dull, black cloth appears colorless. Gray, depending on its value, absorbs a portion and reflects a portion of all white light rays.

Of course, if the light isn't sunlight, but some other source such as an ordinary incandescent lamp, a fluorescent light, a colored spotlight, or even a campfire, then the red ball or yellow lemon might appear a slightly different color, because it's reflecting and absorbing a different set of light rays. So, we can think of color in two ways: as a direct light source, whether white or

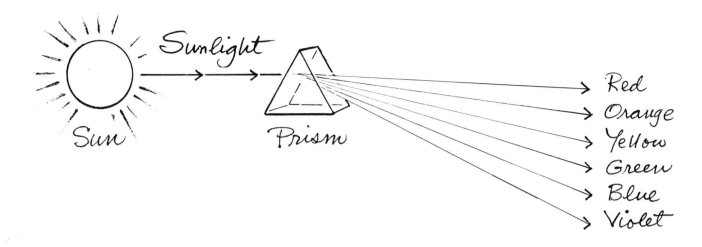

Figure 29. *Within sunlight — or white light — are all the visible colors of the spectrum, as seen through a prism.*

Figure 30. *To start your color wheel, divide an 8" or 10" circle into six equal parts. The easiest way to do this is to use the circle's radius, and with your compass, step-off around the circle's perimeter.*

colored, or as the light reflected by some surface, such as pigment or paint.

Although adding more light to a direct light source produces more brilliance, adding more pigment to pigment produces *less* brilliance, because more light rays are absorbed and fewer are reflected! In short, reconverging all the light rays of the spectrum would produce white light again, but mixing all the colors of *pigment* together would give us something awfully close to black (not to mention a horrible mess!)

Probably the most important point about color for the artist to understand is that the brightest pigment in our paintbox is still only reflective, and can never rival actual light in brilliance.

Primary, Secondary, and Tertiary Colors

As long as paint pigments are our chief concern, let's review a little about them. Red, yellow, and blue: we know we must have at least these three pigments in order to paint in full color. Orange can be mixed from red and yellow, green from yellow and blue, and violet from blue and red. But red, yellow, and blue can't be mixed from other colors and so are called the *primaries*.

Orange, green, and violet can be mixed from primaries, and so are called *secondaries*. Colors such as red-orange, yellow-green, and blue-violet, which are made by mixing a primary and secondary color, are called *tertiary* colors.

Color Wheel

Understanding color relationships in pigment is usually a lot easier for most people if they relate the color spectrum to a gadget called a color wheel — simply the spectrum colors arranged around a circle. I suggest that you make one, if you don't already have one.

On a piece of illustration board or watercolor paper, draw a circle about eight to ten inches in diameter and divide it into six equal parts. This is easy; use the radius you already have on your compass and just go around the circle's perimeter, as shown in Figure 30. The circle's radius will divide it exactly six times. Using the yellowest yellow (neither too greenish nor too orangish) that you have, paint a swatch at the top of the circle; then do the same using red

and blue (the other two primaries) at every other mark around the circle. See Figure 31, page 65. Next paint in the secondaries: orange between red and yellow, green between yellow and blue, and violet between blue and red. You can mix these secondaries from your primaries or you may have tube paint all ready to use. At this point, don't worry about having the *perfect* red, green, or blue — just come as close as you can. For now, our main interest is in understanding the *relationships* between colors.

Look at the color wheel in Figure 32, page 65. There are a number of things we can learn from it already. Directly across from each color is its "complement" (also called "opposite"). Notice that each primary color is always complemented or "opposed" by a secondary color, never by another primary. Complements are very essential in understanding colors; you should try to keep a mental photograph of this little wheel in your head, so you can call on it at will as you paint. Just memorizing the three primaries and their complements will be a big help.

Color Terms

Before we study the meaning and use of our color wheel in more detail, let's clear up some of the clutter related to the many terms used in reference to color.

"I didn't mean *that* green!" says the lady to the house-painter. "I meant more of an apple green." *Apple* green? I always thought of *red* as the color of apples! Of course, there are green apples and yellow apples, as well as apples with both red *and* green in them. How confusing! That's what color terminology is for most folks. I think of one thing, and you think of another for the same word! Every day we hear and use color-related words, but they aren't used specifically enough for everybody to understand in the same way. Here are just a few: brilliant, dull, lively, light, dark, deadly, strong, weak, hue, chroma, intense, sickly, rich, insipid, tint, shade, normal, weird, punchy, and on and on. Add to this the confusion created by colors named after places, flowers, and fruit: Antwerp blue, Nile green, Naples yellow, Chinese white, desert tan, peach, plum, apricot, tangerine, and geranium. Throw in a few terms contributed by the interior decorators who confuse things even

further with elephant gray, pale fudge, colonial pewter, autumn gold, and many more. No wonder the student of color rightly screams, "Help!"

For our purposes, as artists, we can eliminate most of this nonsense, settle for a few words, define them so all of us understand them exactly, and then stay with them as our standard.

There are three principal aspects or "dimensions" to color:

Value. This refers to a color's lightness or darkness. For example, on a gray value scale there are gradations of gray, going from white at one end to black at the other. Every color has a value, and *different* colors can have the *same* value. A good way to remember value is to think of a black and white photograph, and how every color in the actual scene is converted into gray, black, or white values. Figure 33 shows a simple value scale.

Hue. The specific name of a color, as in a *red* ball or a *blue* sky.

Intensity. Also called "chroma" or "saturation," intensity refers to a color's strength or weakness. The same hue, red, for example, can be of maximum intensity (a very bright red) or of minimum intensity (a rather dull red).

Aside from these three "dimensions" of color,

there are some other aspects of color that we should examine and be aware of.

Color Temperature

Colors seem to have a relationship to temperature and are said to be "warm" colors or "cool" colors. There are probably psychological reasons for this, such as associating certain colors with things like fire and ice. Whatever the reasons, if we divided the color wheel in Figure 32 vertically down the middle, we'd be splitting yellow at the top and violet at the bottom. Then, most everyone would agree that the reds and oranges on the left side of the wheel are warm and the greens and blues on the right are cool. But what about the yellow and violet?

The yellow swatch on the orange side would be a warm yellow, while the yellow swatch on the green side would be a cool yellow. The same idea prevails with violet; it's warmer toward red and cooler toward blue. There are more possibilities. Even over on the cool side, a blue that's toward violet can seem warmer than a blue that's toward green. On the warm side of the wheel, a red that's toward violet can look cooler than one that leans toward orange. In an actual painting, a lot of what makes a color seem warm or cool depends on which colors are next to it, or around it. We'll get further into that in Chapter 6. Figure 34 on page 65 shows our color wheel changed a bit more.

Figure 33. *The term "value" refers to a color's lightness or darkness, and not to the specific color or hue. A simple value scale, like this one, going from white to black in five steps, helps in understanding values and planning paintings.*

Local Color

When artists talk about "local color," they're referring to the actual, true, surface color of a thing or object. It's difficult, if not impossible, to really see the pure, unadulterated, local color because of ever-present surrounding colors and changing light conditions that modify and change the appearance of the local color. These conditions are sometimes called "atmospheric color."

Atmospheric Color

The surrounding atmospheric conditions modify color in many ways. Obviously the color reflected during a dull, cloudy day won't rival the intensity of color reflected on a bright, sunny day. For instance, let's say a friend is wearing a blue shirt; the color of his shirt will appear different indoors, under artificial light, than it does outdoors, in brilliant sunshine. In direct sunlight, the highlights on the shirt look almost white, or bleached out. If he is standing on green grass, the shadows on the shirt could tend toward blue-*green*. If he walks over to a shiny red car, then the red reflected from the car could modify the blue of his shirt. Later on, at sunset, longer red light waves would dominate the available light, turning that blue shirt into still another color, so that it might possibly not even look blue at all! As night comes and the amount of light is greatly reduced, the shirt would appear nearly colorless, or perhaps as a slightly lighter value than the darkness around it.

Colors that Advance and Retreat

Often, in a painting, some colors appear to advance toward us while others appear to retreat, without having anything to do with, or getting any help from, scale or perspective. It seems to be the colors themselves that give this illusion. I don't know the reasons, but it appears that warm, dark-value colors come forward, while cool, light-value colors recede. It's useful to know this, and we'll discuss it more in Chapter 9.

Tint, Shade, and Tone

These words are used continuously (and ambiguously) in referring to color. Let's define them for our use and then not worry too much about them. In watercolor you produce a *tint* by adding water to the color (in opaque painting, you would add white paint), so, a tint is always lighter than the color you start with. A *shade* is produced by darkening a given color, using black, or the color's complement, or near complement. A shade can be not only darker in value than the color you started with, but warmer or cooler than the color, depending on what you add. The term *tone* is really ambiguous, but most often refers to the value of a color.

Graying a Color

We just discussed intensity in color, and how a specific color could be at maximum intensity or at varying degrees of *lesser* intensity, and still be the same hue (color). How do you lessen a color's intensity and still keep it the same color? In other words, how do you neutralize, or gray, a color?

There are two ways to do it without changing the hue. One is to mix black with the color, the other is to mix the color's complement with it. In transparent watercolor painting, where so much depends on the reflection of light, I prefer to gray my colors by mixing them with their complements. If you use black, it will gray your color very effectively, but because black absorbs all light rays, the results probably won't be as lively and clear as when the complement is used.

A little of the complement grays the intense color only a bit. The more of the complement you add, the grayer or more neutral the color becomes, until — in theory at least — you reach a completely neutral gray.

Now let's go back to our color wheel and add one more dimension to help our understanding of color relationships. First we'll establish that the outer edge of the wheel represents colors at their most intense — maximum intensity. Then, as colors are mixed in greater and greater proportions with their complements, they become more and more grayed, and move toward the center of the wheel. The center itself represents totally grayed or neutralized color — in effect, black, with *no* reflection of color. Figure 35 on page 65 shows only two intermediate grayed steps between the rim and center of the wheel, but you *could* make as many as you wish.

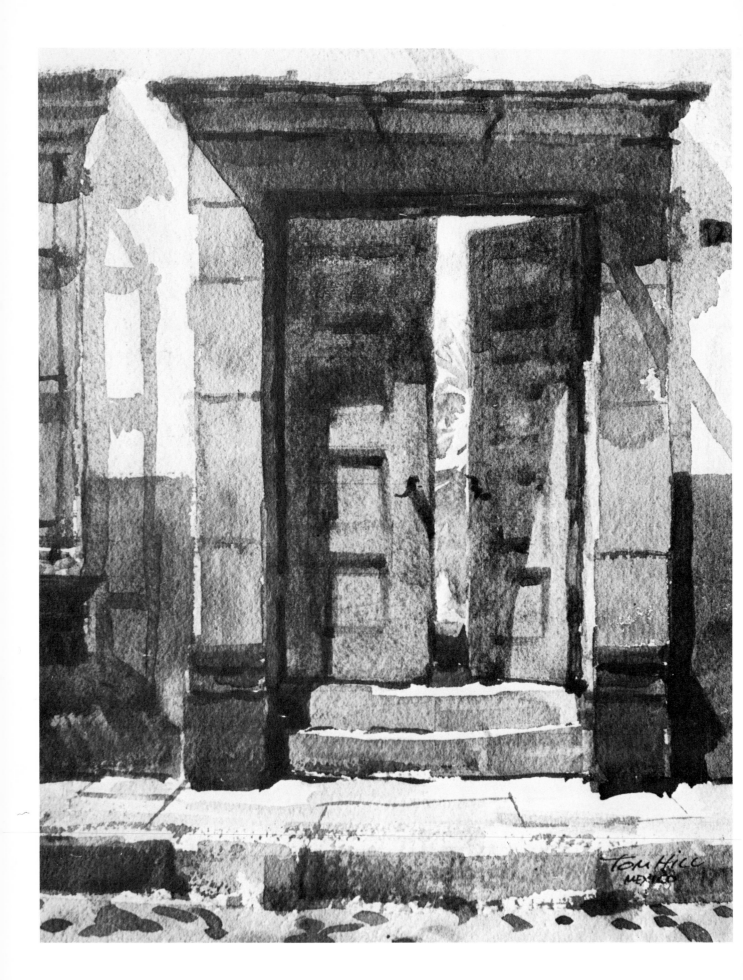

A Final Note About the Color Wheel

All this discussion about color and the color wheel is, of course, theoretical to a degree, and its purpose is to help set our thinking straight about color relationships in painting. The actual tubes of watercolor that you buy in the art store just don't act in a nice, neat, theoretical manner; they behave with personalities and idiosyncracies all their own. Instead of lining up on the spectrum or the color wheel like good little soldiers, they fall here and there, missing their idealized places, often by quite a wide mark!

For example, ultramarine blue — that wonderful, workhorse of a color — isn't the idealized exact blue that we visualize on the color wheel, but rather leans quite a bit toward violet. Not only that, but one manufacturer's ultramarine may differ slightly from the next guy's product. Cadmium orange seems to be the perfect orange when you squeeze it out of the tube at maximum intensity — seems like it would be great for graying its complement, blue. The trouble is, even if you *had* a perfect blue (and you don't), when you add water to cadmium orange, it suddenly veers toward yellow, and any graying of blue you do with it will have a greenish touch!

However, all things considered, the color wheel is *still* the best way I know of to keep color theory and relationships in mind, and will always be a useful tool to us as we get further into color in watercolor!

Mexican Doorway (11" × 14"). Private collection. Doorways like this are a common sight in the colonial cities of Mexico, and new construction often resembles the very old. The color of this door was blue originally, but had weathered to a marvelous patina, blending beautifully with the grayed, warm blue of the stone door frame and lintel. My interest in this painting was to develop a feeling of being bathed in sunlight, and especially the little glimpse of the flowering plants seen within in the patio. I used a simple palette — mostly cools, but complemented by touches of warms in the street paving and in the patio.

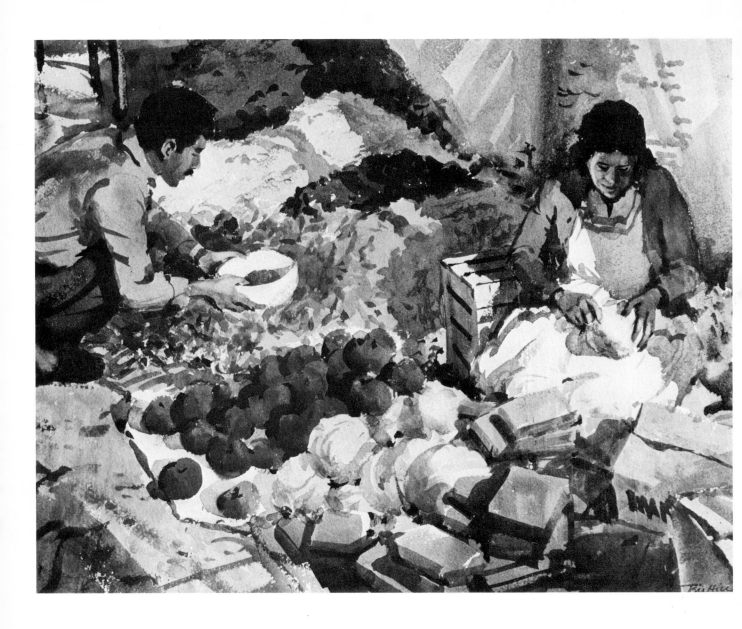

Market in Patzcuaro *(22" × 30"). Private collection. Patzcuaro is way up in the mountains of central Mexico, at about 7,000 feet elevation, so you get an Alpine feeling there while still in the tropics! Market day here, as in many areas of Mexico and Latin America, is one of the main events of the week — people come in from many smaller, surrounding communities, loaded with things to sell. Stalls are established along the streets under the ever-present sunshades, and the bulk items, such as beans or dried fruit, are often just dumped out onto woven mats (or, more and more, plastic sheets!), and the day of selling and visiting proceeds.*

I find all this irresistible as subject matter, but since there's usually so much confusion and clutter, organizing the picture becomes an item of first importance! I treated this as an abstraction, and handled the piles of goods as shapes, textures, and colors. The figures and the box made it all come together as a representational painting. Sunlight falling across part of the produce and wares reflects up into the apron and face of the woman at the right, giving a glow to the figure.

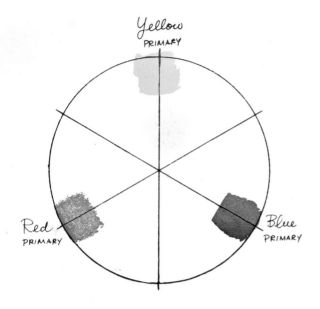

Figure 31. *Paint in the three primaries—yellow, red, and blue, as accurately as you can, with the yellow at the top.*

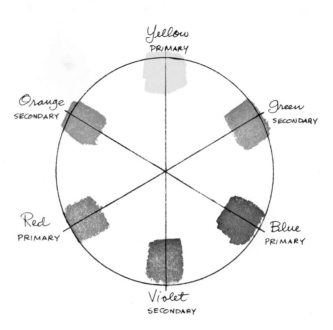

Figure 32. *By adding the secondary colors—orange, green, and violet—the color wheel makes it possible to see at a glance each color's complement, or opposite color, by simply looking across the wheel!*

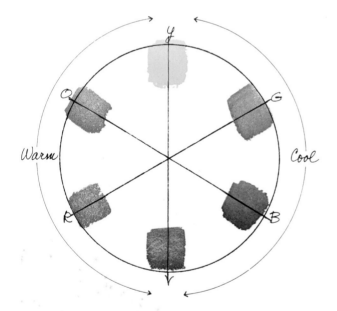

Figure 34. *Colors seem to convey temperature, appear either warm or cool to the eye.*

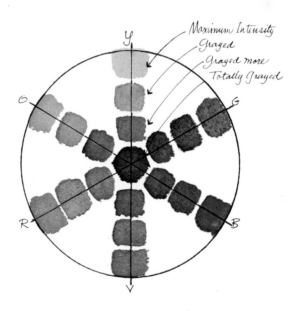

Figure 35. *The rim of the wheel represents colors at their maximum intensity, and the center represents totally grayed color. In theory, any color can be grayed, or neutralized, by adding some of its complement to it. The more complement added, the closer the color gets to the neutral center of the wheel.*

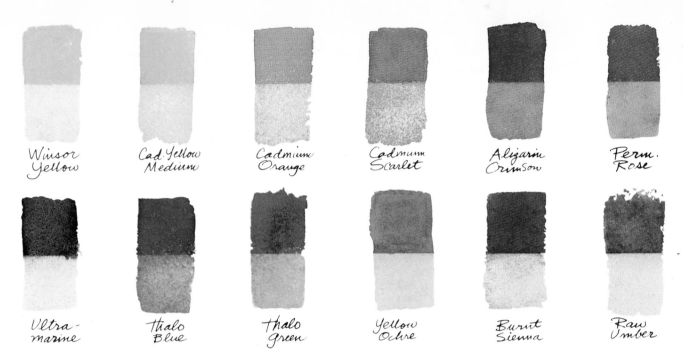

Winsor Yellow — Cad. Yellow Medium — Cadmium Orange — Cadmium Scarlet — Alizarin Crimson — Perm. Rose

Ultra-marine — Thalo Blue — Thalo Green — Yellow Ochre — Burnt Sienna — Raw Umber

Figure 38. *This test shows how much each tube color will stain. After the colors are dry, sponge off half of each swatch with clean water, revealing exactly how much each color stains the paper.*

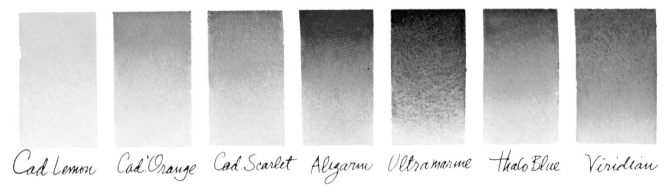

Cad. Lemon — Cad. Orange — Cad. Scarlet — Alizarin — Ultramarine — Thalo Blue — Viridian

Figure 40. *When we dilute a watercolor with water we get a tint, and as different colors have different tinting strengths, this little test shows how each color tested looks in equal dilution. Some seem to change hue a bit, while others seem to stay fairly strong in dilution, and still others weaken rapidly.*

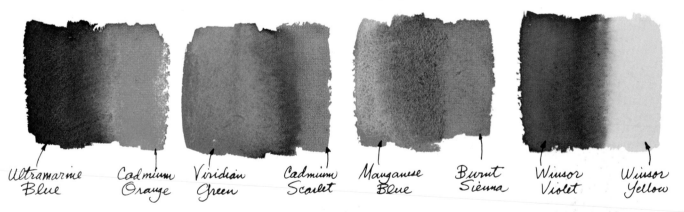

Ultramarine Blue — Cadmium Orange — Viridian Green — Cadmium Scarlet — Manganese Blue — Burnt Sienna — Winsor Violet — Winsor Yellow

Figure 42. *Color theory tells that mixing complements (or near-complements) will result in neutral grays. This experiment, in which different complements are mixed into each other, again shows the individuality of tube colors. Grays are certainly produced—but also notice the variety of grays and textural effects that the different color pairs give us!*

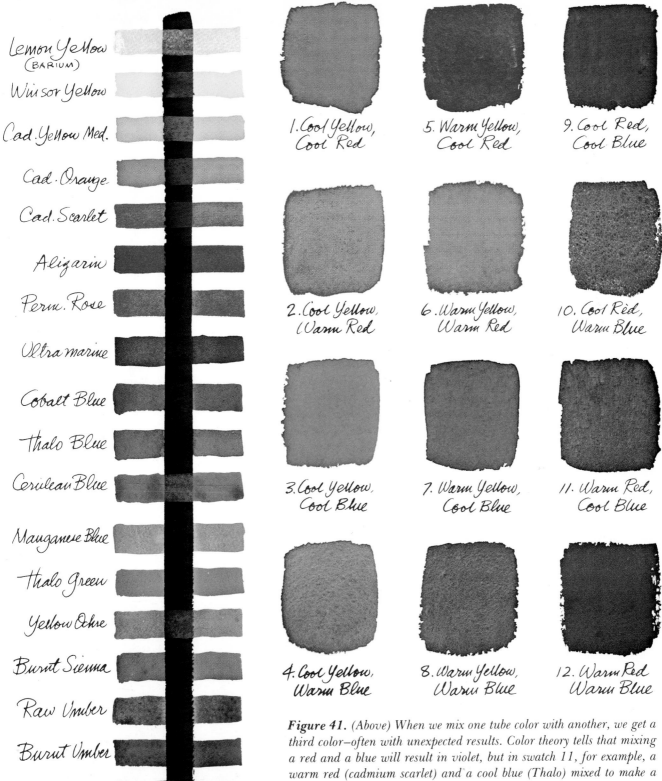

Lemon Yellow
(BARIUM)

Winsor Yellow

Cad. Yellow Med.

Cad. Orange

Cad. Scarlet

Alizarin

Perm. Rose

Ultra marine

Cobalt Blue

Thalo Blue

Cerulean Blue

Manganese Blue

Thalo Green

Yellow Ochre

Burnt Sienna

Raw Umber

Burnt Umber

Davy's Gray

1. Cool Yellow, Cool Red

5. Warm Yellow, Cool Red

9. Cool Red, Cool Blue

2. Cool Yellow, Warm Red

6. Warm Yellow, Warm Red

10. Cool Red, Warm Blue

3. Cool Yellow, Cool Blue

7. Warm Yellow, Cool Blue

11. Warm Red, Cool Blue

4. Cool Yellow, Warm Blue

8. Warm Yellow, Warm Blue

12. Warm Red, Warm Blue

Figure 41. (Above) When we mix one tube color with another, we get a third color—often with unexpected results. Color theory tells that mixing a red and a blue will result in violet, but in swatch 11, for example, a warm red (cadmium scarlet) and a cool blue (Thalo) mixed to make a strange cool/warm gray—anything but the violet expected!

Figure 39. (Left) Although all watercolors are transparent when compared to opaque painting mediums, some of the colors are more transparent than others. This test shows these characteristics. A water-proof India ink line was painted and allowed to dry. Then various colors were painted across it; as they dried, their relative transparency or opacity was revealed.

Street in San Miguel (15″ × 22″). Collection of the artist. In interpreting the feeling of sunlight glancing down between the old buildings of this colonial Mexican hill town, I had the opportunity to use the positive shapes of wall area and shadow pattern to create a strong geometric composition. The pink-violet of the facing building was worth painting exactly as it was, but I arbitrarily made the right-hand building an opposite (complementary) color, a grayed yellow, to enhance the first. The "saved" whites are few, but very important to the picture's vitality!

Old Adobe *(15" × 22"). Collection of the artist. There are still some little towns in New Mexico where stuccoed, sun-dried adobe constitutes the principal building material. I saw this old building late on a rainy July afternoon, when the sky was gray and the lighting dull. The sun came out for a moment, slanting low across the unkempt weeds and grass that choked the yard, and across the building's wall, casting crisp, long shadows and giving me a ready-made composition for a nostalgic subject. Largely painted in flat washes, there are some wet-in-wet areas in the grass, and extra colors were also charged into some of the shadow washes, while they were still wet.*

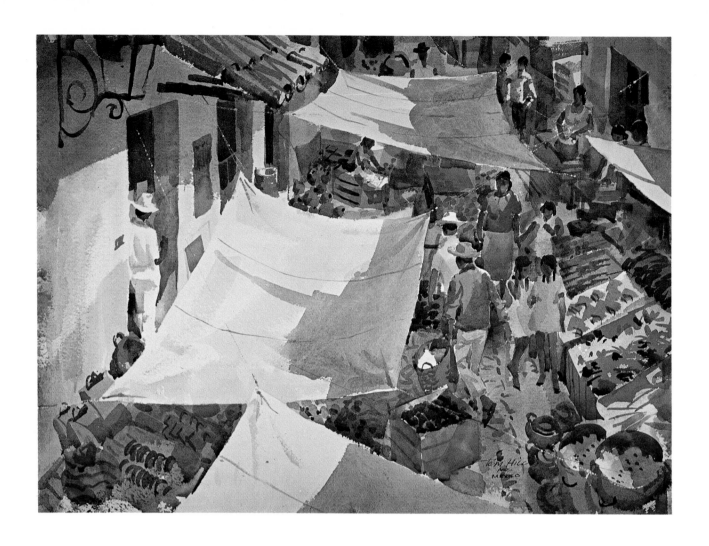

Taxco Awnings *(22" × 30"). Collection Dr. and Mrs. Faber McMullen, Jr. This watercolor started as an abstract design with simple light-value shapes (first) against complicated, dark-value areas (second). The sun-awnings of off-white cotton cloth stretched across this part of the market in Taxco made a perfect first; the people, and all their myriad products made up a richly-colored, busy second. I painted around the awning shapes without the use of any kind of masking. When all the other areas were about complete, I added a little color to the awnings, including the cast shadows from the buildings at the right. A little glazing, mostly with grayed blues and violets, was put over some of the busy areas below the awnings, both to unify them and to make them recede.*

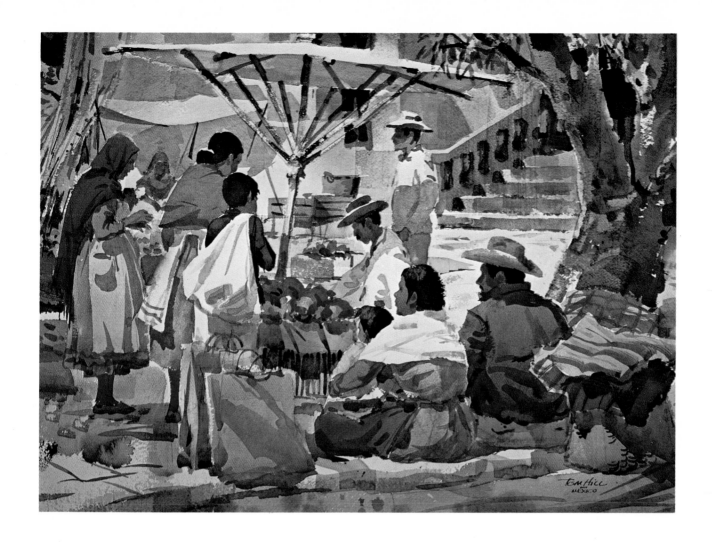

Sunday Morning in The Market (22" × 30"). *Private collection. Colors ranging from pink through violet are common in Mexico, and in this little town of San Miguel, even the local stone used in the buildings and stairways is of a purple cast. Although this is a complicated painting, I tried to avoid visual clutter by careful arrangement of the main elements in the composition, especially the way the figures are grouped. Note how a tree can seem completely a tree, yet we see neither its base nor its top. The same thing is true of the building in the background. Sunday is an especially active day in the market — a social time as well as a shopping time. Things to eat of every sort are sold alongside clothing, household items, tools, pottery, folk-medicine, and on and on. What more could an artist ask for?*

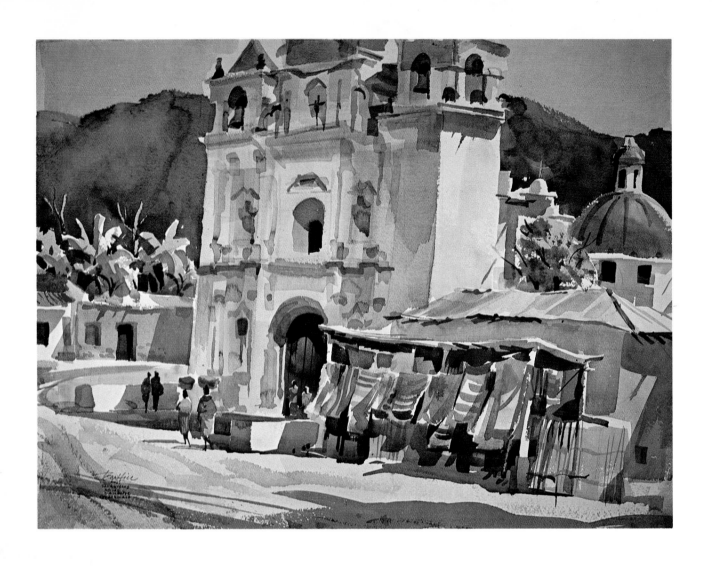

Church at San Antonio Aguas Calientes (22" × 30"). Collection of the artist. This old Spanish church faces the plaza of a tiny town in the Guatamalan highlands. Colorful handweaving is done here and sold around the plaza. I wanted to capture the feeling of the church's massive, off-white masonry, contrasted with the flimsier surrounding structures. I ran the church towers off the top of the picture to help create a feeling of greater size, and handled the complex church front as a few, simple, wash patterns. Jungle-covered mountains contrast in color and value with the rest of the picture. The figures give life and scale, while the gayly colored fabrics offer opposing-color accents.

5
TUBE COLORS AND THEIR CHARACTERISTICS

Now that we have a neat pigment-color theory and the simplified color wheel to help us use it, let's examine what's actually available on today's market in transparent watercolors, and (given each tube color's particular personality) describe what can be expected from them.

Next time you're in the art supply store (or looking through the catalog), take a look at the vast array of colors in watercolor, gouache (opaque watercolor), oil, acrylic, and pastel packed in tubes, pans, jars, and boxes, catalogued and stacked on the shelves, each color consistent in quality and quantity every time you buy. How handy! Let's stop for a minute and hoist a salute to the oldtime artist—almost *any* artist, anywhere, in any century, before our own.

A Glance at History

What a chore *he* had before he could do his thing. Not only did he often have to make his own brushes and prepare his own grounds — cave wall, bark, animal hide, papyrus, canvas, paper — but he also had to make his own *paint!* No ordering by mail or over the phone. No dashing down to the nearby art-supply store. We have it easy today, by comparison!

Think of the cave art of Europe, 20,000 years old and still breathtaking. Where did those artists get their paint? First, you must have a *colorant* (a pigment) and some sort of liquid *vehicle* to carry the pigment and make it adhere to the ground. We know some sources of pig-

ment that those ancient people used; they dug colored clays and earths from the ground, took white chalks from calcium carbonate deposits, and salvaged soot, charcoal, and burnt animal bone from their fires — probably combining these with water or animal grease. No doubt they used vegetable sources for color, too, but these faded long ago. Today, in the age of technology, sophisticated chemistry, and space travel, we still use a number of the very *same* pigment sources; umbers, ochres, siennas, charcoal, and burnt bone are available in your friendly art supply store, neatly done up as artists' paint!

Closer to our time, but still long ago, the Egyptian, Babylonian, Chinese, Indian, Greek, and Roman civilizations — as well as many others—contributed to our paintmaking knowledge.

A fascinating example of colorant source is Indian yellow, which was originally derived from a dye produced in India and made by heating the urine of cows fed mango leaves! Though the Indian yellow you can buy today is artificially produced, the original source was still in use in the early 1900's.

Another interesting bit of history was the search for a good, permanent blue. Nearly 5,000 years ago, the Egyptians developed what must surely be one of the first artificial pigments: Egyptian blue. This was made by melting certain types of sand with copper and various salts. The vitrious blue material that resulted was then finely ground and used as pig-

ment in making paint. Nearly the same process was later used in Crete; much later, a similar color, called Pozzuoli blue, was made by the Romans. An improved version, made in France or Germany in comparatively modern times, was called Italian blue. Now, cobalt blue, introduced as an artists' color in the 1820's, has replaced these blues, and although it's manufactured from different materials, cobalt blue could be termed a descendent of that ancient line.

Ultramarine blue, long a standard in every artist's paintbox, was originally very expensive, available only on a small scale, and even considered precious. In a way it was, for its pigment source was *lapis lazuli*, a semiprecious stone which was mined, processed, and ground into powder for pigment. In the early 1800's, an artificial ultramarine color was produced by heating certain clays, sulphur, soda, and coal in furnaces; since then, this color, which resembles *lapis lazuli*, has been the standard blue, widely available and much less expensive.

The search for new, brighter, and more permanent colors continues today. In recent years, many marvelous additions to the artist's line-up have become available via the chemist's lab and synthetic organic compounds. As an example of just how recent some of this has been, the watercolor Permanent Rose, a Winsor & Newton product, appears to be very stable and lightfast, possesses good tinting strength, and was first produced in 1958!

So, until comparatively recent times, most artists — or their apprentices — made their own paints, painstakingly grinding the pigments and binders. It was hard work and the results were often uneven and dissimilar to the previous batch. Today, with everything ready-made, reliable, and always the same quality, we artists have more time for creative painting!

Basic Palette

On my desk as I write this are several manufacturers' watercolor paint charts; you know, the actual paint on cards, listing permanency and price groups. One company offers 55 colors, another 60 colors, and the third shows *84* transparent watercolor swatches! This last includes 15 yellows and 17 reds, not to mention many violets, blues, greens, and so forth. Also, the same color may differ slightly from the competition's version, adding to the confusion. It's more bewildering than the modern ice cream shop with all those tempting flavors! How do you select the colors you need?

Obviously, there's great similarity between many of these colors — even near-duplication. Since our color wheel has only *three* primaries and *three* secondaries, it's clear that we don't need *all* the colors shown on the charts! For any complete, basic palette, I suggest a warm and a cool of each primary, to give you a better chance at mixing other hues than you'd have with only *one* of each primary. I'd probably add an orange, or maybe an extra blue and red, and of course, those wonderful earth colors — the umbers, siennas, and ochres. With an occasional addition or substitution, this palette should be capable of meeting every color painting problem!

This chart, Figure 36, lists 37 commonly used, generally available tube watercolors. It also defines each color's characteristics and personality based on my experience. You might disagree with some of my descriptions, but, like everything else about this business of painting in watercolor, understanding it is a personal thing and seems to come, a little at a time, with *doing!*

Color Chart

The terms "warm" or "cool" in the temperature column refer to which side of the color wheel that particular color falls on. As we discussed before, a cool color (such as blue) or a warm color (such as red) can have both warm and cool versions. A color's opacity is also relative, since all these watercolors are transparent when compared to the opaque mediums. A color's staining characteristics means how much that particular color will stain watercolor paper, and how well it can be washed off that paper. (In the next chapter, we'll explore how various colors stain *each other* in mixes.)

Figure 36. Here are 37 commonly used tube watercolors, analyzed in terms of their temperature, transparency or opacity, and staining or sedimentary characteristics.

Color Group	Name of Color	Temperature	Transparent or Opaque	Staining or Sedimentary	Comments
Yellow	Lemon yellow (Barium)	Cool, toward green	Somewhat opaque	Very little staining, a slight amount of sediment	There are two versions of lemon yellow on the market. This one, made with a Barium base, is very cool, veering toward green, and on most papers can be completely washed off. Weak in tinting strength, it almost disappears in mixture with most other colors. Very permanent.
	Lemon yellow (Hansa)	Cool, toward green	very transparent	a little staining, not much sediment	This is the other lemon yellow, made with a base of Hansa yellow, which is a bright, pale, yellow synthetic dyestuff. Brighter than the lemon yellow above, it holds its own in mixtures.
	Cadmium lemon	Almost center of yellow position on color wheel	Slightly opaque	Some staining, a fair amount of sediment	This is close to a true yellow on the color wheel, neither toward green or orange. It holds its tinting strength well in mixtures (all cadmium yellows seem to) and is a good all-around yellow.
	Cadmium yellow: pale, medium, deep	All are warm	All have some opacity	Although all have some sediment, there's still a stain left after you wash them off	Good, warm, permanent, workhorse colors. All mix well, adding a little opacity in maximum intensity washes. The deep seems almost an orange, in a rich mix.
	Winsor* yellow	Cool, toward green	Very transparent	Although some staining, no sediment to speak of	This, like Cadmium lemon, makes a good all-around yellow, though it's cooler than Cadmium lemon.
	New gamboge	Warm	Fairly transparent	Somewhat staining	Although it's not as transparent as the original gamboge (which isn't permanent), I love to use this color, especially for mixing the greens of foliage.
Orange	Cadmium orange	Warm	Somewhat opaque	A lot will wash off but a definite yellow-orange stain will remain, some sediment	Looks like the perfect orange —neither warm nor cool—as you squeeze it out of the tube, but it tends toward yellow in mixtures and dilution. The best of the oranges available.
Red	Cadmium scarlet	Warm	Some opacity	Leaves some orange-y pink stain when washed off, some sediment	Sometimes called cadmium vermillion, this is a beautiful red, slightly toward orange, and a brighter and more permanent replacement for the ancient, true vermillion. The brightest of the cadmium reds, and a versatile color.

*Proprietary name

Color Group	Name of Color	Temperature	Transparent or Opaque	Staining or Sedimentary	Comments
	Cadmium red: light, medium, deep	All are warm	All are somewhat opaque	Some stain left in paper when washed off, some sediment	Like the cadmium yellows, all the cadmium reds are good, permanent colors, somewhat opaque, especially in maximum intensity. For a bright, light red, I prefer cadmium scarlet, but cadmium red light makes good oranges when mixed with yellow. Cadmium red medium and deep do *not* make *bright*, clear violets, when mixed with any of the blues.
	Scarlet lake	Warm, but past true red and a bit toward violet	Very transparent	Staining, very little sediment	A brilliant red, redder than alizarin crimson. Clearer and more transparent than any of the cadmium reds, it mixes well with all colors, holding its own, while influencing all mixtures.
	Winsor* or Thalo* reds	Warm, but toward violet	Very transparent	Very staining, no sediment	Not unlike scarlet lake, but a little cooler—closer to violet. Tends to dominate most mixtures, so use with discretion!
	Permanent rose	Warm, but toward violet	Very transparent	Staining, with no sediment	One of the family of new synthetic organic compounds, this is a beautiful, permanent red that was only available in fugitive or impermanent, watercolors, just a few years ago. Not too much body to it, even in maximum intensity mixes.
	Alizarin crimson	Warm, but on the violet side	Very transparent	Stains the paper with a vengeance, little sediment	Another workhorse color that serves well as an all-around red toward violet, and mixes well but tends to overpower weaker-tint colors. Use with discretion in such cases.
Violet	Cobalt violet	Slightly toward the warm side	Some opacity	Sedimentary, no staining,	A gorgeous hue, permanent, and great in passages where it's alone—or nearly so. Easily dominated by most other colors, and tends to disappear in most mixtures. Has a luminous quality and granulates beautifully in big, wet washes. Very permanent, expensive, and said to be poisonous, so don't put your brush in your mouth!
	Winsor* or Thalo* violet	Close to center of violet position on color wheel	Very transparent	Staining, no sediment	Good replacement for mauve, which is listed as fugitive. Both are made of the new organic compounds and have excellent brilliance. I generally prefer to mix my violets and purples, however, and don't use this color much.

Color Group	Name of Color	Temperature	Transparent or Opaque	Staining or Sedimentary	Comments
Blue	Ultramarine or French ultramarine	Cool, slightly toward violet	Transparent	Practically no staining if carefully lifted off good watercolor paper, some sediment	A wonderful, permanent, indispensable color, long a "must" in every artist's paintbox. The French ultramarine seems a little warmer than the ultramarine. Holds its own in most mixtures, never seeming to "seize" or dominate other colors, out-of-proportion to its quantity. Can be combined with the earth colors to produce wonderful sedimentary, granular washes.
	Cobalt blue	Cool, close to center of blue position on color wheel	Somewhat opaque	Practically no staining, as with ultramarine, some sediment	Close to a "true" blue, but not as intense as one should be. Very permanent, but a little weak in tinting strength when combined with stronger colors. Excellent for glazes to produce atmospheric effects.
	Winsor* or Thalo* blue	Cool, slightly toward green	Very transparent	Very staining, no sediment	A powerful blue, edging toward green. Dominates every color it's mixed with unless care is taken: add this blue a little at a time! Replaces older and less permanent blues, such as Prussian and cyanine blue. Actual name: Phthalocyanine blue.
	Cerulean blue	Cool, slightly toward green	Quite opqaue	Practically no staining, fair amount of sediment	An old, reliable, and permanent color, which, like Cobalt, is useful in glazing to obtain atmospheric effects. Its name comes from the Latin word *caeruleus*, meaning sky-blue.
	Manganese blue	Cool, but toward green	Transparent	No staining, can be washed off completely, some sediment	A relatively new color for artists that is permanent, makes wonderful, sedimentary or granulated washes, combines well with most other colors, and holds its tinting strength fairly well in most mixtures.
Green	Viridian green	Cool, slightly toward blue	Transparent	Leaves some stain, some sediment	A permanent, reliable middle green. Doesn't dominate other colors like the newer Phthalocyanine green listed below. A good, all-around green.
	Thalo* or Winsor* green	Cool, nearly on center of green on the color wheel	Very transparent	Very staining, no sediment	Real name is Phthalocyanine. Very potent in tinting strength, will dominate and stain every color it's mixed with, so use with caution, a little at a time!

Color Group	Name of Color	Temperature	Transparent or Opaque	Staining or Sedimentary	Comments
	Hooker's green dark	Cool, but leans a little toward yellow	Transparent	Some staining, very little sediment	A popular color with many watercolorists, especially for painting foliage. I usually prefer to mix my greens from various blues and yellows. Hooker's green light is listed as less permanent.
	Terre verte	Cool	Somewhat opaque	No staining, good sedimentary qualities	A low-key, rather neutral, earth color that's weak in all mixtures, but I find it useful for textured washes and atmospheric effects. Very permanent.
Brown	Yellow ochre	Nearly center of yellow as a grayed yellow	One of the more opaque watercolors	No stain, can be almost completely washed off the paper, sedimentary	A real "must" color for most artists. Soft and never dominating, it's still a most useful color that mixes well with all other colors, and adds a subtle glow to passages by itself. Excellent in glazing over more "staining" washes.
	Raw sienna	Nearly center of yellow as a grayed yellow	Fairly transparent	Stains slightly, some sediment	An alternate for yellow ochre, some brands of raw sienna seem cooler than others. A very permanent earth color, actually a grayed yellow on the color wheel
	Burnt sienna	Warm	Transparent	Stains slightly, some sediment	The reddest of the earth colors, permanent, a marvelous mixer, one of the most useful of all the colors.
	Raw umber	Cool	Slightly opaque	No stain, some sediment	Varies from green to yellow, depending on brand. Think of this old reliable earth color as a *grayed* yellow-green, usually slightly toward yellow.

Color Group	Name of Color	Temperature	Transparent or Opaque	Staining or Sedimentary	Comments
	Burnt umber	Warm	Fairly transparent	Leaves a little stain after being sponged off, some sediment	Very permanent, warm, reddish color by itself. I find it tends to deaden some other colors, especially if the mix is made of more than two colors.
Gray	Davy's gray	About center on the color wheel (neutral)	One of the more opaque watercolors	No stain, lots of sediment	A very neutral gray, sometimes useful in calming down a color scheme that's gotten too brilliant. A very permanent color made of ground slate, it washes off completely.
	Payne's gray	Cool	Transparent	Slightly staining, a little sediment	A great favorite with beginning watercolorists, it tends to dry a great deal lighter in value than it looked when wet. Equally good, or better, grays can be mixed with complements.
	Lamp black	Cool	Somewhat transparent in dilution	Moderate staining	Although I don't use black very often in watercolor painting, it's good to know that even here, warm and cool are evident. Permanent, cool, and weaker than Ivory black. Made from pure carbon, usually with soot as the source.
	Ivory black	Warm	Somewhat transparent in dilution	Very little staining	This is the most-used black among watercolorists. Originally, it was made from burnt ivory, but for many years it's been made from burnt animal bone. Very permanent.

Where Tube Colors Fall on the Color Wheel

In the chart above, I indicated whether certain colors were on the cool or warm side of the color wheel. Now let's make a color wheel and drop all the tube colors into position on it, so we'll have an idea of where each tube color goes in relation to the idealized primaries and secondaries. The more intense the color, the closer it should be to the wheel's rim; the more grayed the color, the closer it should be to the neutral center. (Use tube colors at their maximum intensity, as they come from the tube, with nothing added except water.) For example, we know that yellow ochre isn't as intense as our ideal maximum-intensity yellow, and therefore should fall toward the totally-grayed center of the wheel. And, as I noted in my color chart, yellow ochre is about center of the yellow position on the color wheel. See Figure 37.

Testing Tube Colors

Now let's do some tests and experiments to see what our colors are capable of doing, individually and in mixtures with each other. You may want to test more or different colors than these, but for starters, I'd suggest the following:

Basic Palette	Colors
1. Cool yellow	Lemon or Winsor yellow
2. Warm yellow	Cadmium yellow medium
3. Orange	Cadmium orange
4. Cool red	Alizarin crimson
5. Warm red	Cadmium red light or cadmium scarlet
6. Cool blue	Thalo (or Winsor) blue
7. Warm blue	Ultramarine blue
8. Green	Viridian or Thalo (or Winsor) green
9. Grayed yellow	Yellow ochre
10. Grayed red-orange	Burnt sienna

Staining Strength. This test shows at a glance, exactly what amount of staining you can expect from each color—a useful thing to know and to anticipate as you're painting.

☐ Measure 10 2″ wide spaces (more, if you want to test more than the colors listed above) on a stretched sheet of good watercolor paper. With your 1″ brush, paint a 1″ × 2″ swatch of each color, centering each swatch in the 2″ space (Figure 38, page 66). Be sure you use a rich mix of each color. Wash your brush out completely between each color, using only clean water as you mix your color. Take care to keep the whole procedure meticulously clean or the results won't be accurate.

After the colors are thoroughly dry, gently wet half of each swatch with clean water and then lift the color out of the paper's surface with a clean cosmetic sponge. Blot up excess paint and water with a very clean, absorbent paint rag, or with tissues. It might be helpful to cover half of each swatch with masking tape, as I've done here; it's a little easier to lift the color out and it gives a sharp, clean edge between the original paint and the sponged-out area, for comparison. After all is dry, remove the masking tape very carefully, so you won't pick up any of the paper's surface with the tape!

Transparency. This little experiment is as useful to the watercolorist as the staining test we just did, for it reveals another characteristic of the paint that you should be aware of — transparency. Some colors, although called transparent, actually do hide a bit of what's underneath them.

☐ With waterproof black ink (India ink), make a straight line about ½″ wide and 12″ to 14″ long, or longer if you want to test more colors. Let the ink dry completely; otherwise, it won't be waterproof. Using the colors in the list above (and more if you want), paint maximum-intensity brushstrokes about 1½″ long × ½″ wide of each color across the black line. See Figure 39, on page 67. Lay on your brushstrokes deliberately and completely, don't go back into the paint. The strokes should be about ¼″ apart. Here again, cleanliness is essential if we're really going to see each color by itself, so wash out your brush between each stroke and use only clean water. After the col-

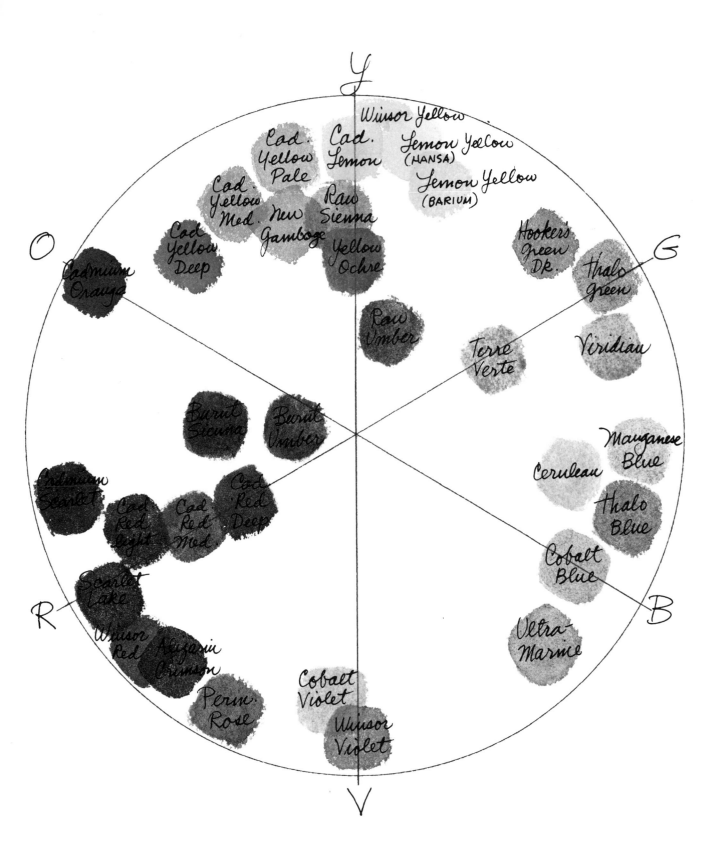

Figure 37. *Here you can see where tube colors fall on the color wheel.*

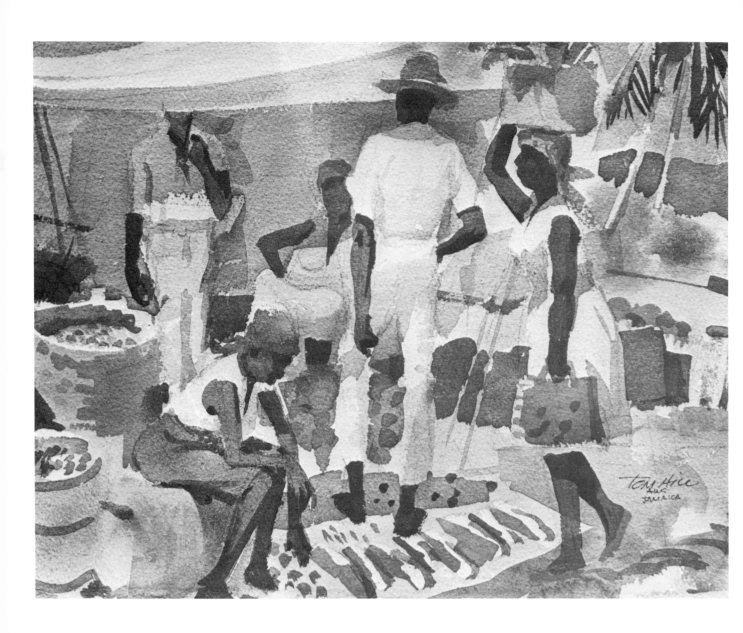

In Port Antonio *(11" × 14"). Private collection. I guess you could say that markets everywhere fascinate me. Port Antonio, a town on the north shore of the West Indian island Jamaica, has a busy and colorful market, full of intriguing subject matter. Because the local people have an aversion to having their pictures taken, I made very quick little "gesture sketches" of their actions and painted this watercolor later, working from those sketches and a fresh, vivid memory of the place. First, I lightly sketched in the figures, and then I painted the negative shapes (the areas around the figures), using a 1" brush and laying the color on in simple flat washes. After this was dry, I painted the local colors of the clothing, and when this was dry, the shadow patterns that helped define the form. I tried, throughout, for the simplest solution possible. The shadows under the awning are a warm blue, almost grayed blue-violet, and were painted mainly with scarlet lake and manganese blue. Baskets, bags, and produce are yellow ochres, pinks, and burnt siennas, and there are also dashes of hot oranges, reds, and red-violets, along with touches of Thalo green and lemon yellow in the accents and details.*

ors are dry, you'll be able to see the black line completely through some colors, like alizarin crimson and Thalo blue, but less completely through more opaque colors like yellow ochre, cadmium yellow, cadmium orange.

Tint Intensity. When we dilute a color with water, we produce a tint of that color; the more water added, the weaker in intensity the tint becomes. Given the *same* dilution, some colors retain their intensity better than others. Also, whereas a color may look like one hue when right out of the tube (at maximum intensity), it's surprising how often it seems to change *hue* a little in dilution. This test shows both these characteristics.

☐ Allow a space about 2″ wide × 4″ deep for each color tested, leaving enough space between colors. Actually, these will be little versions of the graded washes we did back in Chapter 2 (Figure 18) with the maximum intensity at the top, graded down to white paper at the bottom. You can test as many colors as you have space and time for, especially those you paint with a lot. I put masking tape all around each swatch before I paint. Figure 40 shows how my test turned out.

Combination Color Grid: Overwash and Underwash Characteristics. If you've never done one, I suggest that you make a color grid. It's easy, and will give you both the transparency and opacity characteristics of each color on your palette *as they overlay each other.*

☐ Using the basic palette I've suggested, or one of your own selection, make 1″ wide vertical bands, ¼″ apart, of each color to be tested. After these are completely dry, make *horizontal* bands of the same size and proportion, in the same order, across the vertical bands. Avoid going back into the bands; just use a fairly full brushload of paint and try to make each band in one rather slow stroke. After you're done and the colors are dry, you'll be able to see how each color looks, both *under* and *over* every other color! Now the transparency and opacity of each color in a wash-over-wash, or glaze, technique is apparent. This is useful information to have and understand when you're painting. Write the name of each color at the end of each band, so you'll have no trouble remembering later.

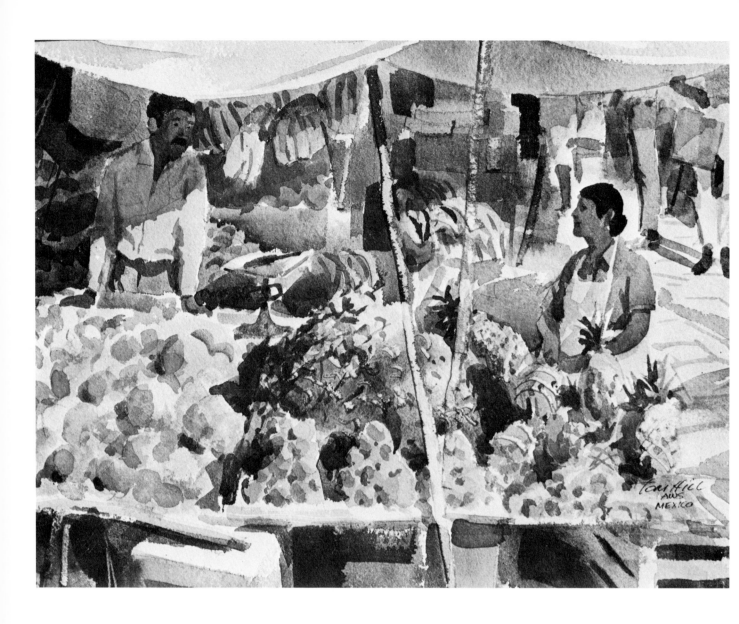

Afternoon Glow *(14″ × 22″). Collection of the artist. Another Mexican market, loaded with the fantastic details and glowing colors typical of them all, and lit by a warm, late-afternoon sun — this was my subject and the feeling I wanted to convey. I decided to show a lot of the detail on the produce, but to handle it as almost an abstract pattern, which wouldn't read too well all by itself, but would become apparent when backed up and explained by the two principal figures. These were a woman seated in the full light, and a man standing only partly in the sunlight, with the upper half of his body lit by intense reflections bouncing off the produce in front of him. I used a warm palette for this picture, dominated by yellows and oranges. Even the man's shirt is a light orange color, and the woman's dress and apron are a grayed red and light-value pink. Only the paving on the right and the areas in back of the man contain cool colors — manganese blue and a few grayed, warm greens.*

6
MIXING, GRAYING, AND INTENSIFYING COLORS

So far, all our experiments and tests have been with individual tube colors, alone or as a glaze. Let's explore further!

When we *mix* any two colors, we get a third, and depending on several factors, the results of that mix can vary greatly. Such factors include *which* two colors are mixed, in what *proportion* to each other, and in what *dilution* with water. If we were to try and mix every one of the 37 colors mentioned earlier, with every *other* color individually, we'd have an impossible 1,369 color mixes! We can find out a lot about mixes, without getting that involved!

Mixing Two Colors

To start, we'll confine our mixes to the three primaries, using a cool and a warm version of each — and see what will result in full-intensity washes of each possible combination. There will be 12 swatches in all, so make each one about 1″ square and leave white paper all around, with enough space below each swatch to write down the names of the colors you mixed together. Here's what the combinations will be:

1. Cool yellow with cool red.
2. Cool yellow with warm red.
3. Cool yellow with cool blue.
4. Cool yellow with warm blue.
5. Warm yellow with cool red.
6. Warm yellow with warm red.
7. Warm yellow with cool blue.
8. Warm yellow with warm blue.
9. Cool red with cool blue.
10. Cool red with warm blue.
11. Warm red with cool blue.
12. Warm red with warm blue.

Figure 41 on page 67 shows how my combinations turned out. I tried for equal intensity from each color, and then mixed a fairly rich wash of each pair of colors. You may want to use different colors than I did, but my choices for warm and cool were as follows: cool yellow — Winsor yellow, warm yellow — cadmium yellow medium, cool red — alizarin crimson, warm red — cadmium scarlet, cool blue — Thalo (or Winsor) blue, warm blue — ultramarine.

There isn't enough room on these pages to show all the color pairs that are possible even from just the 10 colors in the basic palette, but you should go ahead and try mixing the cool and warm primaries above with the green, orange, and earth colors — and any others that you feel you'd like to know more about. The same could be done with varying proportions of one color to another.

In this experiment, it's interesting to note that where the second color is so far around the color wheel as to be near the first color's *complement*, the mix will be grayed. For example, in the first swatch, where I mixed cool

yellow with cool red, the green tendency in the cool yellow grayed the red a bit, resulting in a less-intense orange than the mix in the sixth swatch, where a warm red and a warm yellow (closer together on the color wheel) yielded a nice bright orange. Notice which colors seem to dominate each mix, which swatch turns out brighter, or more intense, and which seems to be grayed. I think that now, having done these color experiments, we could decide a rough rule-of-thumb about our colors: the more a color stains the paper, the more likely it is to stain (dominate) the other color it's mixed with. Of course, neither color will dominate when both colors are of equal staining strength. Further, we might say that the more sedimentary a color is, the weaker its staining power, and the greater the likelihood it will be dominated by a staining color, in any "equal" mix. All of this with occasional exceptions!

Mixing More Than Two Colors

I feel that the fewer colors you mix to arrive at what you want, the cleaner, truer, and less muddy your results will be, with the best reflection of color from the pigment. Obviously, you can't mix every color, value, etc. that you need, from only *two* pigments every time. But if you think through what you want and how to arrive at it, you can *come close* almost every time! Just look again at the great variety of swatches achieved in Figure 41 — and here we were only using mixes that were at full intensity!

Of course there are times when you will have to add a third color to the mix to achieve your goal. As we discussed earlier, in Chapter 4, every pigment reflects its identifying color rays and absorbs all the rest. The more colors you put together, the more rays absorbed and fewer reflected, resulting in duller, less-clear color. We know that equal mixing of complements results in near-black and of course, mixing any triad (red, yellow, and blue, or orange, green, and violet) in equal parts would amount to the same thing. So, if you want to add a third color, consider what we've been discussing here — intensity, staining strength, and complements — and try to make your third color do the job, without turning the mix to mud! As an example of how this might happen, say you want a clear, slightly grayed, yellow-green, and you've made

a mix of Winsor or lemon (hansa) yellow with Thalo green. You have achieved a yellow-green, but it's *too* brilliant. Adding water would only make a lighter tint of the same yellow-green, so you decide to add a little of its complement, red-violet. Not having a red-violet tube color, you mix your red-violet from a red and a blue, probably using alizarin crimson and ultramarine. By this time, you've got *four* colors going, really lessening your chance for a clear, clean final result.

Suppose, instead, that you started with yellow ochre or raw sienna (similar yellows that are already somewhat grayed). Then, by adding Thalo green a little at a time (or viridian, which isn't so dominating), you could get your result with only two colors! I could go on with other examples, but there's no need to — you get the idea.

So you see, there are easy, logical ways to achieve clean, clear colors in watercolor painting, and it's not *that* difficult to start doing it now. In a short time, it'll become a matter of habit and then you'll wonder why you spent all that time poking around your palette — a dab here, a glob there, hoping to strike it lucky and maybe get the result you vaguely had in mind. I *know* — I've been over this road myself!

Color Mixing While Painting

Not all color mixing need be so prosaic and monotonous as making color charts, useful though they are. As a matter of fact, unlike the tests and charts we've just done, mixing color *while painting* can be downright exciting — especially as the color relationships and the forms grow and change right before your eyes!

In addition to glazing one color over an already dry one, and mixing colors together on the palette before applying them to the paper, you can also mix the colors *right on the paper*. You can put a color down on the paper, and while it's wet, charge other colors into it, modifying some or all of it. Referred to as *wet-in-wet* (discussed earlier, in Chapter 2), this method can add a special "life" or extra quality to a painting passage. One reason is that the colors aren't as thoroughly blended as on the palette and tend, instead, to mingle. This means that there's better reflection of light because each color still has a little of its original identify. Add

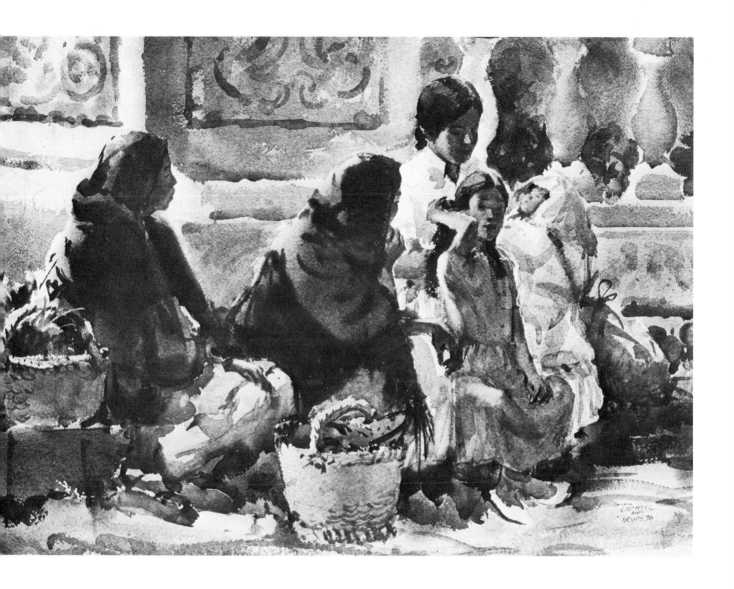

In Front of the Church *(22" × 30"). Private collection. It seems like there are always some people in and around the churches of Mexico. This painting depicts a family group — mother, baby, daughter, possibly grandmother and a friend. Just what they were waiting for, I don't know. But they made a marvelous compositional group sitting there. I painted from sketches made on the spot, refining the drawing and rearranging the compositional elements back at my studio. I painted some wet-in-wet light value washes in the background, and as these dried, I indicated some of the architectural elements with flat washes and shapes. The figures were then added, working from light to dark, painting around and saving my whites. A good knowledge of figure drawing is essential to make a painting subject like this convincing.*

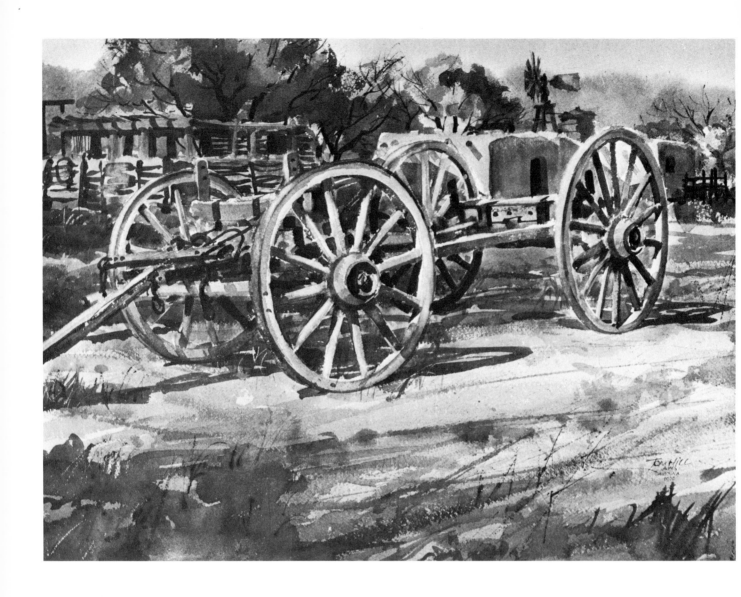

Old Wagon *(22″ × 30″). Collection Dr. and Mrs. Ross Chapin. This old ranch wagon has long been abandoned and forgotten, although the ranch in the background is still in use. Apparently the wagon was just left where it last rolled to! I was intrigued with the way the afternoon sun accented the spokes and rims of the wheels, at the same time offering a repeat pattern in the mesquite-wood corral in the background. Manganese blues and grayed violets, used wet-in-wet in the sky and mountains, were my only complements to the yellow ochres, grayed cadmium oranges, and burnt siennas that dominate the rest of the painting, emphasising the warm, dry glow of the desert.*

to this all the possibilities of sedimentary versus staining color, different values, warm and cool, and you've got a lot of potential color excitement!

Possible color combinations are literally endless, but here's one for you to try that I think is exciting and surprising! Reach for your manganese blue — this is a bright, permanent blue, available to artists only in the past few years. It's somewhat like the older cerulean blue, but less opaque, slightly more green, and brighter. It forms a wonderful, granular wash on rough watercolor paper, and can easily be removed without any stain. Also prepare a rich, full-intensity mix of scarlet lake.

□ Working wet-in-wet, charge a brushload or two of manganese blue into clean, moderately wet paper. Let some areas keep more pigment than others; this is one of those pigments that you can shove around on the paper, while things are still wet. Rinse out your brush. Immediately flow some irregular, scattered strokes of scarlet lake right into the manganese wash you just put down. Things will be pretty wild and exciting as the *staining* scarlet lake mingles with the *non-staining*, granular manganese blue. You'll be able to push the scarlet lake around *a little*, but not much and not for long, because it gets right down between the particles of manganese blue and bites into the paper's fibers fast! Results? A fascinating stain-grain, warm-cool, painted passage that you just couldn't get in any other medium that I know of! The "hot" red stain of the scarlet lake glows through and between the cool, intense granular "settlings" of the manganese blue.

You should try other variations on this idea of staining and sedimentary colors in wet-in-wet mixtures. Substitute raw umber for the manganese blue, and then charge it with a potent dash of permanent rose. Here again, the raw umber can be moved around before it dries — and the permanent rose literally *pushes* it aside, creating another stain-grain, warm-cool passage.

Another suggestion, before we move on to more color investigation. Two colors, both non-staining, and relatively transparent, that make great granular, warm-cool washes when mixed wet-in-wet on paper are ultramarine and burnt sienna. You can tip this combination toward warm or cool by increasing either color.

Graying Colors

Back in Chapter 4, we talked about graying a color by mixing it with its complement. Our tests with color mixes in this chapter reveal that tube colors are "characters" with distinct "personalities," and don't always behave according to color theory. It seems the best way to know what tube color most effectively grays another without changing its *hue*, is to learn by actually trying the various combinations.

Graying Reds (and Greens). Although we are going to talk about graying reds, the same thing, of course, will apply in reverse to graying red's complement, green. For the reds that are toward orange, like cadmium scarlet and cadmium red light, try graying them with either viridian, or (careful!) Thalo green a little toward blue! As a matter of fact, you can gray cadmium red light or cadmium scarlet fairly well with either manganese blue or cerulean blue, because they are blues that are somewhat green, and so will do the job.

For graying cadmium red medium or deep, you can still use the two greens, either viridian or Thalo. Just keep in mind Thalo green's super tinting strength and add only a little at a time.

These two greens also work pretty well graying alizarin crimson; as a matter of fact, intense mixes of alizarin crimson and Thalo green can produce a *very* rich dark the value of black, but not as "dead." If the alizarin, grayed only with Thalo green, looks a little too *cool*, then warm it up to the right hue with just a bit of lemon or Winsor yellow. Graying permanent rose (quinacridone) is tricky. I found fair success by mixing it with a green I made from ultramarine and lemon yellow. When permanent rose is mixed with viridian or Thalo green, it produces a strange, lovely violet, and the more Thalo green added, the more the mix turns toward a dark purple — very unexpected!

There are many more possibilities for graying the different reds. Try them with different complements and near-complements, and see what you discover.

Graying Yellows (and Violets). Yellow is one of the lightest colors in value, whereas violet, its complement, can be quite dark in value. When trying to gray a given yellow, it's a bit difficult to keep it from sliding toward the cool (green)

side or warm (orange) side, and sometimes it's difficult to positively be sure *what* you've done to the yellow!

For the cool yellows like Winsor or lemon, a mix of alizarin crimson and ultramarine that's a little toward the warm (violet) side, does pretty well. The same is true for the warmer yellows like cadmium pale and cadmium medium, except that you make the violet mix a little toward the cool (blue) side — not too much, however. A little practice (with a good light source, clean water, and paints) will help you learn how far to go in order to achieve what result.

Graying Blues (And Oranges)

To gray a warm blue, ultramarine, let's use its complement, orange. If we add a bit of cadmium orange to ultramarine, instead of behaving like it should in proper color theory, the cadmium orange seems to veer off toward yellow, so our ultramarine looks like a somewhat dirty, grayed *blue-green* (rather than simply a grayed ultramarine). (See the first swatch on the left in Figure 40.)

Now let's try a near complement — burnt sienna — which is really sort of a grayed, or neutralized, *red-orange*. It works beautifully with ultramarine, graying it without changing its hue. Most of the other blues can be successfully grayed with this versatile color, so you ought to try it with them. Burnt sienna neutralizes cobalt as well as it does ultramarine, however cobalt blue isn't as powerful and it's easy to overdo the burnt sienna and wind up with a grayed burnt sienna, instead of a grayed cobalt blue! Burnt sienna even does a fair job graying Thalo blue. Remember: rich, full-intensity mixes of ultramarine and burnt sienna can give you excellent darks, and in greater dilution with water, offer an extended range of either warm or cool granulated grays.

To familiarize yourself with the graying characteristics of any of these complements or near complements that we've been talking about, try the following experiment.

☐ Mix a little batch of each in separate areas of your palette. With clean brush and water, make a vertical band about 1″ wide and 2″ high of each color, allowing about an inch of white space between them. Then, while they're still wet, pull the two colors together, in the white center, blending them as they meet with your brush, and making a grayed neutral band in the center. I did several such swatches, which are shown in Figure 42 on page 66; you might want to try these and others, working back and forth with the colors that you use a lot — or those you want to find out more about.

Intensifying Colors

It's clear that complementary colors gray or neutralize each other when mixed togther; we've just proven that with our tests. Now, here's a paradox: the same complements that gray each other in mixtures can be placed side by side — or one surrounding the other — and *not* mixed, and they will *enhance* each other's hue! In other words, complements can *intensify* each other's intensity! Strange as it seems, a maximum-intensity color isn't as intense by itself on white paper, as when directly next to or surrounded by its complement. Going further, the same color directly against or surrounded by an *analogous* color (for example, yellow next to yellow-orange) appears *less* intense!

Value is another factor influencing the way a color or hue appears to us. Some colors in their brightest or most intense state are dark in value, and others light in value, while still others are somewhere in between. For example, yellow, at its brightest, is still a light value, whereas its complement, violet, is a dark-value color. These two, placed side-by-side, will contrast both by their color complement *and* their value.

Blue and orange are not as great in value-contrast as yellow and violet, while red and green, at full-intensity, are about the same value. These last two colors, in equal areas and intensities, and in juxtaposition, can cause some rather strange visual phenomena (a whole scientific study in itself). Where their edges meet, the colors seem to oscillate or vibrate in a rather disturbing manner. If the area of red is large and the area of green very small, then the green seems to get *very* active — visually appearing to almost jump right off the paper! However, if a little red is mixed with the green and a little green with the red, then both red and green calm down and seem compatible — even harmonious! Orange-to-blue and yellow-to-violet don't react with quite this much agitation, but certainly do enhance each other's intensity.

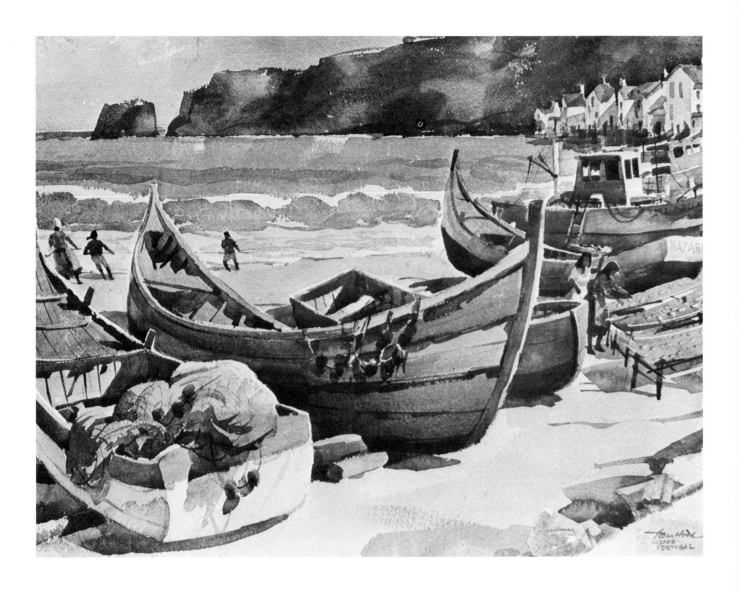

Nazare, Portugal *(22" × 30"). Collection of J. Gordon Carr. Here, hundreds of fishing boats line the beach, split fish dry on racks in the sun, and the white-washed, tile-topped town marches right down to the beach front. Nazare, one of Portugal's most colorful fishing villages, is also a mecca for European vacationers, seeking the sun and sea. My main concern in this painting was to utilize the shapes of the great fishing boats with their high-prows as the compositional theme, while at the same time arranging all elements to tell a bit about Nazare. After carefully drawing the boats on location, as well as the men, women, and houses, I carefully penciled the composition on my watercolor stretch and painted the sky as a flat wash, then the ocean, leaving out the curling white water of the breaker's cap and modifying the colors within while everything was still wet. I then painted the sand and the boats as a flat wash, working from light to dark. The headland in the background was next, and here I charged colors wet-in-wet and cut around the shapes of the village. I painted the village, boat details, and figures hauling in a net and spreading the fish to dry last.*

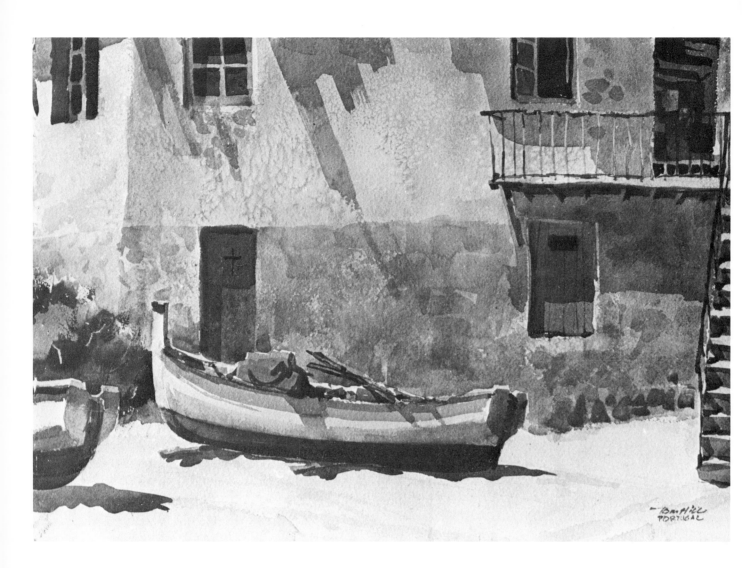

High Noon, Albufeira (14" × 22"). Collection of Amanda Kirby. This ancient stone and masonry building sits right down in the beach's sand — and must be above the high-tide mark. The fishing boats are drawn up onto this high point by oxen or tractors and sit here waiting their next call. This is southern Portugal's Algave section, a dry, sunny corner of Europe that faces the Atlantic. I wanted to show the antiquity of the building, the brilliance of the painted boats, and the feeling of the sun directly overhead. The boat was painted a brilliant lemon yellow, which seemed to point up the subtle grayed violets in the wall. First, I painted the wall a big, simple shape, sprinkled some salt into parts of it to achieve additional texture, and charged wet-in-wet colors into other parts of it. I used yellow ochre and raw umber, with some violets and reds. Next, I painted the lighter values on the boats and sand, the "washed-out" Thalo greens of the upstairs window frames, and the dull, grayed reds in the doors on the lower floor. Then, I painted the stairs, railing, shrubbery, and boat and window details. Last of all, I took a 1" brush and socked in the cast shadows, across the face of the building and under the boats. The entire painting was done on location and completed in about one hour.

Here are some experiments in intensifying and modifying colors that you can try.

☐ Mix a middle-value, neutral gray and paint two identical squares, 1″ × 1″ and about 4″ apart. Surround the first with a 1″ band of a *lighter* value of gray and the second with a *darker* value of gray. Paint right up to the dry squares, without leaving any white paper between the band and the square or overlapping the squares. After everything's dry, examine the results. Which of the identical squares now seems the lighter? (the second) Which seems the darker? (the first) Which seems to be a little larger in size? (the second)

☐ Now paint two identical, neutral-gray, middle-value squares, the same as you did before. Surround the first with a full-intensity yellow, the second with a full-intensity violet. Notice that the first square appears faintly *violet*-tinged, while the other square has a definitely yellow cast.

☐ Paint three, full-intensity 1″ squares of cobalt blue (a middle blue) about 4″ apart. Surround the first with ultramarine blue (a warm blue), the second with Thalo blue (a cool blue toward green) and the third with cadmium orange (blue's complement). Notice that the first square appears *cooler* than it did when it was alone on white paper, the second appears to be slightly *warmer*, and the last appears *bluer*.

☐ Paint two 1″ squares, of a slightly-grayed, middle-value green. Make them about 4″ apart. Surround the first square with an intense red of about the same value, and surround the second with an intense green also of about the same value. What happens? The first square now appears to be a brighter *green* since it's surrounded by its complement, and the second

square seems even more grayed, in contrast to the more intense green surrounding it. You'll find it hard to believe that the two green squares are actually identical!

Summing It All Up

I think we could safely make the following observations about intensifying, influencing, or modifying a given color or value. Complements intensify each other when painted side-by-side. Light-value colors show up best against dark-value colors and dark-value colors show up best against light-value colors. A grayed color seems even grayer when a more intense version of the same color is put next to it. Any color is influenced by the color next to it, each tinting the other with its own complement. For easy reference I've made a little chart for you.

If you want a color to look:	*Put next to it:*
More intense	Its complement
Less intense	A more-intense version of the same color, or a near-hue (its neighbor on the color wheel)
Darker	A lighter value
Lighter	A darker value
Cooler	A warmer color
Warmer	A cooler color

We could sum up the whole idea in Eliot O'Hara's words: "The law for keying a color or value is always the same—an area will vary in a direction opposite to its immediate surroundings."

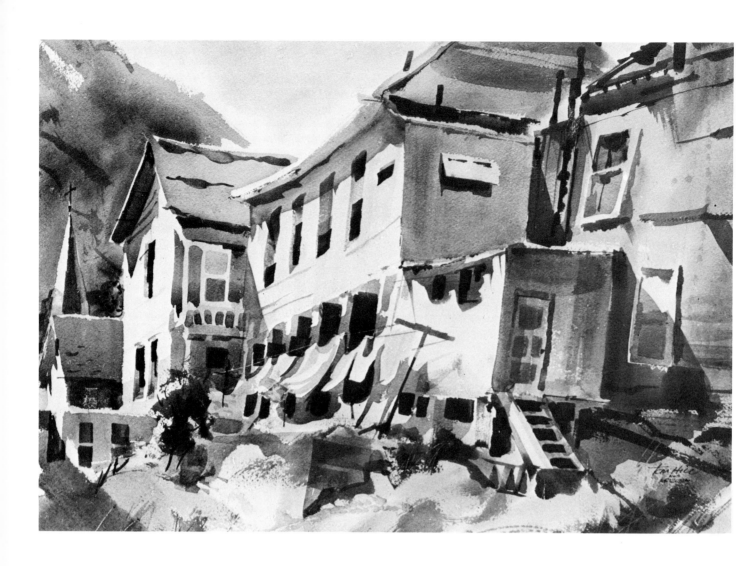

Bisbee *(22" × 30"). Private collection. At the turn of the century, the little mining town of Bisbee in southeastern Arizona was a wide-open, rip-snorting place. Dozens and dozens of saloons and bordellos crowded Brewery Gulch, and thousands of miners clamored to spend their money each payday. Today, Bisbee is a rather quiet, easygoing place, and the many buildings clinging to the steep hillsides, as well as the roads, paths, and stairways leading to them, make great painting material. This watercolor was completed on the scene, and was a class demonstration. Stressing the patchwork appearance of building tacked onto building, I tipped them a bit to increase the visual dynamics of the composition. I used complementary color combinations throughout — mainly grayed blues against small areas of intense oranges and grayed violets against greenish yellows.*

7
COLOR PALETTES

Let's talk a little about your palette — I don't mean the gadget that you squeeze color out onto — but rather the colors that you pick to do your watercolor painting with! Strange as it seems, I doubt you're likely to find two artists that will totally agree on *the* ideal color palette. In spite of all the color theory, charts, tests, and experiments that we've just been doing, that final choice of *which* colors to pick for the palette is still a very personal thing, and I guess it boils down to the experience and preferences of the individual.

Every time in the past that I (foolishly) said I didn't like a particular tube color, I usually lived to eat my words. Every color seems to have its place and use. Still, as I mentioned before, it's pretty darn confusing if you're just starting to paint, since there are over 80 tube colors to choose from. Even though we narrowed it to 37 colors and then down to 10 in the last chapter, these might not seem right to every painter, and the business of choosing is still a problem. May I make a suggestion? *Don't* decide! At least, don't try to settle it once and for all; keep an open mind about it, and be willing to "jilt" old favorites; try "flirting" with their competition. In other words, if you've been crazy about Payne's gray, and rely on it for all the effects it has been giving you, well, try a "separation" — put old Payne's on the shelf and step out with a mix of ultramarine and burnt sienna, or Thalo blue and burnt umber! You can always come back to your first love, Payne's, if you want, but think of what new and different experiences

you might miss if you don't play the field!

In Chapter 5 we talked about a basic palette consisting of about 10 colors, and I will elaborate on good all-round color palettes a little later in this chapter. First, let's consider the idea of painting with even *fewer* colors than the 10 outlined above. Can a successful painting be executed with fewer colors? The answer is definitely *yes!* Indeed, I think most artists are better off working with fewer colors. All the professional artists that I've known shun the use of a lot of colors on their palettes at any one time. Though they may vary the palette from painting to painting, they usually retain a somewhat limited palette is a good way for *beginning* painters to really learn about their colors and how to limited palette is a good way for *beginning* painters to really learn about their colors and how to get the most out of them. Even if you aren't a beginner, some of the palettes I'm going to talk about might interest you and be useful to you in your development as a *color* watercolorist!

I remember, as a kid, seeing the rotogravure section of the Sunday newspaper. It was printed in a sort of rich, dark brown color. It was amazing how much "color" seemed to be there, though there was really only the one ink used to print it. In contrast to the part of the paper that was printed in black ink, this section seemed more alive; the darks weren't as dead and the light values had a warm tint that seemed to be livelier than those printed in black. You've probably seen watercolors or sketches that were done in only one color, such as sepia or burnt

umber. These, too, can have a feeling of color to them. The paintings that are reproduced in this book in black and white, though far from equaling the ones printed in full color, *do* nevertheless, carry a lot of the feeling of the original painting. Why? The answer, it seems to me, is that the values, drawing, and composition go a long way toward carrying the picture. Of course, a nonobjective, or abstract, painting for which the color is one of the *main* reasons for its being, will naturally suffer in black and white reproduction.

Monochromatic Palette

Many painters work with a low-key palette, that is, they use their colors in a very grayed or neutralized way. Color, in the sense of brilliance or intensity, isn't a part of the painting. These paintings still can have a very rich and complete "feel" to them, and since they are so nearly monochromatic (carried by .value, drawing, and composition), they look very good when reproduced in only one color! You might like to try a painting using only one color and see how much vitality you can get into it. Use your white paper for your lights and your darkest value of one color for your dramatic dark punches. Side-by-side these two would then be the maximum contrast you could hope for; it's how you use this contrast, and all the other values in between the two extremes, that gives you a feeling of color. You'll do best if you use a dark, warm, already-grayed color such as burnt umber or sepia.

Analogous Color Palette

Now that you've tried a monochromatic color palette using burnt umber, you might try an "analogous" color combination — that is, related colors on either side of a given color on the color wheel. In Chapter 5, I identify burnt umber as a sort of very grayed red, a little toward orange. (Some artists think of burnt umber as a very grayed red, a little toward violet, so it depends on your eye, and which manufacturer's product you happen to be using, I guess!) For an analogous color palette, then, you'd combine reds and oranges with the burnt umber — and maybe some red-violet. That's about all you could include and still have

a strictly analogous combination. There are certainly more color possibilities to work with here than with monochromatic painting, but it's still not too exciting. However, with this arrangement, you could easily have a cool or a warm palette, and there are times when such a palette is useful. If you were to use an analogous color palette, letting one of the colors dominate the others and keying the whole painting to the dominant color, this would be called an *analogous scheme with dominant hue.*

Analogous Color with Complement

Using the analogous palette described above, but adding even a tiny bit of the dominant color's complement — or near complement — puts the whole color scheme into a much more exciting position, as far as I'm concerned. That little piece of complementary color can "sing out" and make the rather dull, analogous scheme really come to life!

Complementary Color Palette

It's possible to get an amazing value range and a fairly good feeling of color by using only two complementary (or near-complementary) colors. Not *every* complementary pair will work well, especially if both the warm and the cool colors are too intense, but combinations like ultramarine blue with burnt sienna, and cobalt blue with burnt umber do very well.

☐ I've sketched a little picture problem in Figure 43, and then noted how a pair of complements might be used to paint it. You could try this exercise, either using the two colors that I've suggested, or some other pair. See how much you can simplify your painting procedures; of course, with only the *two* colors to use, choices *will* be limited! You can only use values ranging from the deepest intensity to the lightest tint of each color, and of mixtures obtained with both colors. It's a good way to learn to make limited color do its utmost for you!

Three-Color Palette

Back in Chapter 4, we agreed that to paint in full color, an artist must have at least red, yellow, and blue — the primaries. In our 10-color palette, we used a warm and cool ver-

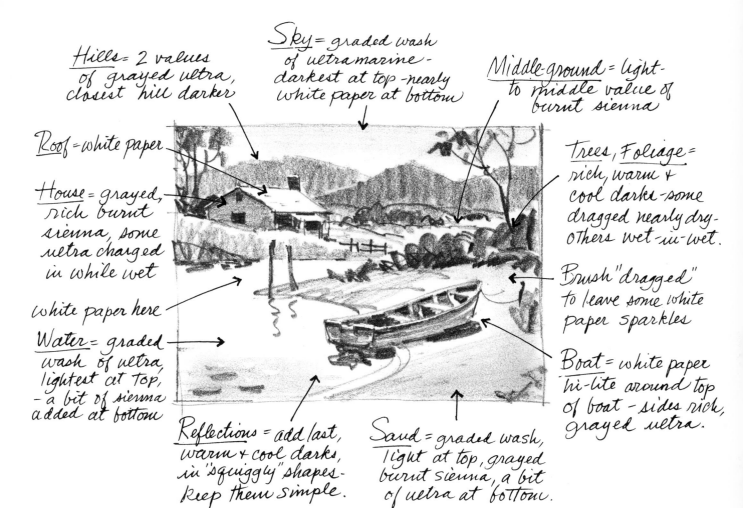

Hills = 2 values of grayed ultra, closest hill darker

Sky = graded wash of ultramarine - darkest at top - nearly white paper at bottom

Middle-ground = light- to middle value of burnt sienna

Roof = white paper

House = grayed, rich burnt sienna, some ultra charged in while wet

white paper here

Water = graded wash of ultra, lightest at Top, - a bit of sienna added at bottom

Reflections = add last, warm & cool darks, in "squiggly" shapes - keep them simple.

Sand = graded wash, light at top, grayed burnt sienna, a bit of ultra at bottom.

Trees, Foliage = rich, warm & cool darks - some dragged nearly dry - others wet-in-wet.

Brush "dragged" to leave some white paper sparkles

Boat = white paper hi-lite around top of boat - sides rich, grayed ultra.

Figure 43. *This little value study could be used by you to try painting a two-color-palette picture. Use ultramarine blue and burnt sienna for your two colors, and remember to save your white paper areas and to strive for maximum clarity and value correctness in each step of the painting. I've jotted down notes around the sketch for you to follow.*

If I were painting this picture, I'd probably work in the following sequence: First, I'd paint the sky and the water areas, using graded washes and adding bits of opposite color where needed. Next I'd do the sand area, leaving some white paper "sparkles" at the upper part. When the sky was dry, I'd paint the hills, cooler and lighter in the distance, slightly warmer and darker in the middleground. After these had dried, I'd do the foliage, keeping it simple — mainly painting its overall shape. Some of it could be handled as wet-in-wet, while other areas could be drybrushed, with a "dragged" edge, to give a ragged feeling to the leaves where they silhouette. I would handle the middleground area very simply, with no detail — burnt sienna washes, light to middle values, with some lightly-grayed ultramarine passages indicating distant foliage and the roll of the land. After all this was dry, I'd paint the house, boat, and reflections in the water, striving for simple shapes. Then, I'd add any final detail — only enough to make it work, with rich darks, both warm and cool.

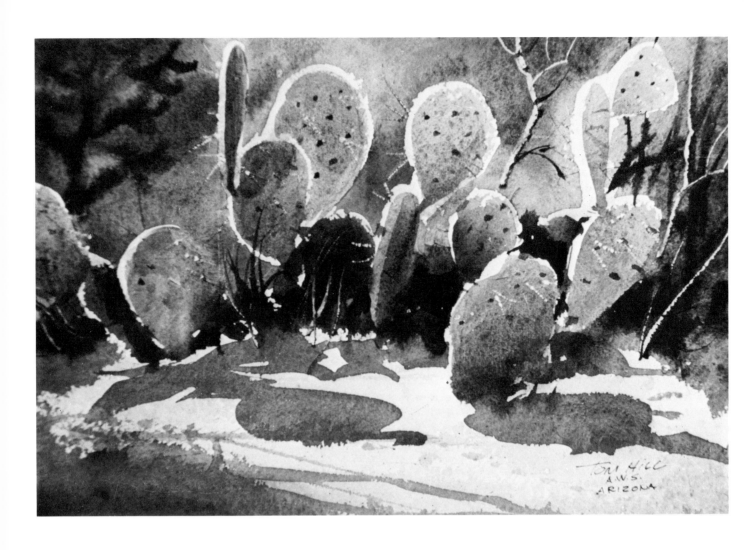

Prickly Pear and Cholla *(11" × 14"). Collection Mrs. R. Schilling. This little watercolor was fun to do — I tried to capture the essence of these common desert plants, back-lit by the sun. Dried weeds and shrubs will often obscure the prickly pear, but here I focused on the latter, leaving the former in back to set them off. The entire background was painted first, carefully working around the pear cactus "pads," which were very lightly penciled in to guide me. (You could mask them out with liquid frisket, but I elected to paint around them, leaving a more casual edge.) This predominantly warm background has several colors in it, which were mixed on the paper after it was wet with clear water. The cholla cactus on the left was painted in while the background was still damp, and thus looks diffused and out-of-focus. I also scraped out highlights on shrubs and a few of the pear cactus needles, where they caught the sun. After all was dry, the pear cactus pads were painted in a light-value, cool, grayed green, allowing some warmer darks to be charged on the bottom ones. Finally, I painted the cast shadows, using a grayed violet over the light-value, grayed pink soil.*

sion of each primary, to help overcome the fact that there aren't any *perfect* tube colors for the primary positions. Is it possible to paint a full-color painting using only the *three* primaries? Yes, especially if you don't mind giving up a little intensity in your secondary mixtures, such as orange, green, and violet.

Actually, you can take any three colors that are one-third of the wheel apart from each other, and paint at least an illusion of full color. Here are several *triad palettes* for you to try:

☐ A very low-key palette could consist of burnt sienna for the red, yellow ochre for the yellow, and Payne's gray for the blue. (Some people even use black in place of the Payne's gray.) This triad will yield interesting secondaries; the yellow ochre and burnt sienna mix to make a nice neutralized orange, and the Payne's gray and yellow ochre give a low-key olive green. The result of mixing burnt sienna and Payne's gray just isn't a violet, no matter how you try, but the Payne's gray, in dilution by itself, gives a fair imitation of a neutralized blue. Certainly you can't get real full color with this palette, but its range and scope of color can be surprisingly effective, and working with it will sharpen all your skills in managing what color you *do* have!

☐ A more intense triad palette consists of alizarin crimson for the red, cadmium yellow pale or medium for the yellow, and ultramarine for the blue. This triad gets a lot closer to the intensities that are possible with a full palette — but still keeps color-mix choices very simple for you.

☐ Another triad palette for you to experiment with, which is possibly as close as you can come to having tube colors fit the "perfect" primary positions on the color wheel, would be: scarlet lake or Winsor red for the red, cobalt blue for the blue, and cadmium lemon for the yellow. The mixtures for orange and violet are fairly intense, and the green, though never equaling the brilliance possible with the use of the Thalos, is still a good, serviceable green. Use this triad when you want to keep your palette simple and still go full color.

Complete Palette

For a *full* and *complete* color palette, I would still start with the same basic 10-color palette I dis-

cussed in Chapter 5. This included a warm and cool of each primary, plus an orange, a green, and two or three earth colors. In addition to the two reds (cadmium scarlet and alizarin crimson), you might want to add scarlet lake or Winsor or Thalo red. This will give you another red between the first two. In the yellows, you might want to add another cadmium, say a cadmium yellow deep, for mixing a greater range of yellow-oranges. Possibly you'd enjoy adding raw sienna to your yellows — or using it *instead* of yellow ochre, to which it's very similar. These are personal preferences that develop with painting experience. Perhaps you feel the need of a warm tube green, and so you add Hooker's — or maybe you go the other way, eliminating *all* tube greens, and mixing your own. Fine. Adding manganese or cerulean blue will give you more options (especially in the area of color granulations), than you'd have with *only* ultramarine and Thalo blue. I like to use cobalt violet on occasion. It's expensive, weak in tinting strength, and poisonous (I'm sure you won't be eating it — just keep it out of baby's grasp), but it makes beautiful, granulated washes, which for certain uses, are perfect!

There are many colors that I haven't mentioned, but as we agreed earlier, there's lots of duplication and the list could be very long. If you like a particular color that I haven't talked about here and if the manufacturer says it's permanent, go right ahead, and use it — all the tests that we did earlier can be used on your color to gain an understanding of its characteristics. In general, as you paint, be willing to try out different colors than the ones you're used to, but try to keep your full-color palette to no more than 16 or 18 colors. I predict that the more you paint, the more you'll find that the 10 colors I mentioned earlier will see you through most color problems, and with an occasional addition or substitution, you'll be able to satisfy all your color needs.

Color Schemes

Like me, you've probably heard about color schemes all your life — this or that formula is supposed to make your color selection fool-proof, and help everything sort of fall into place. I realize that there are published theories about color schemes, even color gadgets and

Palette	Colors
One-Color (Monochromatic)	Burnt umber
	Sepia
	Warm sepia
Two-Color Complementary (or Near-Complement)	Ultramarine/burnt sienna
	Ultramarine/burnt umber
	Cobalt blue/burnt sienna
	Cobalt blue/burnt umber
	Payne's gray/burnt sienna
Analogous	Choose one color, then use related colors from either side of it on the color wheel.
Three-Color (Low Key)	Yellow ochre/burnt sienna/Payne's gray
	Raw sienna/light red/ultramarine
Three-Color (High Key)	Alizarin crimson/cadmium yellow pale/ultramarine
	Scarlet lake or Winsor red/cobalt blue/cadmium lemon yellow

Figure 44. These two charts (above and right) list some color palette suggestions.

Full-Color Palette

Cool yellow	Winsor Cadmium lemon Hansa
Warm yellow	Cadmium medium
Orange	Cadmium orange
Cool red	Alizarin crimson
Warm red	Cadmium scarlet Cadmium red light
Cool blue	Thalo blue
Warm blue	Ultramarine French ultramarine
Green	Thalo Viridian
Earth color	Yellow ochre Burnt sienna Burnt umber Raw umber
Alternates	Scarlet lake Winsor red Cobalt violet Manganese blue Cerulean blue Raw sienna Terre verte Permanent rose New gamboge

charts that are supposed to help. I guess every paint store in the country that sells interior house paint has a book or chart of color schemes, designed to make the homemaker feel secure that every color will "go together." Usually these color schemes are analogous combinations, sometimes with an accent (complementary) color added. I don't think any such schemes or rules work very well for us painters. Color and color relationships are very personal things involving the artist's eye, taste, sensitivity, experience — and yes, even intuition! Refer to the charts opposite (Figure 44) for some color palette suggestions.

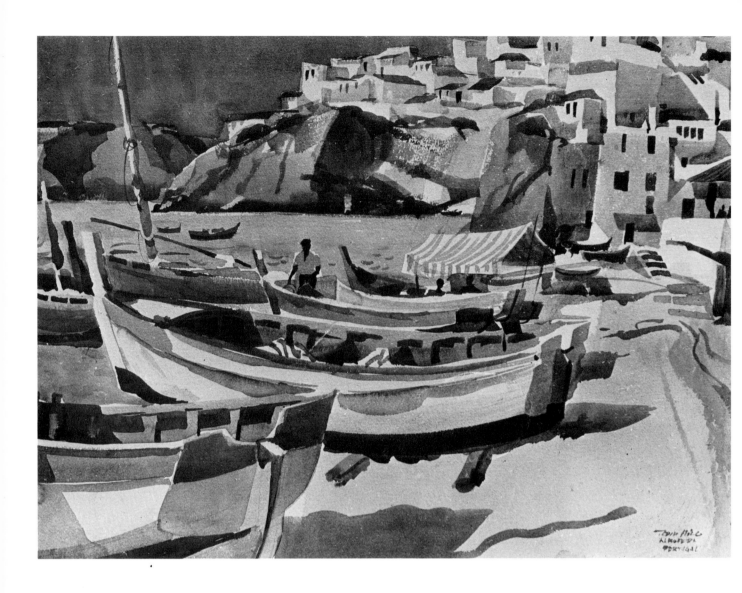

Fishing Village, Portugal *(22" × 30"). Collection of the artist. I painted this full-sheet entirely on the spot, fighting problems with a brilliant sun and a bit of wind. Since there was no shade where I wanted to paint, and the sun was still fairly low (it was about 9 o'clock in the morning), I set my easel almost vertically facing the sun so that it made its own shade. I cut down on the wind problem by sitting behind a fishing boat, and proceeded to paint, looking over my shoulder at the scene. The sky was very blue and the houses on the hill very white. The fishing boats were a number of bright colors, and the sand almost as light a value as the houses. The cast shadows of the boats on the sand picked up a lot of blue, reflected from the sky. Needless to say, it was a colorful, sunny, high-key subject, and that's the quality I was after in the painting.*

8 LIGHT AND SHADOW

If you think about it a moment, it seems that sight is our most-used sense — and though we rely a lot on the other senses (hearing, smell, taste, and touch), seeing is the principal way most of us perceive the world around us.

This business of judging everything by the sense of sight is more ingrained than casual observation reveals. We even use visual terms when referring to the other senses:

"*See* if you can hear the baby crying."

"Taste this soup to *see* if it needs salt."

"He felt his watercolor paper to *see* if it was dry."

Because light makes sight possible, and because we see the world in terms of light, shadow, and color, it's important to have a working knowledge of exactly what light does and how it affects our sight.

Definition through Light

We discussed and explored the color aspects of light in Chapter 4, but we haven't talked about light in terms of how it falls across objects or scenes, creating lights and shadows that define form and shape. We learn a great deal about whatever we are looking at from the lights and shadows falling across it, and especially from the *angle* of the light, or the *light source*.

I can think of several examples to illustrate how the light source affects our understanding:

When I was about 11 or 12, I attended summer camp. Every camper had a flashlight, which was, of course, great fun to experiment with after "lights-out." One night, a buddy whose face I thought I knew well, held his flashlight directly under his chin, pointing up. In the otherwise totally dark cabin, the reverse lighting created (much to my delight) a weird "creature" quite unrecognizable to me!

The Catalina mountains, north of Tucson, run in a generally east-to-west pattern. At high noon, with the sun shining directly on them from the south, the mountains appear as flat and formless as cardboard cutouts. But in the early morning or late afternoon, the changing light source creates dramatic differences! Deep canyons appear and soaring vertical cliffs materialize where at noon there seemed total flatness!

Let's say you're starting to look for your car in a crowded parking lot, and you are facing into the sun. Even though you know your car well, you might have trouble recognizing it, because back lighting reduces everything to a silhouette, with nearly all detail and much color lost. (The fact that there are hundreds of similar car silhouettes doesn't help either!)

The Action of Light

The examples above show how important the *direction* of the light source is to our understanding of what we're looking at. Now let's examine the *effects* of light falling across an object. We'll use the sun as our light source, and a white box on a white table as our object.

Since the sun is so much larger than the earth, the sun's rays can be considered parallel to each other. I think the easiest way to visualize the light rays of the sun is to think of them as streams of tiny rubber balls, unaffected by gravity, hurtling continuously in straight lines from the sun, and bouncing off whatever object they hit. The angle at which they hit determines the angle at which they bounce, and these angles are always equal. When the rays hit a flat surface at a right angle, they bounce directly back toward the light source, resulting in maximum light reflection. When they hit a flat surface at an oblique angle, they bounce off at an equally oblique angle in the opposite direction, resulting in *less* light reflection. The more oblique the angle, the less light is reflected from the surface. See Figure 45.

When light rays are interrupted by an object, such as our box, the object gains light and shadow sides and casts a shadow of itself. The side of the box that most directly faces the light source will be the lightest value, and the other sides, which are more obliquely hit by the light, will be lower in value. The side where the light rays are completely blocked will be the shadow side, and these edges will determine where the *cast* shadow will fall. See Figure 46.

Of course there will be other light rays bouncing about, off the table top and elsewhere, and some of this *reflected* light is going to bounce back into the shadow side of the box. Less light will be able to bounce into the cast shadow on the table, so this shadow will appear darker in value, especially right where it meets the box.

Light rays will reflect off the flat top of the cylinder shown in Figure 47 in the same way as off the flat top of the box. However, since the cylinder's sides curve, there is a continual increase in the angle at which the light rays hit, until at a certain point, the rays go on past and strike the table top, defining the cast shadow's edge. This part of the shadow on the cylinder I call the shadow "core." The same thing takes place on any rounded surface, with light rays reflecting at ever-changing angles from all around the surface (Figure 48).

It's easy to see light's action in the simple, white setup that we've just used above — it will be a little harder to see when the shapes are more complicated, and with color and texture added (Figure 49). Obviously, colored objects or surfaces are going to reflect their color; when they do this into *other* colors, it can be very bewildering. The diffused lighting of a cloudy day makes light reflection much more subtle and difficult to pin down. A multiple light source situation, such as occurs indoors at night or with artificial lighting, is even more complicated. I think the key is to try for a simple approach, that is, try to understand what light really does, then incorporate in our painting the light that fits our picture's needs!

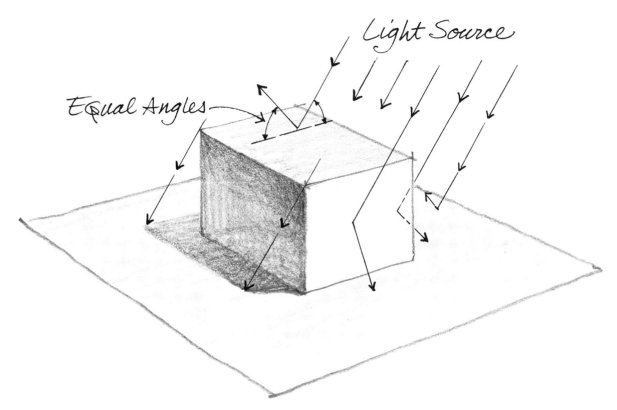

Figure 45. *Here we have a white box sitting on a white table top. (The reason for using white is that is demonstrates the laws of light most clearly.) The sun's rays fall across the box and are reflected. The angle at which they bounce off the box equals the angle at which they hit it.*

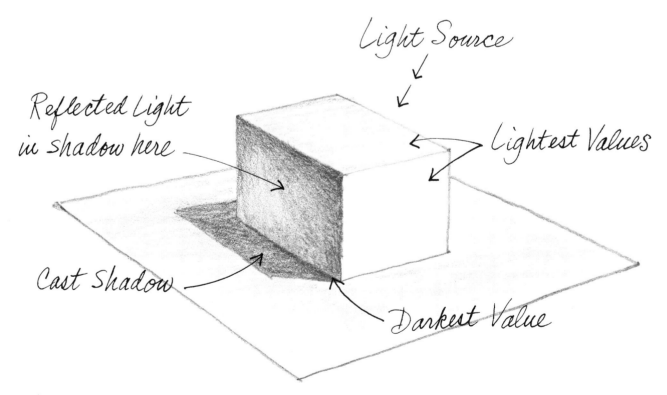

Figure 46. *The more directly the rays hit the box and are reflected back on themselves, the greater the amount of light reflected, and the lighter (or higher) the value shown. Notice that the table also reflects some light into the shadow side of the box.*

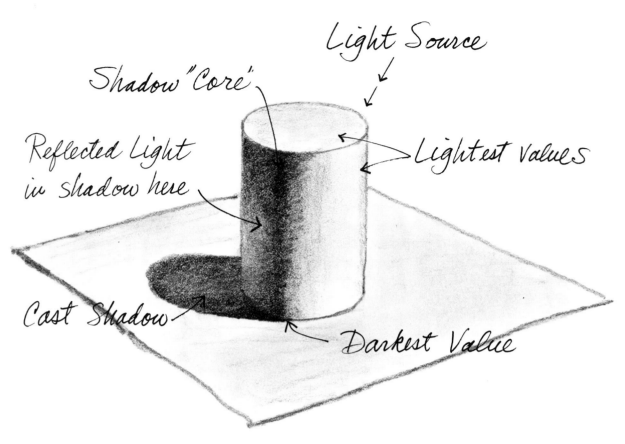

Light Source

Shadow "Core"

Lightest Values

Reflected Light
in shadow here

Cast Shadow

Darkest Value

Figure 47. *A curved surface, such as the side of this cylinder, reflects light at a continually changing angle, resulting in a gradual darkening around the side of the cylinder.*

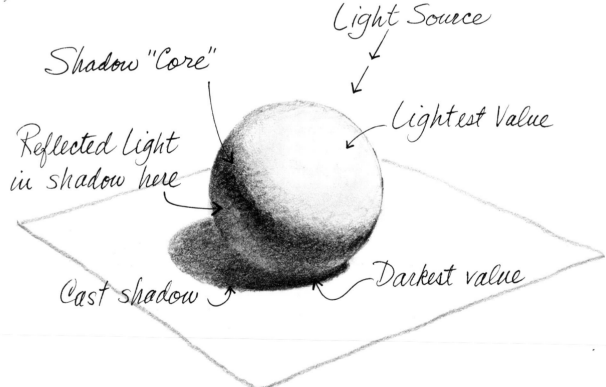

Light Source

Shadow "Core"

Lightest Value

Reflected Light
in shadow here

Cast shadow

Darkest value

Figure 48. *The same thing happens with a sphere — the changing angles of reflected light give its surface an overall gradation of lightest to darkest values.*

Blue sky reflecting cool light on top shadows of tree

Green color from tree bouncing into the shadows on this wall

LIGHT SOURCE ↓

Blue color from sky cooling the color of these tile roofs

Maximum Reflections from this roof

Shadow warmed by bounce of light from tile roof below

Shadow warmed by reflections from street

Shadow warmed by reflected pink from wall across street, and yellow in street

Shadow cast by figure is crisp + dark

Light bouncing and re-bouncing off many surfaces

Some blue color from sky reflecting in these shadows

Glass reflects light and color from areas across street

Figure 49. *The purpose of this little imaginary scene is to study what light does, and then be able to look for similar light effects when out painting on location, or to use the information in the studio, when working only from memory or from sketches.*

Let's decide that the house on the left has light-value pink walls, and the house facing it has white walls. The house in the background has light-value blue walls, and all the tile roofs are the same grayed red-orange (just about a burnt sienna). The sky (out of the picture) is cloudless and blue (perhaps cobalt blue), the sidewalks are a grayed white, the street a grayed yellow (yellow ochre), and the tree a middle-green.

Light bounces repeatedly, especially where the light source is so high-key, so brilliant, and the surfaces, like the walls of the light-colored houses, do such a good job helping it bounce! Because of this, and the many angles present, there will be a lot of interplay of reflected color. A wall in shadow, for example the one on the right-hand house, can have a variety of colors reflected into it.

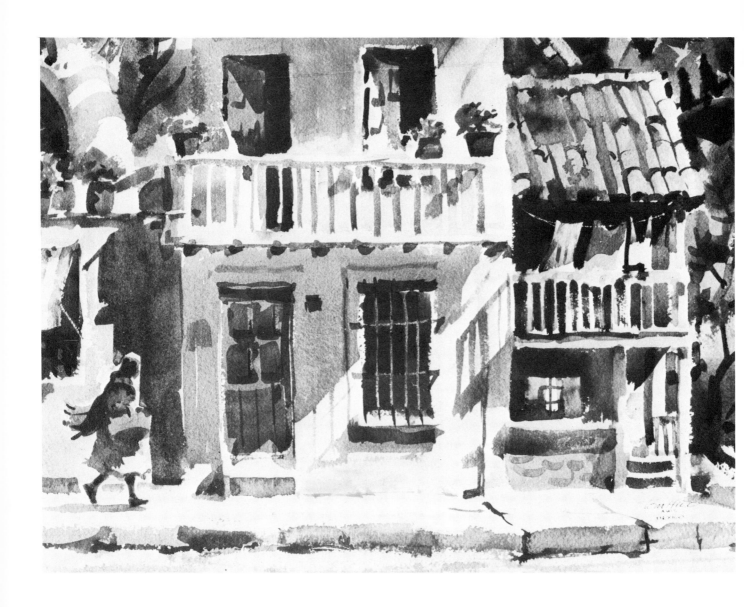

Manzanillo Afternoon *(22" × 30"). Collection of the artist. This watercolor was one of those class demonstrations that succeeded — not all do. I worked from sketches and a vivid memory of a sunny afternoon in this coastal town in tropical Mexico, striving to capture the feeling of brilliant sunshine falling across rather busy architectural shapes. I tried to keep the busyness and still have the painting organized. Lots of complementary colors are used in this painting — the upper half of the main building is pink and the bottom green (which sounds garish, but is typical of Mexico). By adding a bit of one color to the other, they calm down and work together. Blue-greens and violets in the jungle behind are complemented by oranges and yellows elsewhere in the buildings.*

9 AN OVERALL VIEW

Quite often, people make a distinction between paintings, putting them in categories based on the painting's subject matter — landscape, seascape, cityscape, figure and portraiture, abstract, nonobjective (the last two might not really have a *subject*, but are still put into a category). Although I understand this approach, I usually don't think in terms of differences, but rather, in terms of the *similarities* in paintings. In fact, the way you conceive, plan, and create a painting isn't all that different from the way a good piece of graphic or commercial art, a mural or poster, a piece of sculpture, or a building is created. The individuality of a painting comes not from rules, techniques, or style, or from this or that school of painting, but rather from the artist's attitude, experience, and his view of life.

Following this chapter are six demonstrations in color showing you some of the ways I go about painting landscapes, seascapes, figures, portraits, and still lifes. First, however, I would like to discuss some basic guidelines that apply to all paintings, regardless of subject matter.

Basic Painting Guidelines

This following checklist might help you simplify and organize your approach to any painting. Ask yourself:

1. Why do I want to paint this painting? What's my reason?

2. What is the absolute *essence* of what I want to convey?

3. Do I understand my subject (or this essence) well enough to be able to interpret it? Or, should I study it more, before I start to paint?

4. What are the *minimal* elements I can incorporate in my painting and still have it convey my meaning?

5. How can I rearrange necessary elements to further improve the painting — to make it say what I want it to say even better?

6. With a plan in mind for drawing, value, and composition, how can I use *color* to make my painting work best for me?

Landscapes and Seascapes

As I mentioned earlier, I don't tend to make sharp distinctions between pictures based on their subject matter. So, since landscape painting and seascape painting share many common problems, let's talk about them together. Consider these points when painting either:

1. Think about what proportions to make your painting. The vast majority of both categories are done as horizontal pictures, but I see no reason why vertical shapes couldn't be used successfully.

2. Use atmospheric perspective to show distance. In looking out across a landscape or seascape, we are actually looking through a vast amount of air, which usually has a lot of material floating in it, such as moisture and dust.

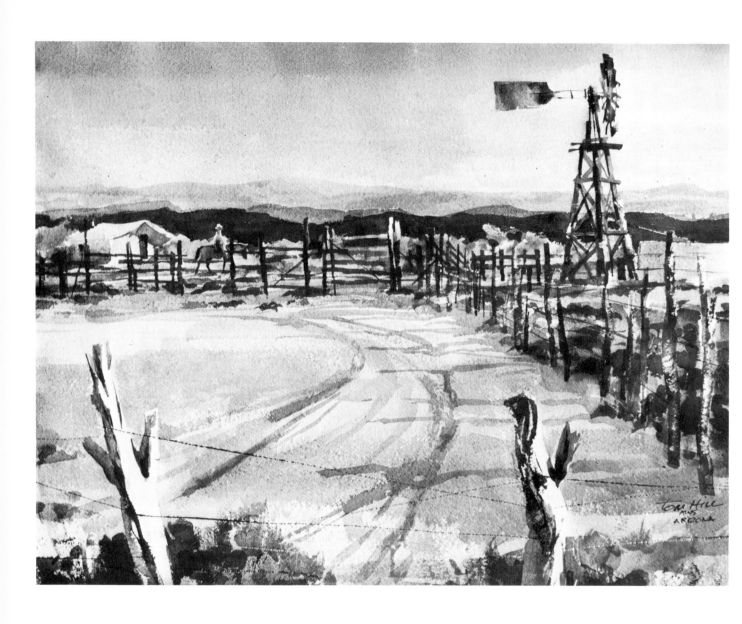

The Corral *(22" × 30"). Private collection. Corrals are intriguing, and this one, constructed mostly of mesquite posts, is no exception. Used mainly to house cattle prior to their being shipped to market by truck, the corral stands vacant at other times. In the distant background are the foothills of Arizona's White Mountains, which are maybe 50 miles to the south. A lone cowboy rides by "just checkin' things." The afternoon sun highlights the windmill and fenceposts, casting long shadows across the rather pinkish, sandy soil. My palette was rather limited — yellow ochre, burnt sienna, alizarin crimson, ultramarine and cobalt blue, with bits of raw umber and cadmium orange. I painted from light to dark and saved the whites of the shack, the cowboy, and the principal fenceposts. Some scraping-out of light values for the other posts was done just after the washes behind them were slightly dry.*

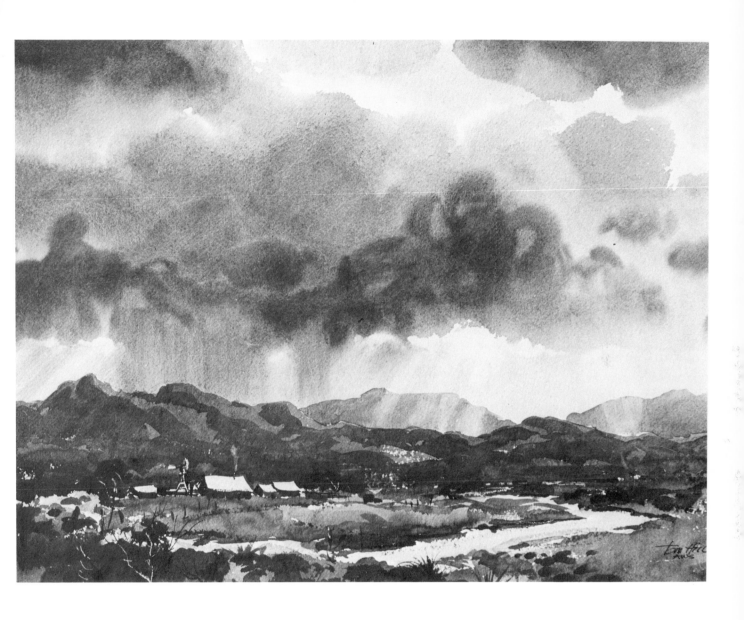

Water in the River *(22" × 30"). Private collection. Summer is the time for rain in the desert southwest, and this storm gave me a chance to paint the evening sky reflecting light in the ordinarily-dry river bed. Rain is falling over the mountains, an effect I accomplished by "pulling down" some of the wet-in-wet wash that was used in the sky, at just the right time, with the 1" brush. The light from the sky was also reflecting off the galvanized iron roof of the ranch buildings; I just painted around these shapes, leaving the white paper to show the reflection. I did the same for the water in the river. The sunburst was accomplished by taking the paint out, at just the right moment of wetness, from the wet sky, and later the wet mountains, with a clean, squeezed-out 1" brush.*

Rio Hondo Mountains *(11" × 14"). Collection Paul Danielson. The first time I saw this area of southern New Mexico, it was in the afternoon, and these rounded hills were a beautiful golden yellow, with long cast shadows of grayed violet. Some of the shadow seemed to be picking up the "sky light," and was turned bluish by it. A cobalt blue sky and burnt sienna foreground dictated my colors clearly, so that all I had to do was paint them in! The ranch building was actually about a mile away, but I put it here; it gives my picture both scale and life!*

Even on a day when the sky may be exceptionally clear — as it often is in parts of the west — there's still a lot of particles in the air. This, plus the sky's bluish color, combine to veil the distance, making things that are farther away look lighter in value and cooler in color. In nature, as well as on our palette, light-value, cool colors tend to recede, while dark-value, warm ones tend to advance. This effect is called "atmospheric perspective," and you should employ it wherever it will help your painting.

3. Use color to help create "mood." This is one of the main ingredients in any landscape or seascape, and color can help you establish it. In my demonstration painting *Yalapa*, I used a lot of yellows, complemented by violets, to help me say "sunshine." I also used dark-value colors in the background, which by contrast, made the yellows even stronger. However, a rural New England landscape on a late winter's afternoon, with a weak sun trying to break through a frosty, overcast sky, certainly wouldn't call for the colors used in *Yalapa*! No, *here* the colors would have to be low in key — cool and reserved. I think of blues, grayed and icy, with somber burnt umbers and very grayed violets. Maybe the only complement would be a bright red jacket on a figure, or a fragment of yellow or orange on a distant dwelling.

4. Plan your landscape or seascape before you paint. Reread the material in Chapter 3 and apply it to your landscape or seascape—and, of course, it applies to any painting.

Still Life and Floral Painting

I think floral and still life painting are all too often overlooked as nearly ideal subjects for the beginning painter — and maybe the more-advanced painter, too! First of all, the subject isn't going to move! And, since your subject's usually indoors, you can have some control over the kind and quality of light falling on it. Further, you can select and arrange the elements in it to suit your liking — something impossible in a landscape or seascape! And if you're suddenly called away from your painting for some reason, it'll still be there waiting for you tomorrow! All the problems of drawing, texture, light and shade, composition and color stay right there, to be worked with and learned

from in a leisurely fashion. Still lifes can have a mood, too — especially if the elements used in the grouping evoke some emotion or reaction in you, and you are able to distill that feeling into your picture.

So, floral and still life painting both have a lot to offer. Here are a couple of points to consider when planning and executing one of these paintings:

1. Again, refer to or reread Chapter 3. Drawing and understanding your subject, seeing shapes and values, solving compositional problems with preliminary thumbnails, etc., all apply to still life or floral painting.

2. Keep the arrangement simple. Don't have too many items, and vary them; for example, juxtapose large and simple shapes against small and complicated ones, light against dark, soft against hard, etc. In the floral demonstration, *Chrysanthemums,* notice that I kept the treatment of the walls, vase, and table simple, in order to set off the complex shape and texture of the blossoms. I also allowed various items to run off the edges of *every* side, using these edges as part of my design.

3. Try using your center of interest as a color key. Let's imagine that as you're collecting some items for a still life painting, a couple of nice, shiny, red apples strike your esthetic fancy and you want to key your color to them. A large, old galvanized pail in your collection makes an ideal foil for the apples: its light value contrasts with their dark value. It has straight sides, they're round; it's dull and matte-textured, they're bright and shiny. You can probably even find the color complement to the red apples, such as some light-value, grayed greens in that old pail's sides!

Figure Painting and Portraits

Lots of skilled watercolorists I know avoid using the human figure in any major way in their paintings, preferring to paint little indicated figures, usually in the distance, to give scale and "life" to their work. This is fine — especially if the little figures are handled in the same way as the rest of the painting. Often, however, they are not, since the artist is a little unsure of his or her ability to paint the figure convincingly. In such cases, the figures often wind up looking

Paper Flower Vendors *(22″ × 30″). Collection of the artist. Brilliantly colored paper flowers, some as big as dinner plates, are sold in Mexico, and this couple in Taxco had a whole stall full of them when I was last there. Using dyes, they are able to produce colors that really knock your eye out — and make marvelous painting material, especially against the warm, dark skin tones of the people. Since this was a very busy scene, I left the shirts on the man and woman as simple areas for relief from all the flower detail.*

To start the painting, I wet large areas of the paper where the flowers were to be, and then, working wet-in-wet, socked in many of the blossoms while the paper was still wet. I added a darker value background just a little later. Because the flowers' colors are so intense, I kept the background dark in value and warm and neutral in color.

Taxco Couple *(22" × 30"). Collection of the artist. This painting, done entirely from sketches and memory, was a demonstration painting that I did before the American Watercolor Society a couple of years ago. In it, I tried to show watercolor treatment of large figures in a large picture — how they could be handled in a simple way and still be effective. Starting with wet-in-wet, I used a 1-1/2" muslin brush to charge in the lighter values of the background and foreground, and some of the color under the flower's blossoms. After this had dried, I painted light-value warms and cools on the clothing of the figures, and when these were dry, the shadows on the clothing. Next came the "bolsas" (shopping bags) on the left, done in scarlet lake and cadmium orange. I painted their local color first, then the shadow. While all this was drying, I added the box in back of the man's shoulder, and indicated a weighing scale to the left of the woman's head. Here, you can see that the paper was still a little damp, and parts of the scale bled, adding a happy, out-of-focus accident. The skin color — mainly burnt sienna — was used to block in simple face and arm shapes. When they were dry, a darker value of the same color was used for further delineation. Hat, "rebosa" (scarf), sandals and flower details were added to finish the painting.*

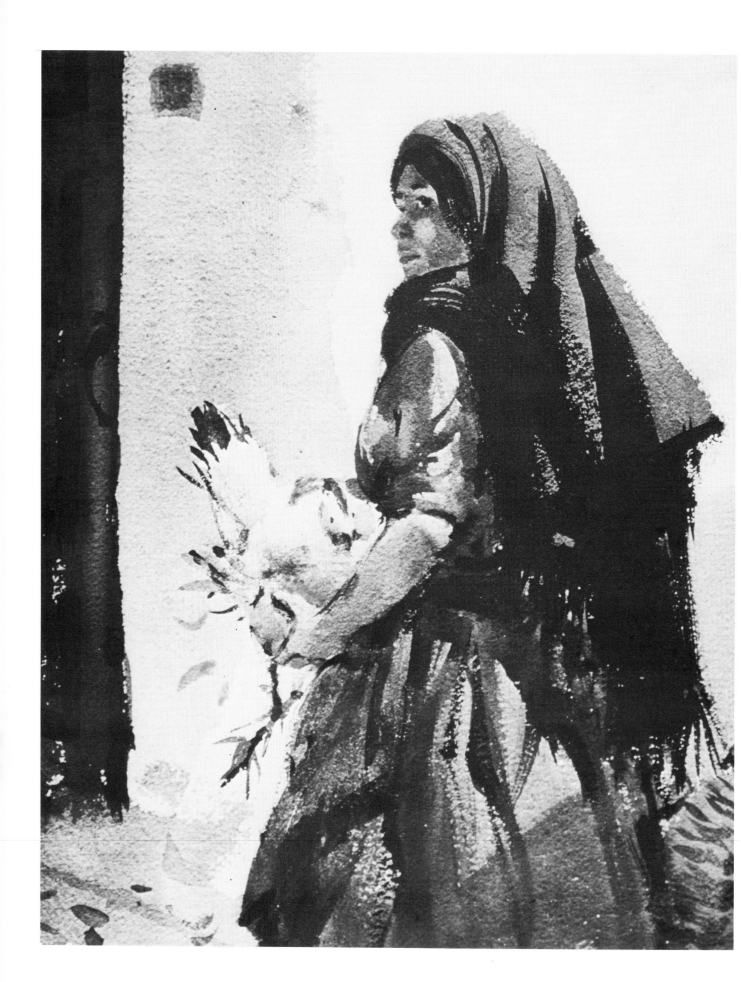

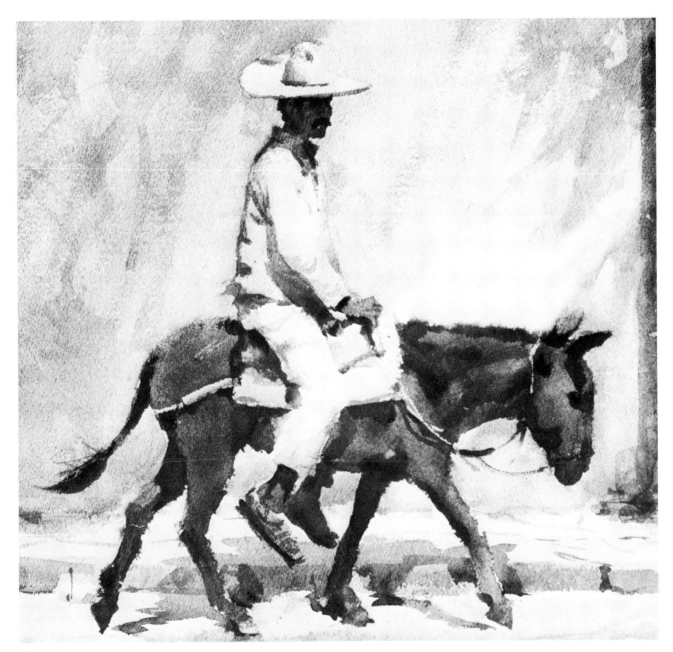

High Noon, Dolores Hidalgo *detail (14" × 16"). Private collection. Understanding both the man's and the burro's anatomy is a prerequisite to interpreting them in watercolor. Here I tried to convey the gesture and action of the two figures in the simplest watercolor terms, hoping that the viewer will get the feeling of the little burro's gait, and the slight lurching of the man atop him! First, I made a careful pencil study of the two on tracing paper. Then I turned the paper over, and on a second piece of paper, redrew the pair in reverse. When I had it down to only the elements needed, I rub-transferred the reversed image onto the surface of the watercolor paper and was ready to paint.*

◁**Mexican Lady with Chicken** *detail (11" × 14"). Private collection. There were two other figures in this painting, but I zeroed in on this one for you to see the simplified watercolor handling of a complicated figure subject. First, the gesture and shape of the figure go a long way toward making it convincing, and then the rather simple "1-2-3" values help explain the form without complication. The attitude of the head, the angle of the eye, the rebozo (scarf) hiding the chin — all tell a lot to the viewer about the figure — and yet are simply done.*

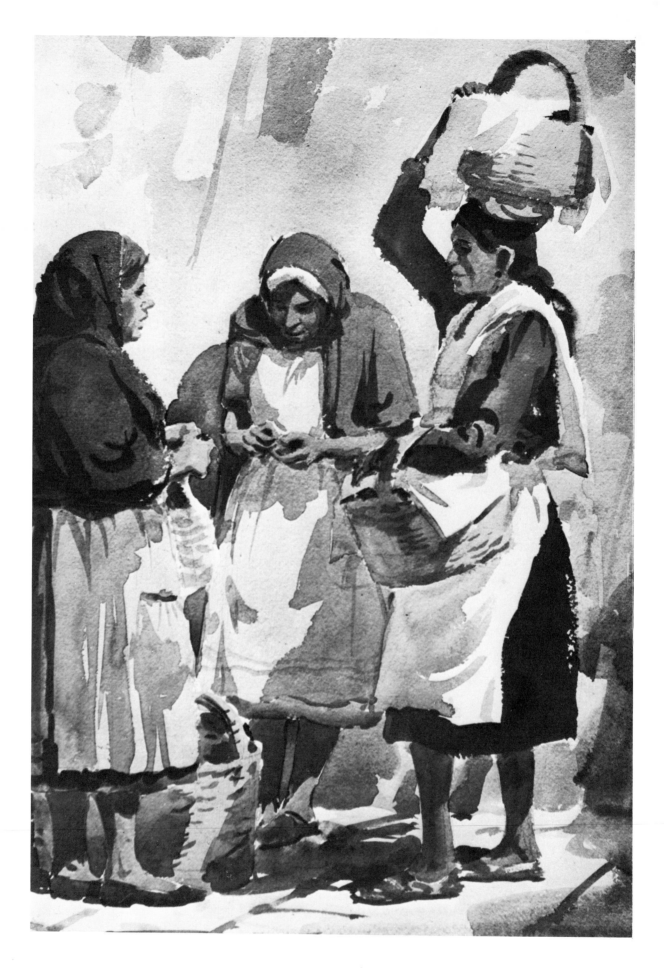

awkward, out-of-key in color or value, and sometimes looking thinner than the paper they're painted on. This is unfortunate, and needn't happen.

I don't think there's any question but that it's harder to paint a convincing representational figure than it is to paint a tree, mountain, or barn, but you shouldn't let that prospect throw you. It all comes back to what we've been talking about all along; if you understand and are thoroughly familiar with your subject, you're going to be able to interpret it better — in watercolor or any other medium! As I said in Chapter 3: observe and draw! True, many years of study, drawing, and painting go into making a good figure painter, and there's no instant replacement for this kind of experience. However, if you feel inadequate to painting figures in watercolor — especially where these figures are fairly important in the composition — I think there are ways that can be employed to get you going sooner, and I'll list them in a minute.

Painting faces on those figures, or actually painting portraits, is an extension and even an enlargement of the difficulties many watercolorists have with figures. If figure painting requires skills greater than those needed to paint a barn, then portrait painting requires even more skills than figure painting. The portrait has to have that certain "spark" that carries it beyond a diagram, as I said in my demonstration portrait painting, *Laurel*. Not only must you really be able to observe and know your subject to draw and paint well, but you must know what to de-emphasize, or even leave out, as well as what to emphasize. The viewer *invariably* will look at the face in any figure representation, and if it's right, be satisfied — even if other parts of the painting aren't as well solved. If the face is wrong, all the rest of the picture can be *excellent*, and still not compensate for the failure of the face!

Here are some suggestions that might be useful to you in improving your figure and portrait painting:

1. Study some of the excellent books available on anatomy, figure drawing and portrait work. (See Bibliography.)

2. If you can, enroll in a life drawing, or costumed figure class, preferably one where the instructor will offer criticism and help. Draw your family or friends if you can't find a class.

3. Draw to *learn* and understand your subject, not to impress anyone with your flashy techniques!

4. Be analytical and critical of your work; try to find out what you do that's wrong, or how to do it better. Use a mirror to look at your drawings — it will show up errors you didn't see at first. Also, bring out drawings done before, and look at them with a "fresh eye." If you see something that's not right, redraw it right over the old drawing (in a different color, if you like, to help you see the difference).

5. When you set out to *paint* a figure in watercolor, consider doing as I did in the *Yalapa* demonstration — perfect the figure on tracing tissue, before you transfer it to your watercolor paper. Then try to see the figure as a "gesture" created by a few simple shapes with only enough detail added to make it "read." Avoid the trap of painting details such as eyelashes and nostrils at the expense of the overall simplified masses and planes of the face.

Portrait painting (particularly in transparent watercolor) requires a host of skills and experience, but the only way these will ever materialize is to start — so don't be afraid!

Three Mexican Women (22" × 30"). *Collection Milton Heath. Three ladies on their way home from market, pausing for a bit of gossip in the brilliant, midday sunshine made a great subject. I sketched them from the privacy of my parked car some distance away, carefully noting their stance and attitude, which I later put down in watercolor, using a series of washes, working from light values to dark values, and trying to keep things as simple as possible.*

LATE AFTERNOON
NEAR SONOITA

This painting depicts an area of high grasslands in southwestern Arizona, where there aren't a lot of people. Here, an artist out to sketch or paint can find himself alone in vast, open country with the sky free and clear from horizon to horizon, the air warm and dry, not another soul in view, and the only sound the wind whispering through the grass and low-growing shrubs.

I wanted my picture to suggest tranquility and peace. For the picture's ingredients, I use a lone horseman riding up to the crest of a hill, with the late-afternoon sun just catching his back. Behind him are distant, rounded mountains, and a cloudless sky; some ranch buildings and cottonwood trees are just visible in the valley below. The use of large, simple, horizontal shapes for the painting's composition amplifies the feeling of tranquility provided by the picture's subject matter.

Although I've painted and sketched this area many times, this particular demonstration is done from memory, drawing on my knowledge of the countryside and trying to distill the painting to just the few elements that convey "aloneness but at peace."

Step 1. *First, I do several little thumbnail studies (above right) to help me solve the compositional aspects of this picture. Satisfied that the plan would work, I lightly sketch my design on a full sheet of stretched, heavy-weight, rough watercolor paper (right). I use a 2B pencil, giving the horse and rider a fair amount of detail in this pencil stage, but only indicating a little of what will later be added in the foreground and background.*

Step 2. *Using a 1-1/2" brush, I wash in the sky, using warm yellow slightly grayed with violet and making it slightly lighter on the left and darker on the right to create the illusion of approaching sunset. A grayed-violet wash (ultramarine blue, scarlet lake, manganese blue, and a bit of burnt sienna) is quickly laid over the entire foreground except the rocks, which I paint around. I then charge in areas of yellow ochre and burnt sienna; when this is somewhat dry, I scrape out grass and branches with my matknife. I paint the hills a warm grayed pink, working around the figure, ranch, and trees. The hills, like the sky, get darker in value toward the right.*

Step 3. *The shadows on the hills are painted, then a more distant range of mountains is indicated beyond them in a grayed blue. I begin painting the horse and rider in middle values as shapes, with no modeling. Shrubs and plant growth are added, using medium to dark values, some warm, some cool. I had carefully balanced these groups in the composition so they read well against the neighboring shapes, values, and colors.*

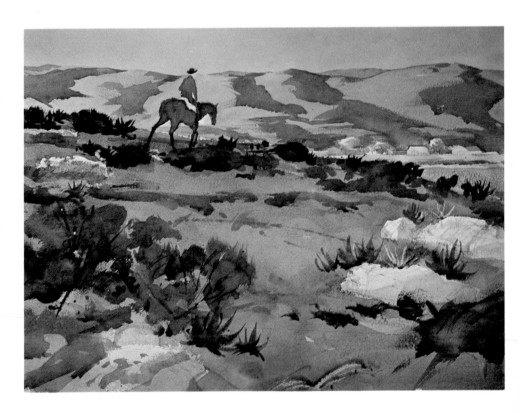

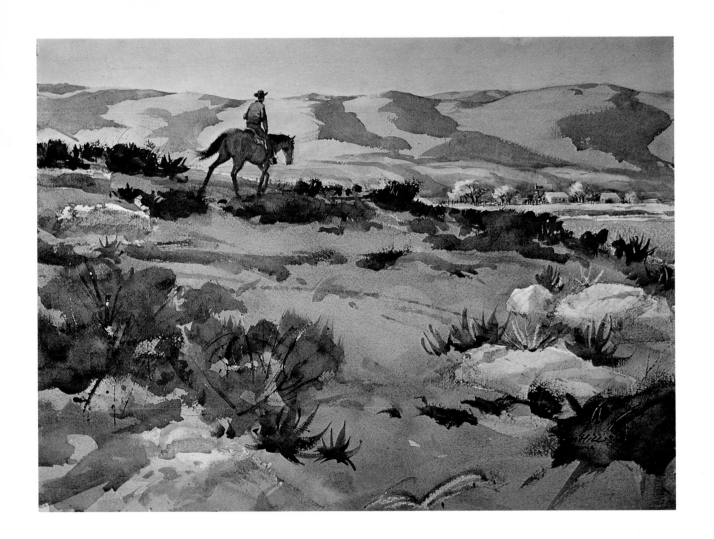

Late Afternoon near Sonoita *(22" x 30"). Private collection. I add details and shadows to the horse and rider, the ranch buildings, and the foreground. The temptation for many of us is to add details upon details—when it's usually better to add only what's needed, in the simplest manner possible, to make the painting read! For example, at this distance and in this lighting, we really wouldn't see the stitching on the man's trousers, the detail of the saddle and tack, nor the window and door detail in the buildings. That's exactly the little nitpicking stuff a lot of us feel compelled to paint, but the addition of these things won't make a better painting. The big compositional elements, the choice of colors, the direct and spontaneous manner in which the watercolor is handled—these will insure the painting's success!*

YALAPA

Yalapa faces the Pacific Ocean, with its toes in the water, and its back directly against the steep, tropical mountains. It looks exactly like an old M.G.M. movie set, all trimmed to shoot a South Seas film! This tiny Mexican village, which is maybe a thousand miles from the U.S. border, runs on its own schedule (namely, *none*, except for the daily boat from Puerto Vallarta), and has a marvelous haphazard air about it, with a feeling of *mañana* permeating everything. Painting material abounds everywhere you look! My goal in this demonstration is to try and capture some of this feeling, along with the marvelous sunshine of the tropics.

In contrast to the simple, horizontal shapes used in *Late Afternoon Near Sonoita,* here I employ some out-of-perspective angles (on the huts) and interesting curves (boats and palms) to convey the rakish, handmade, "grew-like-Topsy" look of the village. Simple handling of the foreground makes the busier treatment of the background and middleground more effective by contrast.

I use a palette consisting of Winsor yellow, cadmium orange, scarlet lake, alizarin crimson, cobalt violet, French ultramarine blue, cobalt blue, manganese blue, plus three earth colors —yellow ochre, raw umber, and burnt sienna. I mix my greens from the yellows and blues. Dominating this picture are the yellows, contrasted with violets.

Step 1. While I was in Yalapa, I made a number of sketches and took a few snapshots (above right). Working from these back in the studio, I try to create an organized picture (right) that will still keep the charming jumbled look typical of Yalapa. I decide to eliminate most of the ocean from this picture, and to use the relatively uncluttered beach for a calm area to complement the busy areas in the upper part of the painting.

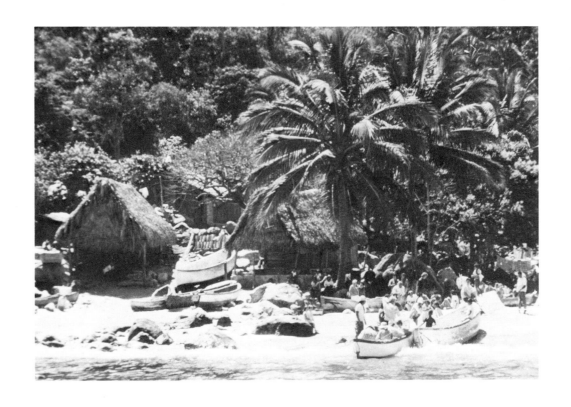

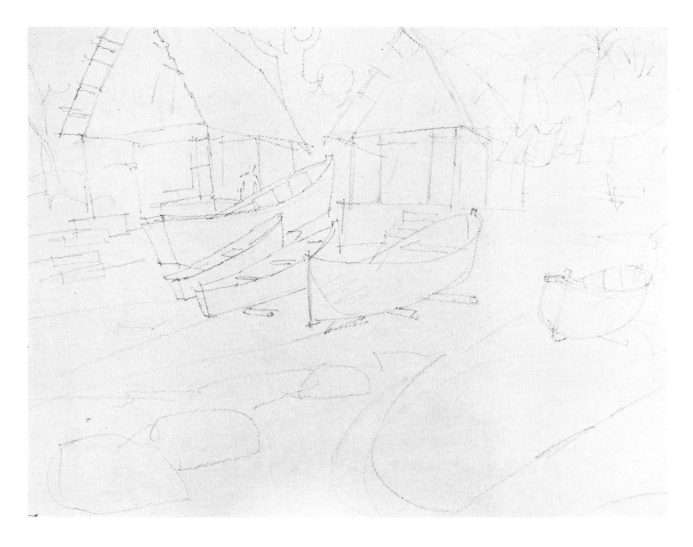

Step 2. *Using wet-in-wet technique, I apply yellow ochre to the beach area, manganese blue and cobalt blue to the sky areas, and some greens, cadmium orange, and alizarin crimson for the underpainting of the jungle and trees. I use yellow ochre with a little raw umber for the wet-in-wet wash on the front of the huts, keeping it crisp along the roof line, but letting it run and bleed out toward the bottom. The underpainting of the palm fronds is Winsor yellow, while the rocks and boats are painted simply as* shapes. *Their exact delineation will be established later.*

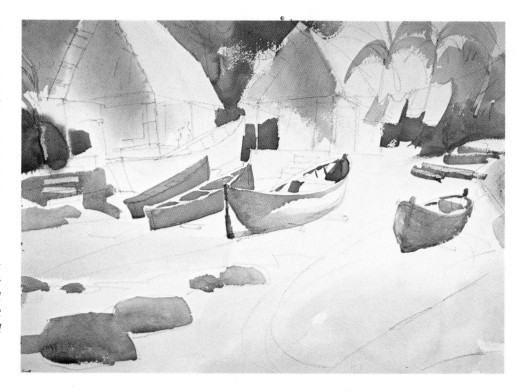

Step 3. *Now I paint rich darks of alizarin crimson and ultramarine blue, charged with burnt sienna and a mixed green, working around the palm-frond shapes (painting the negative shapes to define the positive ones). I do the same for the clothes on the line, giving them a little swing to help say "breeze." Then I further define the thatched huts, using burnt sienna, raw umber, alizarin crimson, and ultramarine blue. I scratch out some architectural and jungle elements, while the paint is the right wetness. I leave the shadows on the beach more violet than they actually are to increase the sunlit effect and complement the yellows in the huts and on the sand. For this I use cobalt yellow, part of it modified with manganese blue and yellow ochre.*

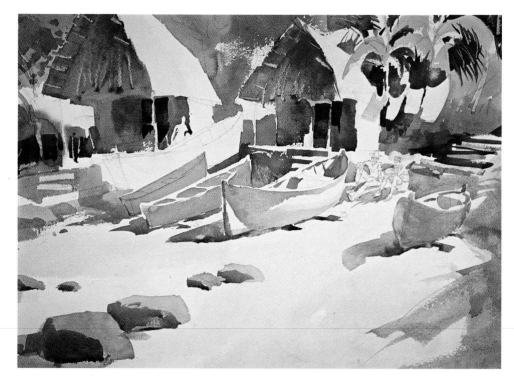

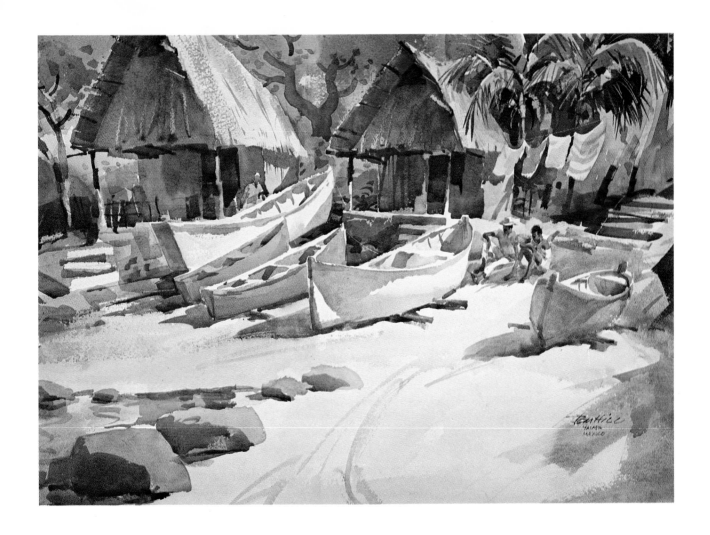

Yalapa (22" x 30"). *Collection Mr. and Mrs. Richard C. Weaver. The painting was pretty well solved by Step 3—only a few details are needed to "button it up." The problem with most of us is that we keep on adding details and add too many! It's a good idea to take a little break when you've established your main compositional, value, and color elements. Walk away from the watercolor and come back with a fresh eye, and with the determination to add only those things to the painting that will help it—and* no more!

I indicate the tree trunks and limbs, the foliage, and the two men as simply as possible. I add a wash of manganese blue to show the reflection of the sky on the little bit of ocean in the lower left corner. When it's dry, a few judicious raw umber squiggles are done with my round sable brush to suggest the water's surface. Some more details and colors on the boats, huts, and clothes on the line—and the painting's finished!

MANZANILLO

I guess I'm some kind of a nut when it comes to painting sunlight and what it does as it falls across a subject. The near-noon, back-light of Manzanillo was no exception and offered me great opportunities for interpreting the water, as well as the harbor's buildings and boats.

Actually, this isn't a very literal interpretation of Manzanillo (a Mexican West Coast port), for I've used only those elements that convey a mood of bright sunshine in a tropical setting, leaving out the telephone poles, litter, warehouses, and wharves that were really in the background. This was a busy scene—one that had to be reorganized.

My palette consists of Winsor yellow and new gamboge, scarlet lake, permanent rose (Quinacridone), alizarin crimson, ultramarine, cobalt, and Thalo blues, Thalo green, yellow ochre, burnt sienna, and a little cobalt violet. The final painting is dominated by blues and greens, which are complemented by yellow-oranges and pinks.

Step 1. First, I do several thumbnail studies (above right) to plan the composition and eliminate extra detail that wouldn't help the picture. Then, in my drawing (right), I modify my final thumbnail sketch a bit, running part of the mountains out the top of the composition and changing the angles on several of the boats. I've made the upturned rowboat smaller and grouped it compositionally with the larger dry-docked boats, as it seemed to work better that way. There were actually many rocks in the real foreground, but since they would be too busy and detract from the water and sunlight, I only indicate a few. I make the actual rocky bank that existed on the left into a rather simple area of beach.

Step 2. *I paint the sky and foreground wet-in-wet, charging clear water with Thalo blue and Winsor yellow in the sky, yellow ochre and burnt sienna on the beach, and yellow ochre and cobalt violet in the foreground water. While this dries, I paint the hulls of the two dry-docked boats, using yellow ochre and ultramarine blue, modified with alizarin crimson. The tree foliage is permanent rose, diluted and painted as a flat wash. I add the mountain shapes, using violet for the distant ones, and mixed greens charged with ultramarine blue, Winsor yellow, burnt sienna, and alizarin crimson for the closer ones. I work carefully around the boats and house shapes.*

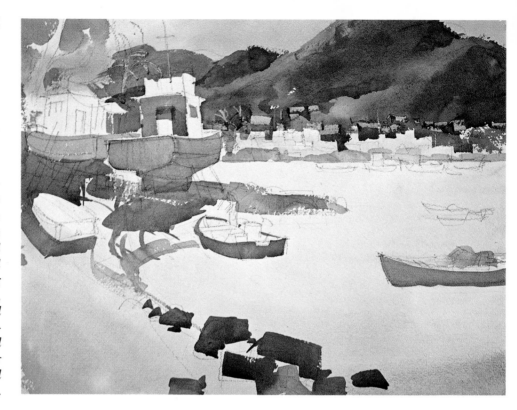

Step 3. *I give additional texture and direction to the beach, using burnt sienna and a 1" flat oxhair brush. Then I add more details to the rocks, boats, tree, and town. For my darks (both warm and cool), I mix full-intensity or saturated combinations of opposite colors, such as ultramarine blue and burnt sienna, or alizarin crimson and Thalo green. I rewet the water area with clear water, and paint around the distant boat shapes, leaving areas of paper dry to represent the highlight area of the sunlight reflecting off the water. Using a 1-1/2" brush, I apply a mix of cobalt blue and a touch of Thalo blue, working right to left and picking the brush up as it approaches the highlight area. I use the same blue in the foreground water areas, charging in some green and violet in the lower right.*

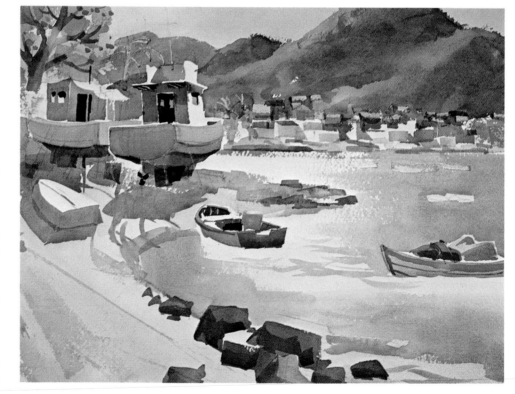

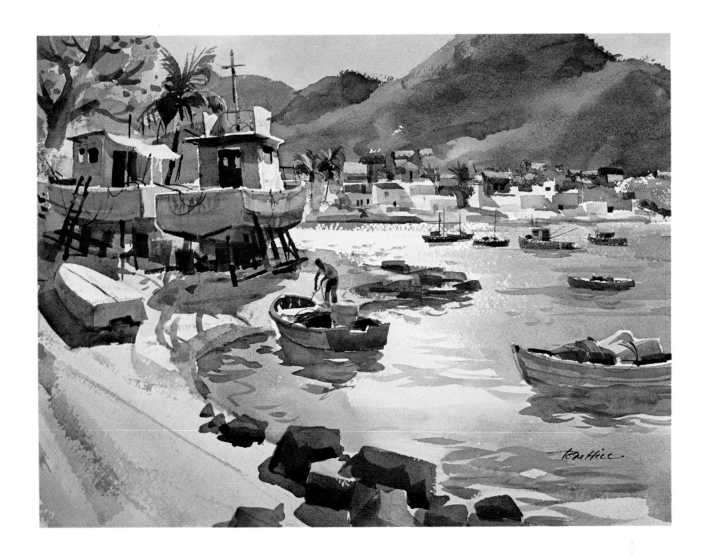

Manzanillo (16" x 21"). *Private collection. Using a No. 10 round, red sable brush and a blue-green made of cobalt blue and yellow ochre, I paint the reflections in the water caused by the boats, the shoreline, and the town and mountain. I give some of these reflections charges of the same colors as those of the objects reflecting them. Of course, the more distant reflections are lighter in value. After this has dried, I paint in the distant boats, and add a touch or two to the town, the coconut palms, and the drydock. I use my little Grumbacher No. 4 Rigger brush to swing in an indication of ropes and rigging about the boats. Finally, I add a few grayed violet shadows cast by the foreground rocks.*

CHRYSANTHEMUMS

Lots of people seem to think of the desert southwest as mostly sand, with cactus the only living plant! Far from true! Many other types of plants are successfully grown here, often imported from other parts of the country. A good example is the chrysanthemums that thrive beside a patio wall by my house. Their bright colors and sparkling whites look just great against the subtle dusty pinks and ochres of the mortar and washed-adobe bricks.

Although there are blossoms of various colors here, I use only the white and light pink ones. My plan is to paint the bouquet bathed in cool north light coming in the window. The wall of this room is a cool blue-gray, with a value of about 20%. The chest of drawers is a dark stained wood with an off-white Formica top. Nearly every element in the picture is to the cool side of the color wheel, so it seems a good idea to introduce a little warm color by showing the glint of old gold (or yellow-orange) from the nearby picture frame. I choose the following colors for my palette: Winsor yellow, scarlet lake, cobalt violet, cobalt blue, Winsor blue, and burnt sienna.

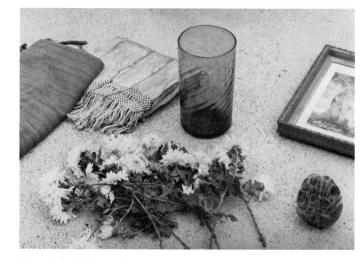

Step 1. *The photo above shows you the cut flowers, plus the other items I'll use as props in my composition. I like the vertical blue-green vase and the dull-green carved stone idol from Guatamala. They carry out the cool color theme. Placing the flowers in the vase, and carefully studying their detail and structure, I do some compositional and value sketches (right). Selecting the compositional study that I like best, I enlarge it to the size of my watercolor stretch (about 11" x 15"), and pencil in sufficient detail for easy following (far right). I use a 2B drawing pencil, which goes onto the rough watercolor paper fairly easily and yet can be successfully erased when the painting is dry.*

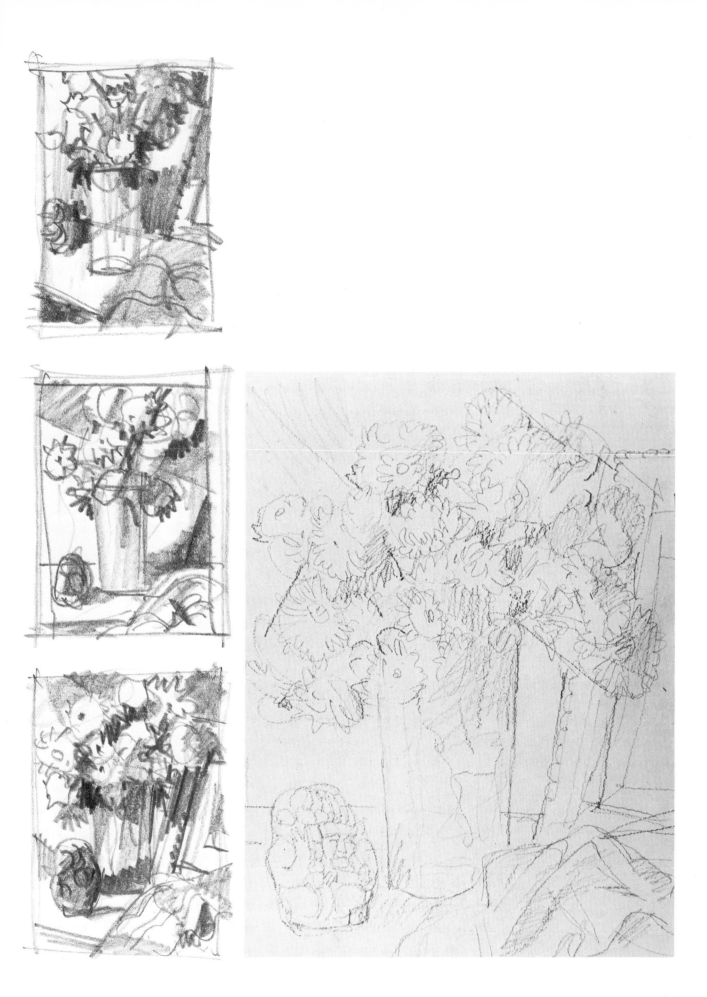

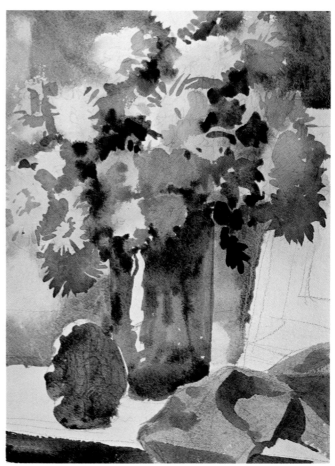

Step 2. *I wet the entire stretch evenly, using a large brush and clean water. With cobalt blue grayed with a touch of yellow and burnt sienna, I paint the shadow side of the white blossoms, using a wet-in-wet technique. I try for a good shape and don't worry about details of individual blossoms. Next, I drop in a grayed mix of scarlet lake, not too intense, painting the shadow side of the pink blossoms the same way. Depending on the light source, I make some of these shadow areas warm gray, and others cool. After the paper is dry, I paint the basic shape of the scarf, using only cobalt violet. While this is drying, I turn my attention to the background. I decide to take advantage of the partially dried paper and let some of the blossom edges be hard or crisp; where the paper is still damp, I let the background color blend with the blossoms in a wet-in-wet or soft edge. I work rapidly, mixing the background wash mainly of cobalt blue, but modifying it here and there with touches of Winsor (Thalo) blue and Winsor yellow. Then, with lighter values on the left (toward the light source) and darker values on the right, I charge dashes of cobalt violet and burnt sienna into this background wash. I indicate the edge of the cabinet with a simple brushstroke or two using cobalt blue and burnt sienna.*

Step 3. *I paint the basic shape of the stone idol with a grayed-green made of cobalt blue, Winsor yellow, and burnt sienna, leaving a white paper highlight on its top and side. While all this is wet, I charge yellow into the right side of the idol to indicate the reflection of the gold picture frame. The shadows on the scarf are achieved with more cobalt violet lowered in value by scarlet lake, burnt sienna, and cobalt blue. When the entire stretch is dry again, I paint the crisp shadows on both the white and pink blossoms, keeping in mind the overall floral pattern and shapes, as well as the individual blossom character.*

Chrysanthemums *(22" x 14"). Private Collection. Now I add a few details to the vase, which I've painted with a mix of Winsor (Thalo) blue and some yellow, leaving the white paper for the highlights and charging darks into the wet wash for the shadows and indistinct stem and leaf forms under water. I paint the light gold of the frame, the dark of the shadow, and a little indication of the frame's molding. Then I do the shadows on the cabinet top and on the wall, using a mix of cobalt blue, grayed with burnt sienna. I add the stripes on the scarf with a mix of yellow and scarlet lake, taking care to bring out folds in the cloth. The shadow of the mat inside the frame is painted with the same wash used for the cabinet-top shadows. The centers of the chrysanthemum blossoms are dropped in — Winsor yellow on the white ones and scarlet lake with a bit of yellow on the pink.*

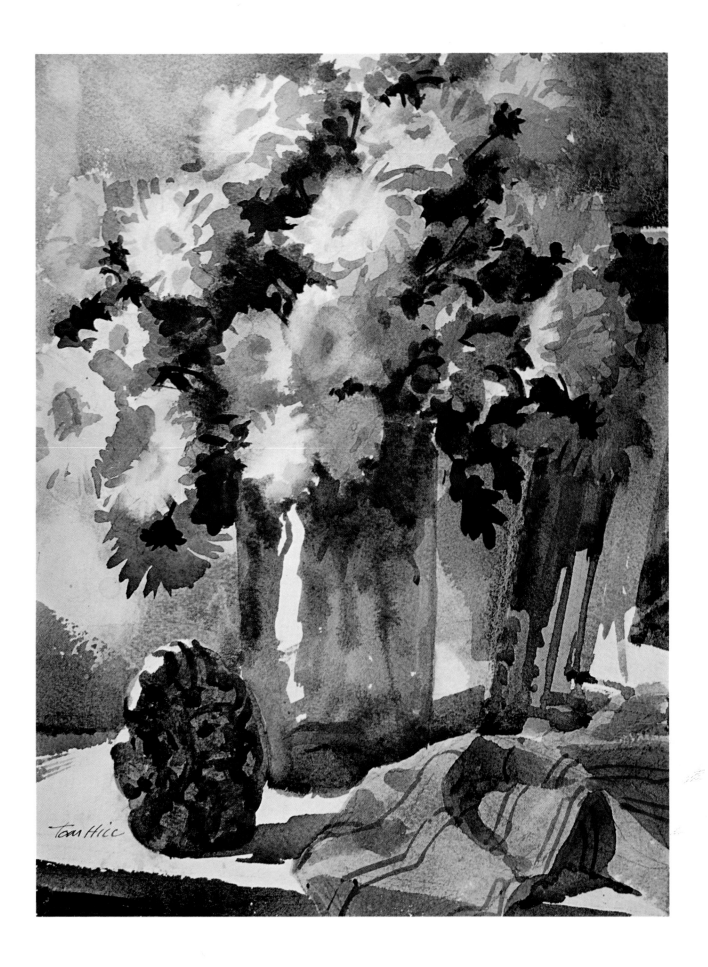

BEHIND
THE CHUTES

I don't know where the rodeo had its origin
—probably there have been exhibitions of skill
at handling animals for centuries and in many
lands. Rodeos today can be big, exciting,
ritualized affairs, with contestants competing
for honors and cash in many events such as
bronco-busting, calf-roping, etc.

There's a big annual rodeo in Tucson, and
I've gone lots of times, not only to watch the
contests, but to go "behind the scenes" to ob-
serve and sketch the cowboys and their animals
as they wait to perform. This demonstration
shows three calf-ropers waiting behind the
chutes where they can be out of the way and
still see the action. They try to remain calm and
cool by chatting and joking, but a little nervous
tension and excitement manages to show
through!

I use a nearly full "regular" palette of colors,
with the cools dominating: ultramarine, cobalt,
Thalo, and manganese blues, plus alizarin crim-
son, scarlet lake, yellow ochre, and burnt sienna.
There are no really pure greens or oranges in
this painting, only grayed versions of those col-
ors that happened through mixing these tube
colors.

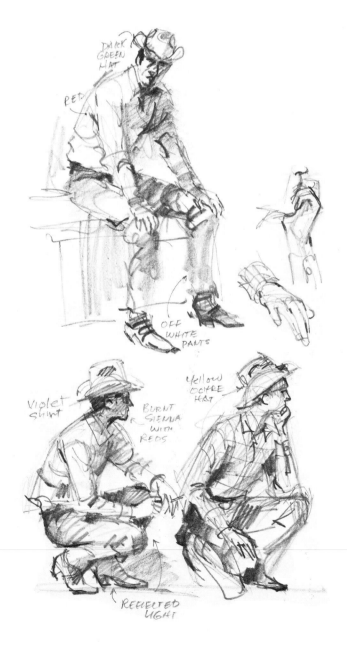

Step 1. *A few sketches (left) are all I need to paint the cowboys' figures with authority. The positions and gestures of these figures form interesting angles and triangles which I use to construct the picture's design (right). I enlarge the third thumbnail sketch directly onto my full-sheet watercolor stretch, using a 2B pencil (below). The triangular shapes give the picture a stable feeling (no pun intended), so I slant the vertical and horizontal shapes of the boards in the chutes to give the composition a feeling of drama and impending action.*

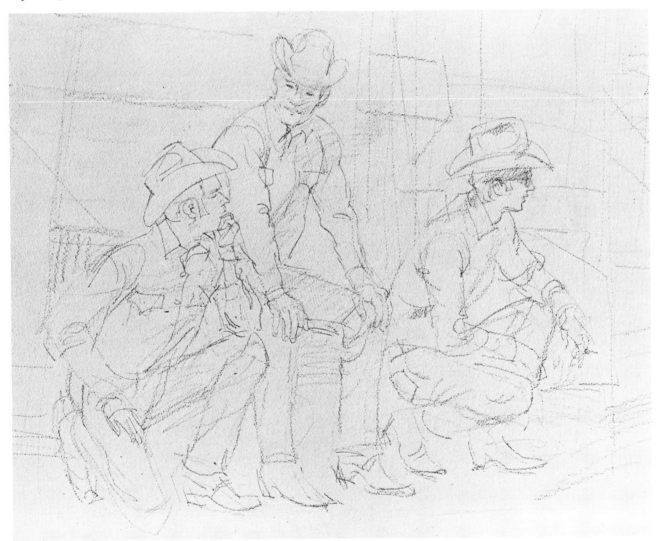

Step 2. Wetting large areas of my paper with clean water, I quickly wash in cobalt and manganese blue, and yellow ochre and violet (a mixture of alizarin crimson and ultramarine blue). I let parts of these passages run wet-in-wet and paint others up against dry paper areas, leaving crisp, ragged edges. I sprinkle salt into some of these wet washes for additional textural qualities, and then scrape out some reverse light. On the left cowboy's shirt, I indicate shadows with a mix of cobalt and manganese blue, yellow ochre and burnt sienna. I paint the trousers a darker value of the same mix. The middle cowboy's shirt is a mix of alizarin crimson and scarlet lake, with some yellow ochre. I use violet for the shirt on the fellow on the right.

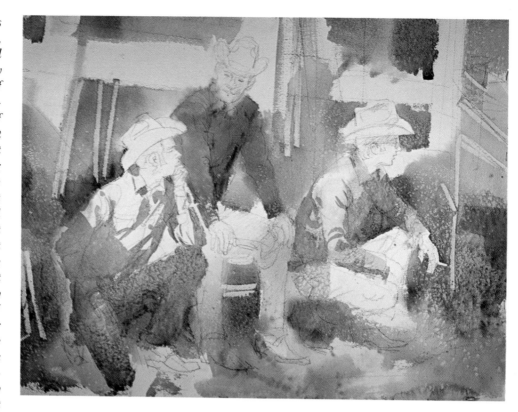

Step 3. As you can see, this painting has come a long way toward completion without any detail, and makes a good composition, with nice color relationships and abstract design. I don't think that I need add very much more. Using facial tissue for blotting and a small bristle brush for gentle scrubbing, I remove the trouser color from the hand of the cowboy on the left. Next, I paint the shapes of the hats, boots, hands, and faces, using a middle-to-light value wash of burnt sienna for the skin color. I add shadows on the shirts and trousers with the same color as originally used, only darkening it in value and graying it with its complementary color. A lot can be suggested about the form simply by the way you paint the shadow falling across it.

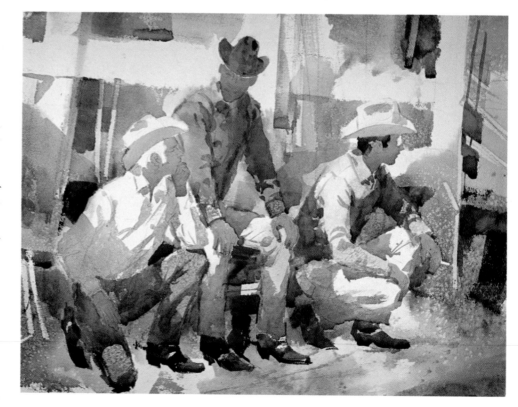

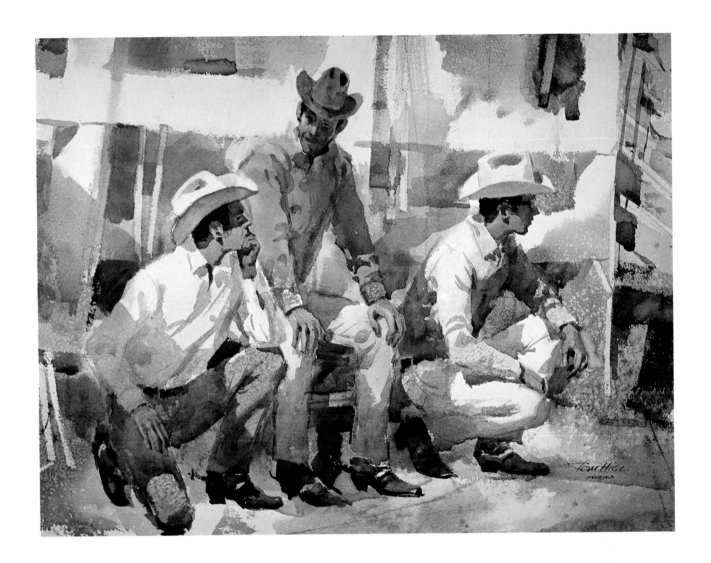

Behind the Chutes *(22″ x 30″). Collection of the artist. Here, I add shadows to faces, necks, and hands. These are critical and must be handled "just so!" As I said in Chapter 9, when the human figure is painted this large (and in a representational manner), the viewer's eye invariably goes to the face. If that face isn't executed with authority (based on knowledge, and on lots of drawing and painting of faces before), then the viewer knows "something's just not right"—even though he or she may not be an artist! Notice how I try to make each face read against its surroundings by making sure there is a sufficient value difference. This is easy with the two figures on the right, since their faces are against white paper. The shadow color is burnt sienna, with some alizarin crimson and yellow ochre added.*

LAUREL

An artist friend of mine once said: "In representational painting, landscapes, seascapes, and still lifes are difficult enough to do really well and require understanding by the artist of his subject and his medium. Painting the figure (and animals, I might add) seems to require even more understanding and skills, because where a tree, a rock, or a hill can be any number of shapes, a figure can't — and must therefore be even more accurately understood and interpreted to be convincing."

What he said is certainly true for me in my experience. Even more demanding than figure painting, is the art of portraiture—especially in transparent watercolor! Here the artist must not only be able to draw well and accurately, be complete master of his medium, and have a good knowledge of value and color, but he must be able to carry the portrait *beyond* the "resemblance" stage, and the well-rendered "diagram," to a somewhat vague and hard-to-define area of capturing that special "soul" or "spark" which sums up the essence of the subject.

For this portrait, I choose a basically warm palette consisting of: yellow ochre, scarlet lake, cobalt violet, ultramarine, Winsor (Thalo) green, raw umber, and burnt sienna.

Step 1. *I decide to use my daughter for a subject. Someone I know well gives me a better chance to capture that "spark" I was talking about. Because of her pretty profile, I choose a near-profile pose, with a little of her left eye showing beyond the bridge of her nose. This makes it a little more difficult than a straight profile, but also a bit more descriptive and interesting, I think. I make a careful pencil drawing directly from the posed model, trying not to put anything down on paper that doesn't help or add to the portrait. I indicate just a touch of one shoulder and let the bandana go off the paper to the left. My drawing is about two-thirds lifesize, done on a small (9" x 12") sheet of rough watercolor paper.*

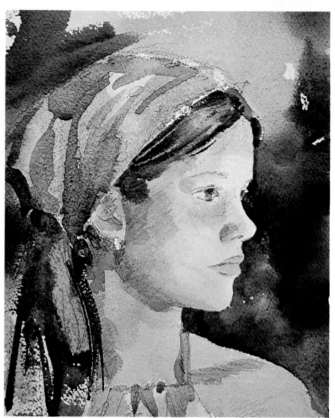

Step 2. *First, I wet the face and neck areas with clean water, then flood them with a light-value wash of yellow ochre tinged with a bit of scarlet lake, using a 1" flat oxhair brush. This constitutes the basic skin color. When just damp, I add some slightly darker values – yellow ochre, scarlet lake, and a touch of raw umber – to the cheek, forehead, and neck. Using a No. 12 round, red sable brush, I apply a wash of cobalt violet to both the blouse and the bandana (eliminating the polkadots on the latter.) When the face and neck areas are dry, I wet most of the background area with clean water and apply a yellow ochre wash with my 1-1/2" flat brush, letting those dry white spots at the top of the paper remain. I charge mixes of Thalo green and burnt sienna into the wet background, cutting carefully around the profile of the face, neck, and shoulder, trying to preserve these very critical shapes that say "this is Laurel." Cobalt violet and a touch of ultramarine blue are also charged into the background.*

Step 3. *To the face area, which is now dry, I carefully paint some subtly darker values (yellow ochre, scarlet lake, and raw umber) to the nostril, under the eye, the cheek, neck, and collarbone area. With a darker value of cobalt violet (modified with ultramarine blue and a touch of burnt sienna), I quickly indicate the wrinkles and stress lines of the bandana that cast shadows and give it shape. I use this same wash to show the gather of the blouse. Next, using raw umber and my No. 12 round brush, I wash the hair shape in, keeping it very simple, then paint the darker areas with a richer mix of raw umber darkened a bit with ultramarine blue and burnt sienna. The brushstrokes help show the sweep, shape, and texture of the hair. When this has dried a little, I scrape out some of the color in the hair above the forehead, creating the effect of highlights and conveying strands of hair without actually rendering them. Then with my old matknife, I scratch out the little pearl earring on the earlobe. Yellow ochre and a dab of raw umber indicate the pupil of the eye.*

Laurel (12" x 9"). Collection of the artist. I further paint the cheek, the lips, and the area just under the eye, with a light wash of scarlet lake. I add darks of burnt sienna to the ear, nostril, and the shadow cast by the halter. Finally, the eyelashes, eyebrow, and pupil of the eye are painted in with bits of raw umber and burnt sienna as simply as possible. A little voice inside said: "Stop while you're ahead, Tom"–and I did.

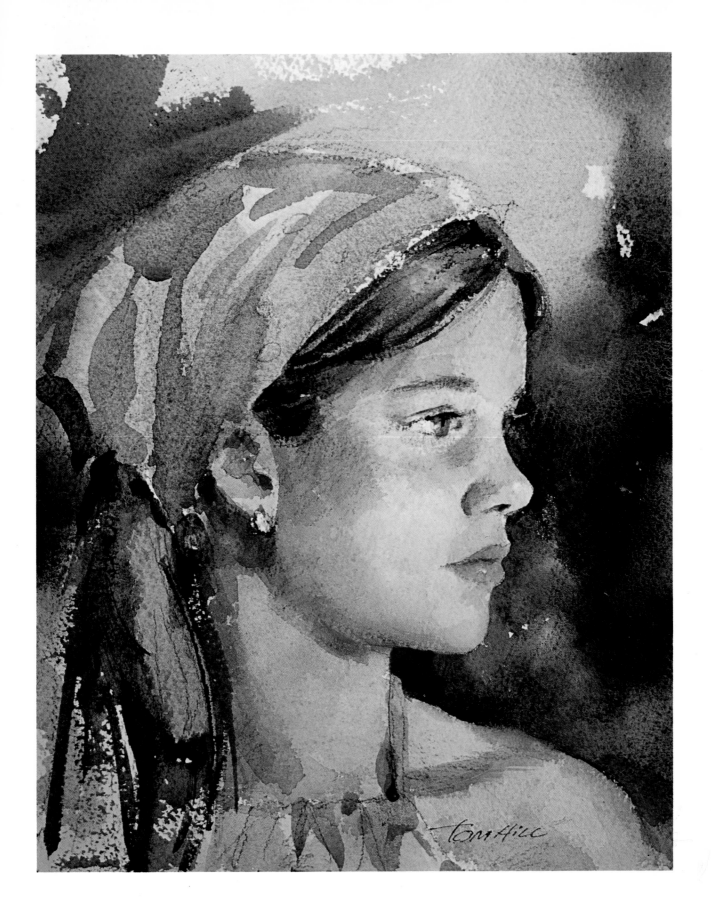

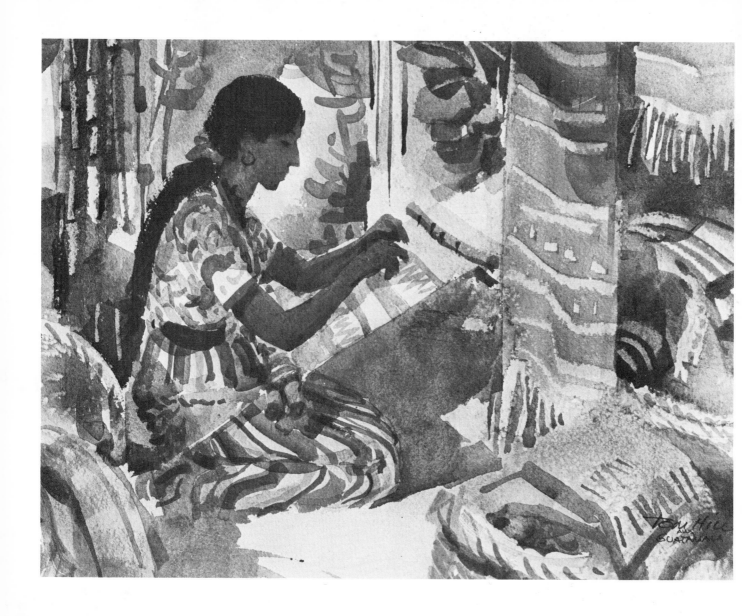

Waist-Loom Weaver, Guatamala *(14" × 22"). Collection Mr. and Mrs. Walter Roediger, Jr. Fabrics are still woven in Guatamala using this ancient method: the weaver sits or kneels, with a harness around her waist supporting her end of the loom, while a tree, post, or a wall supports the other end. The intricate and colorful patterns are only hinted at in this painting, and the hanging fabric is used as a compositional device to help set off the Indian woman. The big shapes of the painting were done first, working with large flat brushes and no detail. Indications of some of the patterns on the cloth were scratched out of the wet washes, and then as the painting dried further, details were added.*

10
QUESTIONS OFTEN ASKED

Here are some questions I've heard from time to time, with my answers:

Hand-made paper's so expensive!
Can I paint on both sides?

Absolutely. The side on which you can read the watermark when you hold the paper up to light is supposed to be the right side, but I find that either side of good handmade paper works fine.

Are there any machine-made papers
that work well with watercolor?

I don't like them as well as the handmade papers, but two machine-made papers you could use are Strathmore and Watchung. Try to get a "mould-made" paper, as its surface is a little better.

Do I have to stretch my watercolor paper?

Not if you paint on 300 lb. — (however, I usually stretch even *that*.) Stretching your paper isn't all that much trouble, especially if you use a staple gun and stretch several sheets — or more — at a time. And stretched watercolor paper is *so* much better to paint on! After you're through painting, be sure everything's dry before you release your stretch or the paper might buckle.

Tube colors are expensive and I've got some old ones.
How can I tell if they're still good?
Do they spoil or rot?

I've never heard of a spoiled or rotten tube color, though I've seen a lot of spoiled results! The color is still good if the tube is still soft, even if it's not too soft. If it's rock-hard, forget it.

How can I loosen the stuck cap
on a tube of watercolor paint?

Roll up the tube from the end, so that all the paint is up by the cap, and then try loosening it. If that fails, try pliers or heat the cap with a match. Don't burn your fingers!

I have some old paint on my palette. Is it still good?

Most colors will soften up if you put a little water on them 20 minutes or so before you paint. Some, like viridian, don't seem to resoften very well. If you can cover your palette, leaving a wet sponge or rag in the mixing area (but not touching the pigments!), the colors will stay moist overnight or longer. If your palette doesn't have a lid, try using plastic wrap (but keep it out of the pigment!).

Where did you get that lightweight, little folding stool?

I bought it at a discount store that carries camping equipment.

*Where did you buy that tripod
that supports your watercolor board?*

I bought it at a photography supply house. It has quick-release, telescoping legs, and on trips the whole thing can be disassembled and stored in a small space.

*What about using colored inks or dyes, which
are transparent, instead of, or with, watercolors?*

Be my guest. Avoid the dyes that aren't permanent — they are very bright and intense, but can fade *completely* in a short time. Inks, like Higgins and Pelikan, are more permanent, but they have no "body" to speak of, and will have an entirely different "feel" and flow than tube watercolors. I use inks from time to time.

Can the new acrylics be used as, or with, watercolors?

Yes — and there are some wonderful new colors in acrylics. They will flow a little differently, in some cases, than watercolor, and they are sure to ruin your brushes if you don't wash the brushes out *repeatedly* in soap and water *as you* paint.

Can I use opaque watercolors with transparent?

Fine, as long as you're consistent. The reflection of light (talked about in Chapter 1) is different with opaque paints than it is with transparent watercolor — and all the other things like staining, tinting, and glazing are also going to be different. After all, it *is* a different medium.

What about using sunglasses when painting?

Painting right in the sun is difficult, and shade is much better if you can find it. I have a pair of neutral gray glasses that aren't supposed to change colors, only cut down on glare. They're better than squinting!

Is it O.K. to use seawater in watercoloring?

Yes, as a lark or in a pinch. The minerals in seawater will affect your colors in various ways, probably not for the *good*, in the long run.

How can I speed up the drying of my watercolor?

Put it out in the sunshine, if there is any. Wind will also accelerate drying time. Indoors, a little electric heater or hair dryer helps.

*How much pencil should I use on my watercolor paper
before painting, and how soft a pencil do you use?
Do you ever use charcoal?*

I use a fair amount of pencil in the demonstrations in this book, mainly so that you can see what I was trying to show. Ordinarily, I'd be inclined to use *less*, rather than more pencil. I use a 2-B, or sometimes, a softer 4-B pencil. I don't use charcoal, because it mixes with the paint and grays it.

Will the pencil erase out after the watercolor's done?

Most of it, if you haven't drawn it in too firmly. I like a Pink Pearl eraser, although art gum, kneaded erasers, and so on, are fine, and I use them too. Erase *only* on dry paper!

Do you stand, sit, or kneel when you paint?

I do all three (not at once) depending on the circumstances. The main thing is to be able to move about freely; have your board firmly supported so that you can move. Never paint holding the watercolor board in your lap!

*Is it good to finish a watercolor painting
in a short time, like 45 minutes or an hour?*

I don't think you can put time limits on painting. If you're working outdoors, you'll probably want to get at least your main areas and shapes established in that time — before the sunlight changes. Many of my paintings are done in a fairly short time — less than two hours — but then there are others that take days. This usually means painting a bit, going away, and coming back with a fresh eye.

*Even though I stretched my paper, now that I'm in
the middle of this painting, and everything's wet,
I see it's buckling a little. What do I do?*

Let it dry a bit — it'll flatten right down and stretch tightly again.

*I've just painted this whole sky, and I don't
like the color, it's too dark. What can I do?*

If you're near a sink or even a garden hose, you can wash the whole sky (or foreground, or whatever) right off, flooding it with water. If you're using kraft tape to hold your stretch, be careful not to loosen it. There'll be some color

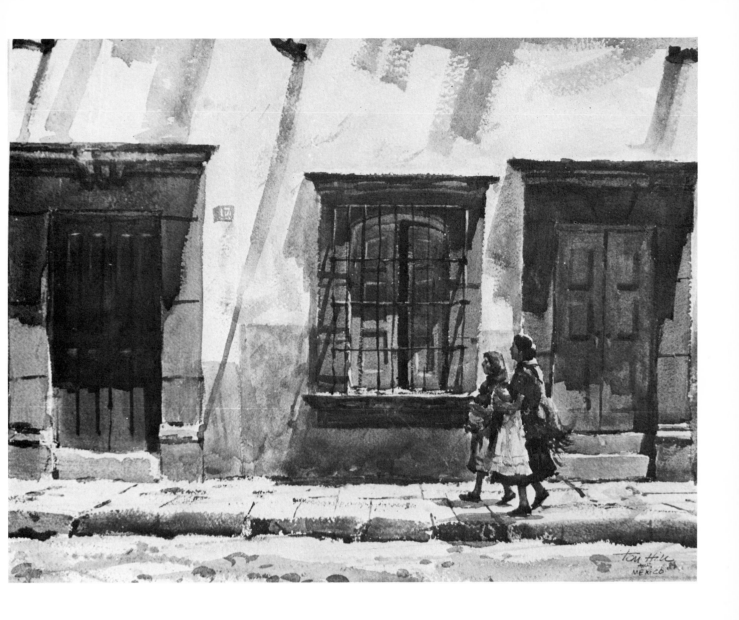

On Pila Seca Street *(22" × 30"). Private collection. These colonial buildings and their interesting architectural elements, lit by a nearly-noon sun, create good light and shadow patterns. The two figures add life and motion to the flat-on, nearly perspective-less picture. A wet-in-wet treatment was given the walls, which were a light-value, grayed violet. After they were dry, I painted the door and window shapes, mostly in grayed oranges and blues. The lower part of the wall had a painted area — a sort of imitation wainscot — and this was painted a flat wash of very grayed, light-value orange, using a glazing technique right over the dry violet color of the wall. Cast shadows from the facia and coping above, as well as those in the doors and windows, were done rapidly with a large flat brush, give dimension to an otherwise flat facade.*

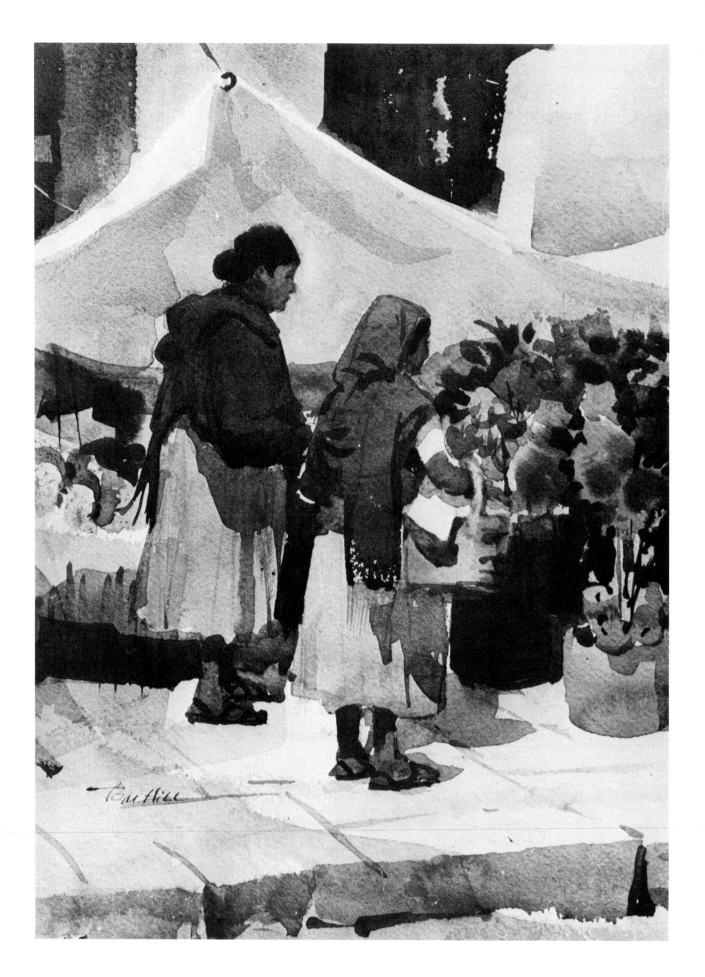

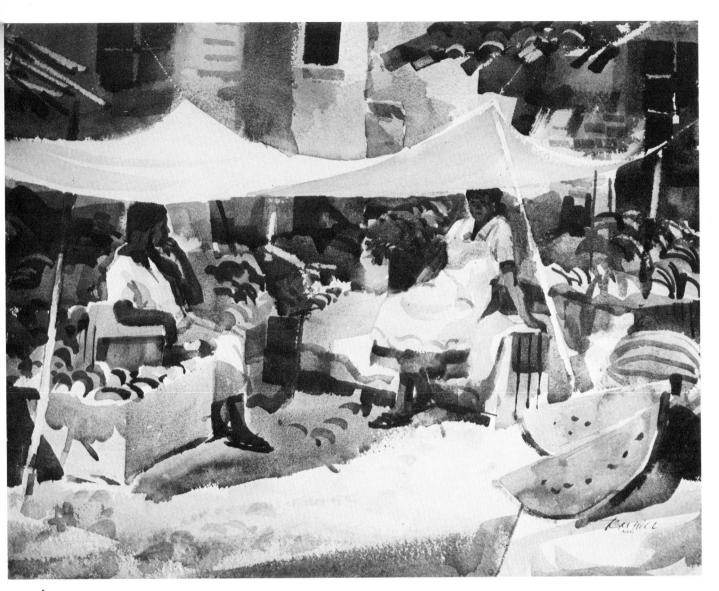

△
Watermelon Stand *(22" × 30"). Collection of the artist. Bright red slices of watermelon kick this painting's color-key off to a good start, and the green rinds and other green produce make the reds look even redder. Again, simple areas, such as the sunshade and foreground, relieve and complement the busier areas — the fruits and vegetables, the tile roofs, and the windows. This painting was done almost as an abstraction, using a large (2") brush for all the main value and color areas and establishing these in the first 30 minutes of painting. I didn't mask out the sunshade when I painted the areas in back of it, but rather painted around it. Window, roof, and sunshade details were scraped out of the wet-in-wet washes at the right time, giving me casual, "un-slick", light-value reverses out of the darker colors behind them. The figures were handled as simply as possible, paying more attention to their attitudes than to their details.*

◁ ***In the Flower Market*** *detail (9" × 12"). Collection Dr. and Mrs. James Fritz. In Chapter 9 we discussed painting the human figure with simplified shapes and gestures. These two figures are a good example of this approach; they were painted quite simply, with their shapes and gestures more important than any detail. Notice how light and shadow help explain shape and form.*

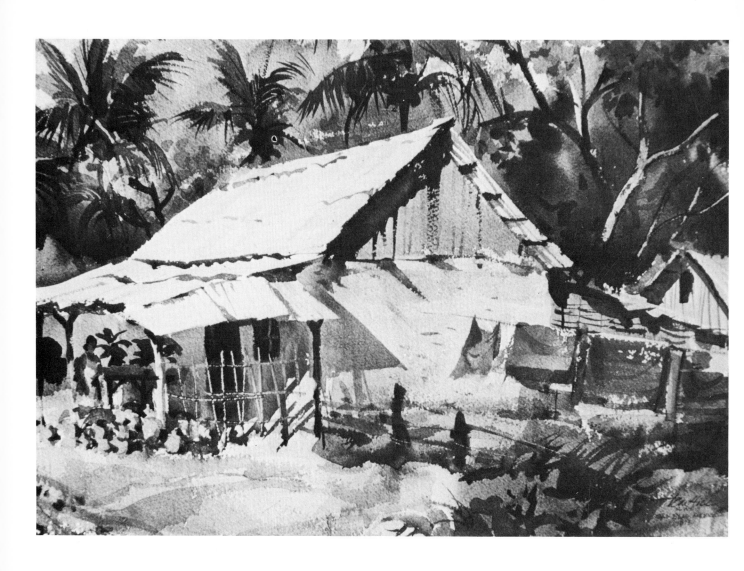

Coconut Lady, San Blas *(14″ × 22″). Collection Mr. Lee Everett. This little shack is both home and business for the coconut lady, who offers coconuts for sale on her front porch. If you wish, she'll top one with a deft stroke of her machete, offering it to you with a paper straw, so you can drink the slightly cool contents. I painted this watercolor right on the spot, gaining a considerably large crowd of curious folks, young and old, as I worked. The coconut lady herself finally came over and seemed delighted to be the center of interest in my painting and pleased with the "crazy gringo" who thought there was something about her house worth painting. As you can see in this black and white reproduction, I let the jungle behind the house define the shape of the house's roof, putting only a* little *texture and detail on the roof itself. The cast shadow of the porch overhang has lots of warm colors reflecting into it from the yellow-ochre street out in front. Purple and pink blankets dry on the clothesline.*

left, but after the paper's dry you can paint again — almost like new!

Why do you hold a mat up to your painting before you have it finished?

I think it's a good idea to have an old "service" mat — and hold it up to the painting frequently while working. It helps isolate the painting from its surroundings, and lets me see if I'm really using the painting's edges to their fullest advantage.

I've done some painting and now my paper has dried. How can I wet it again without disturbing what I've already painted?

One way is to make sure the areas you've painted are *really* dry, then lightly and swiftly apply clear water with a big brush. Be careful to use only enough water to moisten the surface, so the color underneath won't soften too much and start to bleed. Another way is to use a little atomizer, such as the plastic ones used to spray clothes for ironing. Set the spray-head for the finest spray possible, and have your colors ready-mixed on the palette.

I have a "balloon" coming in from the side of a wash. What caused it?

Probably you painted an area next to the wash before it was really dry, and the water from this area found it easy to creep into the first wash, until it was blotted up, and made this undesired edge called a "balloon." Wait longer, next time.

I have gotten an area "muddy." How can I correct it?

Sponge it out with your little silk sponge, or if it's a small area, gently soften it with a bristle brush and blot up the "mud" with tissue. Then repaint when it's dry. The "mud" came from having too many colors in the mix, or from painting over the area too many times.

I think I've overworked this painting. Is there anything I can do to save it?

You could flood the whole thing under the faucet, washing off most of the pigment, and when it's dry, paint back in only what's needed. Or you could prop it up in front of you, and start over with a fresh sheet, profiting from your mistakes.

How do you get such clear, clean colors?

By using the fewest colors possible in a mix, by frequently washing out my brush and palette mixing area, and by using clean water all the time!

I've painted this watercolor about as far as I can carry it, and I'm discouraged with it and feel like throwing it away. Should I?

Don't. Even if it looks like a flop to you, let it dry and put it away for a day or so. Then look at it. It — or parts of it — may look much better to you later. Try blocking off areas within the painting that look good. Sometimes there's a smaller painting — even two little paintings — within the larger one. At the very least, you'll see it with a fresh eye.

The paint "beads up" and crawls on my paper. What's wrong?

It could be that there's too much sizing on the paper's surface, and you should wash off the paper with clean water before painting. If you've stretched the paper before, this will already be done.

There are little pinholes and white dots popping up after I've done a wash. What could cause this?

Could be too much sizing on the paper, or it could be droplets of oil that you didn't know were there. Did you make that stretch in the kitchen while hamburgers were being cooked on the stove — or just after? Greasy or oily fingers can create undesirable resists — so wash your hands prior to painting!

Do you use colored mats around your watercolors?

Almost never. After all, the painting needs help, not hindrance, and is best served by a mat that isolates the painting from its surroundings, and doesn't compete with it or influence the painting's colors by adding another of its own! Because commercial mat-board is made "super-white" with bleaching and whiteners, it's whiter than the hand-made watercolor paper, which is never made with bleaching chemicals. Consequently, if such a mat is used, it looks whiter than the whitest white in the painting! So, I usually paint my

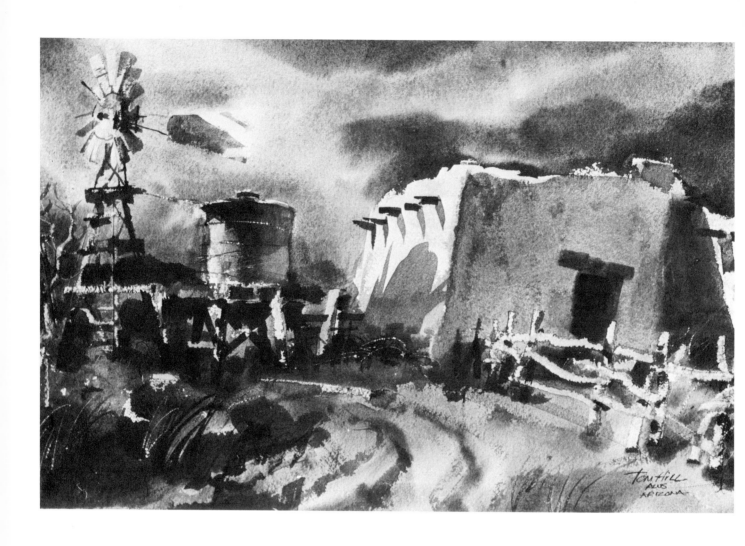

Deserted Ranch, Winter Day (14" × 22"). *Private collection. This moody little painting attempts to depict the feeling of a cold winter's day, with rain clouds scuttling along, pushed by a persistent wind. Using wet-in-wet in both foreground and sky areas, I was careful to leave white, dry paper for the watertank and the old adobe building, both of which I slanted a little to add to the feeling of the blustery wind. The painting is low-key in color, painted with a rather limited palette of yellow ochre, burnt sienna, alizarin crimson, ultramarine and manganese blue, and just a hint of Thalo green. The fenceposts and rails, plus parts of the windmill tower, were scraped out of the wet washes at just the right time, giving me a nice, ragged reverse of light against dark.*

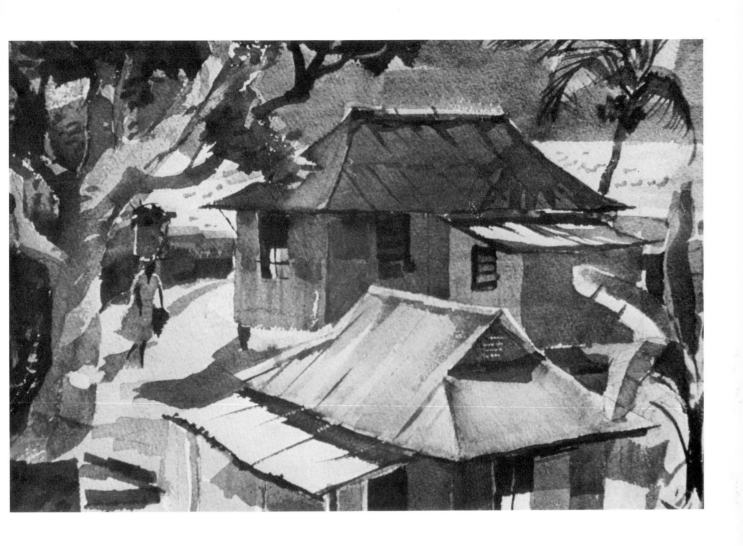

Rural Jamaica *(11" × 14"). Collection P. Pettigrew. I sketched this scene while traveling by car through some of this tropical island's back country (I wasn't driving while sketching!). I painted this little watercolor a few hours later, back at the hotel. My goal was to capture the flavor of the scene: little tin-roofed buildings set this way and that against the forest, with occasional glimpses of sunlit ocean in the background. I used back lighting, leaving the colors in the shadows clear and fairly high in key, and letting the cast shadows explain the lighting by their angle. Even though this is a very small watercolor, most of it was painted with 1-1/2" and 1" flat brushes, establishing principal shapes, values, and colors in the first 20 minutes. Then, just enough detail was added with a No. 8 round sable to make it "read."*

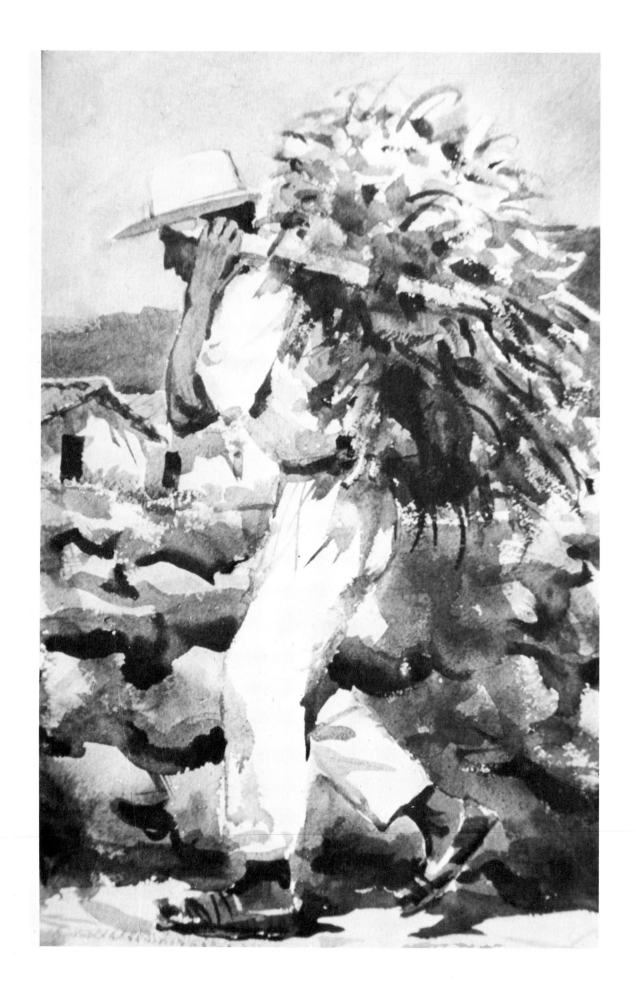

mats a neutral off-white that's not really gray but doesn't compete with the painting. Most paint stores sell interior latex or acrylic wall paint, and usually have several off-whites. Pick the most neutral one and apply it to your mat with a brush or paint roller. If the mat is thin, you may have to give the reverse side a coat of paint, too, so the whole thing won't warp.

The linen cloth, used in picture frame liners, usually goes well with most watercolors.

El Cargador (9" × 14"). Private collection. Human cargo-carriers are still seen everywhere in Mexico — carrying anything that you can imagine (and that they can lift). The loads can be impressive. This man had a relatively light load of corn shucks and was moving right along, as I drove by. I made a quick sketch then and painted the picture that evening. The action or gesture of a figure is most important, and here again, I tried to handle this figure as simple shapes, with light and shadow falling across them, and only enough detail added (belt, sandals, and indications of the eye and fingers) to make it read. The suggestion of houses in the background was managed with only a roof line and a couple of darks for windows. The hill beyond adds distance but is really only a flat wash!

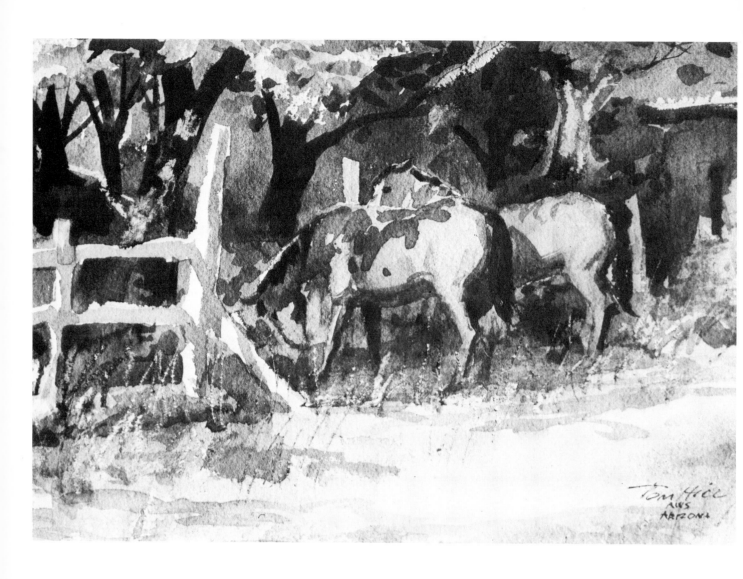

Summertime, Arizona *(11" × 14"). Collection of Dr. and Mrs. Montie Furr. The scene is northern Arizona's high country. It's near noon and the Indian ponies are content to stand in the partial shade of the cottonwood trees, with the July sunshine making dappled shadows across their backs. My goal for this little picture was to capture the feeling of sunshine and quiet contentment in this little corner of Arizona.*

After planning my composition and drawing the horses rather carefully, I wet the foreground and charged light-value yellow ochre and burnt sienna washes into it. Next, I painted the basic shapes of the horses and the adobe building. I dampened the foliage areas of the trees, then painted in light yellow-greens using wet-in-wet technique. Turning to the now-dried foreground, I dragged some rather flat washes of grayed greens and violets, indicating the texture and "lay of the land." After this, I painted the cool, dark background under the trees and around the horses and fence. When this was dry, I painted the tree trunks and branches and a little of the texture of the leaves. Next, I painted the shadows on the fence, the adobe, and the horses, being careful not to destroy their forms. Adding details—the horses' eyes and manes—and scratching out a little grass texture in the foreground completed the painting.

BIBLIOGRAPHY

Blake, Wendon. *Creative Color: A Practical Guide for Oil Painters.* New York: Watson-Guptill Publications, 1972.

Brandt, Rex. *Watercolor Landscape.* New York: Van Nostrand Reinhold, 1963.

————. *Watercolor Technique.* New York: Van Nostrand Reinhold, 1963.

Guptill, Arthur. Ed. Susan E. Meyer. *Watercolor Painting Step-by-Step.* New York: Watson-Guptill Publications, 1967.

Itten, Johannes. *The Elements of Color.* New York: Van Nostrand Reinhold, 1970.

Koschatsky, Walter. *Watercolor, History and Technique.* New York: McGraw-Hill, 1970. Vienna, Australia: Anton Schroll and Co., 1969.

Mayer, Ralph. *The Artist's Handbook of Materials and Techniques.* New York: Viking Press, 1970. London: Faber and Faber, Ltd., 1964.

O'Hara, Eliot. *Watercolor Fares Forth.* New York: Minton, Balch and Co., 1938.

Pike, John. *Watercolor.* New York: Watson-Guptill Publications, and London: Pitman Publishing, 1973.

Note: Also consult brochures and catalogs from such art suppliers as Winsor & Newton, and Grumbacher, Inc.

INDEX

Designed by Bob Fillie
Composed in 10 point Baskerville by Gerard Associates/Graphic Arts, Inc.
Printed and bound by Halliday Lithograph Corp.
Color printed by Sterling Lithograph